Creative Life

Other Books by Bandhu Dunham

Contemporary Lampworking: A Practical Guide to Shaping Glass in the Flame, Third Edition (Prescott, Arizona: Salusa Glassworks, Inc., P.O. Box 2354, 86302); $59.95 ISBN 0-9658972-1-4. For more information or to order online: www.salusaglassworks.com

Formed of Fire: Selections in Contemporary Lampworked Glass (Prescott, Arizona: Salusa Glassworks, Inc., P.O. Box 2354, 86302); $29.95, ISBN 0-9658972-2-2. For more information or to order online: www.salusaglassworks.com

* * *

Additional Hohm Press Titles

Visit our website at www.hohmpress.com, or call 1-800-381-2700 for a complete catalog.

Creative Life

Spirit, Power and Human Relationship in the Practice of Art

Bandhu Dunham

Hohm Press
Prescott, Arizona

Cover design: Kim Johansen
Layout and design: Tori Bushert

Library of Congress Cataloging-in-Publication Data

Dunham, Bandhu Scott, 1959-
 Creative life : spirit, power, and human relationship in the practice of art / Bandhu Dunham.-- 1st ed.
 p. cm.
 Includes bibliographical references and index.
 ISBN 1-890772-46-1 (trade pbk. : alk. paper)
 1. Artists--Religious life. 2. Art and religion. 3. Spiritual life. I. Title: Spirit, power and human relatedness in the practice of art. II. Title.
 BL625.9.A78D86 2005
 701'.08--dc22

 2004031037

HOHM PRESS
P.O. Box 2501
Prescott, AZ 86302
800-381-2700
http://www.hohmpress.com

This book was printed in the U.S.A. on acid-free paper using soy ink.

09 08 07 06 05 5 4 3 2 1

For all the students who have taught me so much

Acknowledgements

*H*elp from a number of people was indispensable to the completion of this book. The topic was originally suggested by Lee Lozowick, and his continued interest carried the project forward. I'm also grateful to the staff at several teaching institutions that so hospitably gave me sane and inspiring environments in which to work on these essays, including the Corning Museum of Glass, The Penland School, Red Deer College, the National Bottle Museum and Snow Farm. Comments and suggestions from friends and colleagues were also important; I especially want to thank Norman Edd, Henry Halem, Paul Marioni, Volkmar Ernst and Che Rhodes for taking a look at early drafts and sharing their comments. My editor at Hohm Press, Regina Sara Ryan, nursed the text along at crucial points, fostered clearer expression for many of the ideas, and helped me cut out redundancy, which was very, very helpful.

Contents

Introduction

*A*rt and spirituality are as often at odds as they are inter-
twined in the Western world. What seems like success in
one field can be in direct conflict with success in the other. On one hand,
the artist is expected to cultivate a highly individual personality, even striv-
ing to pursue its subtlest whims of creativity in order to ride the cutting
edge of value in the marketplace; on the other hand, the spiritual aspirant
pursues devotion to a transcendent reality through investigation of uni-
versal truths—perhaps in the form of a tradition unchanged for centuries.
It would seem that a flair for self-promotion and dealing with the politics
of the art world only bolsters the kind of egocentrism that obstructs spiri-
tual practice, while the morally upright mysticism of a humble spiritual
pilgrim is anathema to professional success in a competitive field where
nice guys often finish last.

Even if we put aside, as we must, the historical baggage of Church
patronage and the conformist proprieties implied by our notions of

religion, and even if we look past the materialistic business side of art, we can run into problems. In fact, these conflicts arise from false assumptions we carry about both subjects and their relationship to each other. They are in fact more like two sides of one coin.

It is not hard to find artists whose unaffected pursuit of their passion imbues them with an authentic spirituality. Successful artistic exploration usually brings at least a degree of spiritual maturity with it. Such maturity may not be couched in religious terms or burdened with "spiritual speak," but the artist's actual conduct in daily life makes it evident. Kindness, generosity, compassion, and other truly spiritual qualities mark the life and relationships of practitioners in whom art and spirituality merge. We are inspired not only by their finesse with brush, keyboard or chisel, but also by their embrace of life as a whole.

This book addresses both art and spirituality under the embracing term *creative life*. It is a familiar expression that is hard to avoid when looking at creativity as an encompassing topic. My use of this term is not meant to relate this book to the work of others who have used in a different context, nor are these essays necessarily at odds with such work. Specific paragraphs address specific issues—mostly revolving around art, its practice and its role in society—but most points should be taken as directed equally to spiritual pursuits like philosophy, meditation, prayer, service and study.

There are many books already available that give a systematic course for developing oneself artistically or spiritually. That has not been my approach for the most part, although this book is meant to provoke forward movement—for those already in the thick of the practice as well as the simply curious. The general terminology of many essays is meant to spark associative thinking relative to your own situation. Furthermore, it is meant to give a context to whatever techniques you choose for your own self-discovery through artistic or psycho-spiritual means. While there are some specific practices, approaches and techniques recommended, there is no specific system to be followed. It seems to me that the context in which we hold our efforts is what is most important. Therefore I have

emphasized an overall context of transformational creativity, believing that, given my own background, this would be my most valuable contribution.

This book is not meant to promote any particular spiritual or religious ideology, although it draws inspiration from many. Real spirituality is beautiful. The true *Dharma* or Teaching, when embodied in our actions, is elegant and uplifting, even as it embraces the heartbreaking reality of embodied life. The architecture, literature, theatre, dance, iconography, ritual implements and quotidian handcrafts of living spiritual traditions have an aesthetic attraction born of deep resonance with the essence of human experience. Appreciators of art who have no ostensible interest in religious matters are nonetheless drawn to ancient Hindu temple sculptures, Egyptian ritual objects, ancient Greek drama, medieval illuminated manuscripts, Japanese ceremonial tea bowls, Native American prayer pipes or Shaker furniture. The spiritual *is* aesthetic, and the aesthetic *is* spiritual.

And while not every spiritual seeker has the inclination to pursue art *per se*, such practitioners have greater access to creative energies that can be applied to any field, including art. Spiritually mature individuals embody a relaxed spontaneity, aesthetic sensitivity, focus, elegance and skillful means that artists aspire to, whether they produce "art objects" or not. In fact, the whole life of a spiritually inspired person might usefully be looked at as a kind of performance art.

This is why the stories of teachers, saints and gurus are preserved and passed down in most religious traditions: they amount to poetic, impactful transmissions of beauty and wisdom. It doesn't matter whether the story is of Saint Francis throwing off his clothing to abandon his social standing, a *koan* between Zen master and disciple, the *lilas* of Krishna or the rakish exploits of the Tibetan master, Drugpa Kunley. The stories of worthy spiritual practitioners embody not only the teaching of principles, but also a challenging aesthetic element that resonates with our deepest being thereby confirming their "rightness." Real spirituality, like good art, has a poetic obviousness that validates it not only within its own culture, but also to anyone with an eye to see or an ear to hear.

In some cultures, in fact, there is no word for "art" because it is so intrinsically incorporated into all aspects of life, including religious practice. Similarly, "religion" or "spirituality" are little-used terms when they are woven so closely into life as a whole that separate discussion is irrelevant if not impossible. It is our modern Western perspective that insists on some of these distinctions, which probably reflects a certain fragmentation in our worldview.

So it is with an awareness of this pitfall that we have to consider art and spirituality. The division between them is artificial, really. Nonetheless, teasing them apart before weaving them back together can be useful at times. By addressing spirituality from an aesthetic perspective, and art from a spiritual one, we can highlight unexamined assumptions and possibilities about both. Remembering that the nature of the mind is to analyze (literally, to break apart), we can use our considerations to bring art and spirituality together in practice as creative life.

CHAPTER 1

Lascaux

It is certain that this long familiarity with the animal due to hunting, a pursuit demanding attention, observation and concentration in the highest possible degree, created in the Stone Age artist the ability to produce something true and lifelike in a manner rarely equaled and never surpassed.... Prehistoric art is full of harmony, nobility and greatness, first because it is essentially based on truth, on that knowledge which comes from a sense of unity with its subject; perhaps also on a sort of spiritual brotherhood between man and animal. This is what makes it supremely religious.[1]
—*Marcel Brion*

In the creation of a work of art, the maker enters a psychic territory in which the image created and the awareness of the artist blend and merge. This is the primary thrill of the artistic process, and what sets it apart from more prosaic activities. Specifically, in rendering an object of the eye's attention into two-dimensional form, the most successful experiments strike an immediate chord, no less apparent, it would seem, to the ancient painters of Lascaux than to our modern perception. The artist experiences, in a successful rendering, not only the pleasure of success, but deeper experience of rightness, a resonance with the chord that has been struck. It is, in a large or small way, a mystical moment. This holds true whether the artist seeks to achieve a convincing rendering, an abstraction that evokes the spirit of the thing depicted, or some combination of the two.

The shamanistic function of artistic rendering in tribal cultures is well recognized. When we look at the cave paintings in Lascaux, as with other prehistoric art, we sense that the intention of these artists was, at least in

part, to concretize a beneficial relationship between man and the spirit world. With some confidence, we can interpret the images of game animals as an effort to invoke or placate their spiritual counterparts.

It is no wonder, therefore, that anyone—primitive or modern—would feel a certain resonant power in their brushstrokes, as if the spirit of the thing depicted were called into being. In Lascaux, we see one of the earliest examples of the evocative power of art. This power has not only inspired artists and their appreciators; its scent has also attracted the attention of those throughout history who have dealt in power of other kinds. The ability of art to communicate, impress and even manipulate its audience has contributed to its co modification, and to a lifelong dance between art and power.

> Primitive and pre-alphabet people integrate time and space as one and live in an acoustic, horizonless, boundless, olfactory space, rather than in visual space. Their graphic presentation is like an x-ray. They put in everything they know rather than only what they see.[2]
> —Marshall McLuhan and Quentin Fiore,
> *The Medium is the Massage*

It is not too outlandish to say that the primordial artists who left us works like the compelling images in the caves of Lascaux were, in the most essential sense, problem solvers. First of all, the creation of the renderings themselves can only be the result of repeated experimentation for refinement of materials and technique. But there is more. The grace and vigor of the Lascaux figures, which provide aesthetic and intellectual value for us, provided as well a more practical value for their makers. Given their shamanistic power, they were probably the most advanced technology available with which to ensure the well being of self, friends and family.

The history of art might be usefully interpreted as a series of problems and solutions. Each new movement in art represents an attempt, through the power of art, to address problems posed by previous movements. Thus the tendency for artistic manifestos to pronounce, with self-flattering finality, that the pinnacle of artistic evolution has at last been reached, that the solutions which eluded previous movements have at last been worked out, or conversely, that things have run their course and that art is dead. But such certainty flies in the face of the obvious ongoing evolution of the human creativity. Even as the directions pursued by some art movements seem to lead to a dead end, and culture seems to lose itself in irony and loops of self-referential nihilism, creativity continues to assert itself in wholesome, inspiring pockets of self-expression.

Problems or challenges call for creativity to meet them; the root of artistic process is the existence of a problem to solve. Sometimes the problem is aesthetic, sometimes spiritual, sometimes intellectual and sometimes simply pragmatic. The creative life, as considered in this book, is a multidimensional means to address the problems posed by human existence. It is neither the exclusive provenance of artists, nor the sole obligation of spiritual and religious practitioners. Rather, it is the birthright of anyone willing to embrace an ongoing and enlivening struggle of continual evolution.

Left to their own devices, artists create problems to solve. Art engages problems in order to resolve questions from within the maker; it is a problem that presents itself to the artist in the form of inspiration. Artists amplify that function of the mind that projects internal conflicts onto the outer world in order to solve them. This is what makes art so useful as a form of therapy for some people. But the artist's externalization draws forth material that does not stop at the boundaries of language or the psychological realm; the projecting function of the mind is a special case of a more general impulse toward expression of the soul.

If we look at the word "express," we see art summarized. The artist pushes, or is pushed, outward. Compelled by an internal pressure known as inspiration, he brings out images (including sounds, sensations, smells, flavors), which reflect or embody the source of that pressure. The pressure

3

is experienced as a problem calling for a solution. The expediency and grace with which the problem is identified and solved is experienced as the quality of expression. But the neat summaries of language reflect only parts of a process that is really quite messy.

Art that is most compelling, and satisfying to its maker, externalizes (expresses) subject matter that the mind may not be able to encompass. We, as audience, are made witness to ideas that are more than mental. When our deepest feelings and physical vitality are engaged as well as the mind, we experience a wholeness (even a wholeness of dread) that contacts the spirit. The strongest communication of art is from soul to soul, and this happens only when the artist is able to draw forth her own deepest embrace of life. This is what is meant by meeting the challenge of life head-on.

The Loneliness of the Artist

A real work of art destroys, in the consciousness of the receiver, the separation between himself and the artist— not that alone but also between himself and all whose mind receives this work of art. In this freeing of our personality from its separation and isolation, in this uniting of it with others, lies the chief characteristic and the great attractive force of art.

—Leo Tolstoy

*I*s the loneliness of the artist any different from the loneliness of the average person? Sometimes it seems that to be "a voice crying in the wilderness" is part of the artist's job description. The nature of having a unique vision is that no one else has it yet. I think we are given visions or inspirations precisely *because* no one else has them. Our job is to buck the trend of what already exists, to swim against the current, to bring the tablets down from the mountaintop or to embody some other suitably Promethean metaphor. But this could be said in every field, really. Inspired contribution is in everyone's job description, not just that of the artist, and as in all fields, some artists are better at it than others. Those who are best at bringing inspiration into tangible form, whether artistic, social or scientific, are often too busy attending their vision to think about whether they are lonely or not.

On some level, the loneliness all people experience is the same; it is the fundamental gap we feel between our own being and the greater universe

or nature, of which social loneliness is just one form. Most of the time this gap is masked, or we are distracted from it, or quite simply it doesn't bother us. In our technological society, we have adapted to this condition of separateness in ways that would shock and horrify our ancestors. We compensate with consumption, with dramatic hedonistic acts—or we numb our senses with substances that, under other conditions, might heighten our sense of loneliness to the point at which we might actually be inclined to do something about it.

Perhaps art is one of these substances. We can become embalmed in beauty as easily as we are inspired by it. The same holds true for other, sometimes contradictory, qualities of art. Cleverness, irony, grief, disgust, terror or horror can all serve either to heighten or dull the sense of our own condition. Entertaining stimulation, whether pleasurable or disturbing, highbrow or low, is a primary modern coping mechanism to deal with loneliness, just as the person who really doesn't have much to say is often the one to talk incessantly. Empty space can be terrifying; its silence represents something unknown or unknowable.

Mark Twain said that if we cannot stand to be alone, it's likely that others find us boring as well. In an obverse way, it could be said that if we fear the unknown, then knowing ourselves is also out of the question. The unknown in the form of empty space, aloneness, lurks behind every corner, really. If we embrace empty space, through meditation, through our practice of art or by some other means, it loses its terrifying aspect. Instead of sorrowful loneliness, aloneness leads to possibility.

If the artist's loneliness is unique, perhaps it is that she dives into that loneliness, mines it for material. Creation begins in silence. Out of necessity, the artist becomes intimate with silence, internally if not outwardly. For the artist, the gap between oneself and the universe is not a terrifying abyss, but an opening through which inspiration arrives. Inspiration is often ephemeral, a ghostlike voice that speaks to us in the quiet hours of the night, when we are most alone.

Loneliness haunts us. If we use it creatively, it is a private source of consolation, a companion that can never abandon us, but if we resist the

empty space that loneliness implies, we become afraid. During daylight hours we can busy ourselves and fill our awareness with other things. Then, as some kind of twilight arrives, we feel uneasy and sense the presence of ghosts. Something about these ghosts is attractive, but contemplating them gives us a chill. The hair stands on the back of our neck, and we need to get out of the house or at least turn on all the lights. The gap of silence must be filled somehow, with noise, things, food, drama.

> You must not fear or hold back, count or be a miser with your thoughts and feelings. It is also true that creation comes from an overflow so you have to learn to intake, to imbibe, to nourish yourself, and not be afraid of fullness. The fullness is like a tidal wave which then carries you, sweeps you into experience, and then into writing. Permit yourself to flow and overflow. Allow for the rise in temperature, all the expansions and intensifications. Something is always born—of excess. Great art was born of great terrors, great loneliness, great inhibitions and instabilities. And it always balances them.
>
> —Anaïs Nin, *Letters*[1]

When we are the audience for art we are confronted by a gap of silence as well. The receptive audience shares empty space with the artist. Then we might sit, for a moment, in the same skin as the artist, grasping with a visceral clarity what it is they wish us to see. In that instant of timeless transmission, the artist's mission is accomplished and his loneliness is abated for a moment, as is ours. Loneliness is a means of connection with others.

So, is the loneliness of the artist unique? It is a bit self-indulgent to speculate about whose situation is better or worse—or why, thereby compounding loneliness with comparison and self-pity. Who knows, there may be qualitative differences. The fact is that all people share a core experience

of emptiness and loneliness. In that, the artist is no different from anyone else and the artist's recourse boils down to the same recourse all people have, even if the form of it is sometimes a bit different.

The undeniable force of emptiness, loneliness, confronts us with a choice. If we cave in to fear, make ourselves small or needy, loneliness can be devastating. In fear and silence, self-pity seeks a foothold, and we suffer if we give it purchase. However, we do have another option if we take the time to see it.

The antidote to the pain of loneliness is not, as we might think, simply to seek consolation in companionship. If that were so, we would never feel alone in a crowd. The solution is not passive, but active. Loneliness is painful if we look inward in doubt; instead we need to look and move outward. What cures loneliness is generosity—not the generosity of others toward us, but our own generous spirit. Nothing we can take in will fill the empty space of loneliness. Rather, what we put out from within ourselves imbues that space with satisfaction. It is impossible to be generous and to feel lonely at the same time. Loneliness is the opposite of generosity.

Each of us can escape the weight of loneliness by cultivating a generosity of spirit. Artists are lucky in that we can do this through our art. Generosity is an expression of our creative energy; when we are miserly, we suppress the flow of our own life force, and that is what makes us feel cut off, alone, desperate. What we give is not as important as *that* we give. The artist is lucky, then, in that his job is to give of himself as directly as possible. This is the essence of creative life.

In one sense, perhaps the loneliness of the artist is different from that of the average man in that the artist has this way out. To function creatively is often a narrow, ephemeral window of opportunity, what shamanistic author Carlos Castaneda called a "cubic centimeter of chance." It is an escape route available to the artist, a mystical bridge across the seemingly intolerable gap between one being and another.

When we consider generosity, we tend to think in terms of money, the least personal form of exchange. This is moving in the wrong direction, although there are plenty of worthy causes to which we can contribute

funds. What satisfies is to make a *personal* gift of energy, whether or not it takes place in person. We make a gift of energy to others (through our social interactions, our art, our time, our support) because we feel large. We are generous because we feel we can afford to be, and that feeling is a decision. Regardless of our circumstances, we become generous when, not unlike Scrooge, we simply decide to.

The feeling of largesse comes from seeing the big picture. If we define our "self" strictly in personal terms, limited by our bag of skin and its territories, we have taken the first step away from generosity of spirit. Disconnected, we can't help but feel a need to look out for number one. If, on the other hand, we take the advice of philosophers both Eastern and Western, and consider the self to exist only as an integral part of a greater whole, we gain perspective.

From that perspective, generosity comes naturally—especially if we are bubbling over inside with a creative possibility. Creative life is about communication. Sharing our art completes a circuit that connects us to the world around us, even to the universe. This is a practical bridge across the primal gulf.

Relevance and Polarization

No synthesized view of reality has replaced religion. Science is not a view, but a method. The consequence is that the modern artist tends to become the last active spiritual being in the great world. It is true that each artist has his own religion. It is true that artists are constantly excommunicating each other. It is true that artists are not always pure, that sometimes they are concerned with their public standing or their material circumstance. Yet for all that, it is the artists who guard the spiritual in the modern world.[1]

—Robert Motherwell

S pirituality is the dimension in which we are all together. Despite the many forms of religious and political definition, when people connect spiritually, we speak the same language. The language of spirit is the language of unity, of coming closer at least. We might also say that the main obstacle to spirituality is the division or marginalization of people, both from each other and within themselves. The spiritual practice of art brings artist and audience together. Examining the mechanisms that create and enforce divisions between and within people can be instructive for us who seek to connect with ourselves and others through art.

Since about 1900, art has often been accused of an inability to connect with its audience. Viewers of modern art sometimes feel at a loss for a mental context in which to hold what they are seeing. This is ironic, since one of the tenets of formalism as a modernist movement has always been the conviction that art, properly executed, can be experienced universally, without the need for introduction or an interpretive setting.

The problem, however, did not end when postmodern theory came into vogue, just as it did not really begin crisply at the turn of the twentieth century. Communication and relevance in an overstimulated world remains a problem. Competing for attention in a media- and image-saturated environment, artists are compelled to develop techniques and strategies to even get noticed, and then to receive the consideration their work deserves. Beneath the methods of getting attention, however, the real issue of connection needs to be addressed. It is not a matter of marketing and publicity, but of relationship.

If viewers understand that a postmodern artist expects them to participate actively in the interpretation of a work, they can at least begin to take hold of the creation. But if they remain in a passive role, their confusion may be permanent. This simple distinction between an active and passive participation is outside the awareness of the casual or occasional art audience. When so much of the stimulus provided in our culture encourages and requires passivity (even dependence) from in the receiver, it can hardly be surprising that so many people also approach art that way. And while frustrated artists might want to blame *someone* for this state of affairs, it may not be fair to blame the audience.

Instead of focusing on how ignorant the audience is, artists are better off looking for ways to be more effective communicators. This could include educating one's audience, but primarily the artist's job is to improve his own communicative techniques. As hard as it might be to admit: if no one likes you, it might mean that you deserve the treatment. The situation is not hopeless, but the only chance for improvement begins with relinquishing the comforts of denial. A realistic assessment of feedback is part of the artist's job description, as it ought to be for politicians, scientists, spiritual teachers and practitioners in any other field.

Young, impatient artists tend to place high value on shock tactics, but more mature practitioners have subtler means of capturing the audience's attention and funneling their awareness into a desired channel. The mature artist can shock when necessary, but is apt to win the viewer's cooperation in a process that is more like seduction. Just as one's first efforts at

romantic seduction can be awkward or crass, early art is often rough around the edges. Such art has a value in its own right, as documentation of a process, but often becomes less interesting over time if the artist goes no further.

Critiquing the viewer is certainly useful and effective from time to time, but it must be handled with care. If the underlying attitude is really a desire to raise consciousness, we can expect people to get the point when conscience is pricked. On the other hand, if we are playing some kind of "blame game," the result will be an outburst instead of an impact. Audience members can tell whether the artist is speaking to them like another human being, or from the role of a critical parental figure. Again the basis of real communication has to be a human relationship.

When an artist disregards what Buddhists call the basic human goodness, she invites disconnection. There will always be some people who are sufficiently steeped in artistic, social or critical theory to interpret almost any obscure communication. There are also always a few who seek out and enjoy criticism and blame for reasons of internal psychology. Addressing this audience might be relatively easy, but creative life invites us to a bigger possibility. What if we could operate such that an entire range of willing listeners hears what we have to say. Speaking to a limited audience, preaching to the choir as it were, is a set-up for marginalization. When an artist marginalizes members of her potential audience, she sets herself up for marginalization as well.

Sometimes, when artists gripe about the audience's lack of perception, they secretly enjoy the superior status this implies for themselves or their work. In fact, in some cases, it is hard to avoid suspecting an artist of putting himself on a pedestal this way through deliberate obscurity. There are also the occasional flagrant expressions of contempt for the audience that some artists put on display. Such work, aside from being self-indulgent, only worsens any polarization that exists between artist and audience. It might be a satisfying outburst, but its impact is questionable. It does little to improve the condition of either party to the conflict, and such tactics may help to erode enthusiasm for the arts in general. In the end, such

gestures work to pull art out of people's lives, instead of putting more into them. They make art less relevant, rather than moreso.

Art that fails to connect to its audience is experienced as irrelevant. Of course, what is really needed is for the audience to participate actively in viewing the work. Just as a conversation must be active both for the one speaking and the one listening, experiencing art is a two way street. It is not enough to sit back passively and expect the artist to do all the hard stuff. But if the audience does not realize this, they can hardly be blamed for feeling left out, marginalized.

The image of the artist as an untouchable, rarified expert does little to remedy this situation. Analyzed in terms of power, the artist who seeks to hold power for himself (the role of expert) sows the seeds of hostility in his audience (everyone else) because they sense his attempt to *disempower* them. This "let them eat cake" attitude brings about the same response in art as it does in politics.

In the absence of a felt connection with the artist, the audience can feel disregarded, even insulted. The failure of an artist to notice or care that the audience has not connected is often perceived as arrogance, and probably rightly so. From the other side, the failure of viewers to participate enough to overcome their own internal inertia can be taken as an affront to the artist. Feeling disempowered in front of a huge enigmatic canvas, uneducated viewers may respond with power plays of their own. Attempting to reestablish their self-respect, they may respond with a disempowering comment.

But glib dismissals ("A three-year-old could have done that!") from viewers who have thought neither long nor deeply about their own reactions seem like an arrogance of another sort to the artist. Why can't the audience get off its high horse when the artist has already gone so much further than halfway in this exchange?

Like disagreement over territory in the Middle East, arguments over who is at fault in the disconnect between artists and their audiences can go on forever. Evidence can be gathered on both sides, but closing the gap will only come with the will to close it. Fault finding only widens the differences

(and allows extremists to define the terms of discussion). Often, artist and audience are left speaking past each other, failing to really understand what the other party is asking for.

A sincerely unitive approach, whether in politics or art, looks for a way to include everyone in a realistic process if at all possible, rather than starting with a list of excuses for excluding people. An aphorism from success training holds true here: Losers focus on reasons, while winners focus on results. Looking for places outside oneself to locate blame might be emotionally satisfying in the short term, but long term results will only come from that neglected place, oneself.

Noticing, for example, that the assertion of power plays out in the background of the conflict between artist and audience, makes it possible to address the subtext. That effort pays off as it filters out to the level on which debate is taking place. Rather than insisting on holding the power to define the terms of discussion, each party (artist and audience) would do well to acknowledge the fundamental relevance of the other party's concerns.

Viewers of art want to enjoy themselves somehow—not only through pleasantries but also through the challenging stimulation of the artist's efforts, and the expansive experience of gaining new understanding. Why deny them that? Artists want the freedom, safety and support to manifest something unspeakable that leaves them feeling rather vulnerable but satisfied. Why deny them that? This is meant to be a win-win situation, and can be if it is approached from a perspective of mutual empowerment rather than mutual distrust. Speaking in these terms may seem naïve or disconnected from gritty reality in its own way, but pragmatic, realistic solutions (or attempted solutions) really only come from a consideration of first principles. This consideration can be uncomfortable, but we deny it at our peril. Reducing any issue to first principles helps to clarify the values from which we choose to operate.

A spiritual approach to the relationship between artist and audience, as in any other relationship, needs to be based on mutual empowerment. And although it does take two to tango, either party can begin the process,

and certainly one will have to. An insecure person sits back saying, "I want the other to be trustworthy first," while a mature person is willing to take risks within reason, meeting the other halfway. Granting validity to the potentially opposing side, acknowledging their concerns and letting them know your own, is the first step toward building a relationship of mutual support.

The specifics of how an artist might empower his audience depend on the artist, the medium and the particular audience. The same is true in the other direction. What's important is to look for ways to establish connection, and to eliminate from our practice those habits that undermine our effectiveness. That effort is what builds relationship.

The shock tactics of so much early modern art—Duchamp's readymades, the dissonant impressions of cubism, Dada and surrealism, etc.— were necessary, but art was never meant to stop there. A slap in the face to get the attention of a sleeping or hysterical audience might be useful. But a few times is enough to make the point. One has to wonder if some artists might not harbor the illusion that if they continue the practice, someday the audience will reward them, personally, one more time, with a hearty "Thanks, I needed that!"

There are better ways to elicit the gratitude of one's audience. It is possible that there are just too many artists, and the compulsion to be different, new and worthy of attention has simply undermined the relevance of art in general; garnering fame has become an end in itself for far too many practitioners of art. But more likely, the possibilities of creative work remain infinite. It is only a particular approach to art that has run its course. At the risk of sounding terribly naïve, conservative and retrograde, the pursuit of a value that outlasts fashion might be suggested as a valid rationale.

Clearly, this is not just a matter of being nice to everybody. There is a certain moral imperative behind creative life. Following that imperative is not only moral, however, but eminently practical. Artists can be most successful by doing what they do with self-discipline and sincere good will. There is simply no way around this fact, and any appearance to the contrary

stems from ignoring long-term consequences. Again, if power is the unstated issue for artist and audience, the relevant question for both is: how is power being used? What ethical core are the players acting from? If the focus is on obtaining or holding power over an opponent, a dynamic of resentment, resistance and even hostility can be expected. If the approach is to empower the other party and respect their needs, then cooperation and mutual support can be realistically expected as a result of nonverbal negotiations.

We The People

The key to bridging any gap in understanding or regard might be summarized in the fundamental separation between "us" and "them." This can be more frankly defined as the perceived division between the "real" people (us) and those who are not real or who don't count (them). In any conflict, we identify with our own side; that is, we naturally give greatest validity, justification and reality to our position. By implication, the opposing side is less justified, valid—and frankly less *real*. The same dynamics that operate in the social cliques of high school are also at play in urban social planning and global politics. Out of sight, out of mind.

In politics, for example, this idea is demonstrated in any class conflict. The class with power and prestige defines the political debate in terms that flatter their self-image. The class or classes that lack access to power similarly define the terms of debate to flatter themselves. Each side views the other as unreasonable, self-serving and less real than their own fellows, whom they deal with every day. The differences in priorities and lifestyle between the opposing sides make each group truly alien and less than relevant to the other. Everyone stays in their ghetto and the status quo is maintained.

In ethnic conflicts, the differences and alienation become even more pronounced. Even when there is no conflict visible on the surface, we tend to define whatever group we are in as "the real people," while other groups are less so. In many languages around the world, a tribe's name for itself is

simply "the people," while other groups must settle for some less exalted or more derivative title. This is probably a natural response to the need for group cohesion and survival, but if left unexamined it is counterproductive in an age of increasing global connection and technological power.

Conflicts begin when the problems of our group, the *real people*, are given greater reality than the problems of those others: Our need for more space, or for water or fuel, is more important than the rights of those other people to live in peace on the land they occupy. Our need for violent self-expression is more important than its consequences for others. Our need for unlimited wealth is more important than the needs of those lesser ones for basic security and health. The arguments used to justify every conflict, whether political, scientific, religious or "other," all have this underpinning. People rally behind causes less because of reason than because of who they identify as the "real" people in the conflict. And we identify people as real, typically, based on how much they remind us of ourselves.

In some cases, the "real" people we identify with are not persons at all, but abstract values or nonhuman creatures: in short, a cause. Animal rights activists and tree-sitters, for example, give greater reality to the elements of nature they vow to protect than to the customary practices of those who would exploit them for financial gain. Whether one agrees with this position or not, it is easy to see how hunters, business leaders or loggers would feel insulted by the implied disregard for their own reality, for they might feel, rightly or not, that environmentalists are treating them, personally, as less than significant people. The knee-jerk reaction can quickly be to disregard the reality of "them damn weirdo tree-huggers" in return, lumping them into an enemy class. The personalization of a conflict that is really about values leaves everyone feeling offended and possibly confused enough to become violent.

When the process of identification with a group or cause grows stronger than our taste for facts, we become less and less reasonable in our position. This is seen clearly in positions that have been held for a long time, which resist change even in the face of mounting opposing evidence. The evidence can be disregarded because on some level, we do not experi-

ence it as real. The automatic tendency of the mind, in such a situation, is to create a kind of loop tape of self-fulfilling prophecy, a circular psychological reasoning that renders our version of reality impervious to contradictory input. Locked into this self-satisfied pattern, we can spin further and further off-center, becoming increasingly rigid, dogmatic and even violent.

Demagogues tend to redefine or reduce issues to the most personal, not only for clarity but also to stir as much passion as possible: "The environmentalists want to destroy your family by destroying your job." Such tactics portray supporters of the other side as alien, unreasonable, even evil people, who must be opposed in principle and in all ways—preferably without too much more thinking on the part of the foot soldiers on this side of the cause. Similarly, in actual wartime an enemy is typically portrayed as somehow not human, to make it easier for soldiers to carry out violence against them. And in politics, candidates tend to aim their speeches toward the extreme ends of the spectrum because that is where they will find the energetic volunteers needed to promote their campaign. Polarization is a preliminary step to manipulation.

The source of violence and injustice in the world does not rest within individuals or groups who are "evil." Rather, it is the unchecked, primitive, paranoid tendency of the mind to rigidify itself, identify with polarized issues and dehumanize other people. It behooves anyone who practices art to seriously question her own tendency to operate in these terms of "us" versus "them." When one's art is conceived and executed in this context, it is likely to confuse or alienate the audience, which renders communication nearly impossible.

While it is probably unrealistic to expect the human race to give up war and extremism any time soon, it is possible, even necessary, for us to look at where we ourselves stand. Art is powerful. We may not have the capacity to change anyone else directly, but we do have the power to conduct our own life and practice from a foundation of clarity. The polarization of human beings into good and bad, real and unreal, human and not, is a natural, primitive tendency of the mind. That does not mean we have

to stick with it or support it in others. We can question its validity as a tactic for resolving conflicts and solving problems. This begins with recognizing when this tendency is at play in our art, in public debate and especially within ourselves. The more we can seek solutions that build consensus instead of polarizing people, the more effective we will be in the long run, and the more we will support the creation of a just, creative and equitable world.

Even if our efforts seem to have no measurable impact on the world around us, the question still remains: *What is a healthy way to live?* Do we stand for anything at all or will we look back on life with regret? Anyone who commits to neutralizing polarities, for example, will undoubtedly suffer many defeats, but the successes that do come will be deeply satisfying. Artists, of all people, should have come to terms with operating under such odds by now. And even if we are only sporadically successful in overcoming our own tendency to polarize and dehumanize people, we will be making important progress. Whatever we ourselves do may seem to be insignificant, but it is vitally important that we do it, as Gandhi pointed out.

One tangible thing we can do is to make a conscious effort to be inclusive in our deliberations. This means inclusive of other people, of their humanity. We need to empathize rather than disregard other people and their needs as if they were somehow less important than our own. For artists, this means recognizing that expression is a two-way street.

In the political domain, people who cling to extremism usually insist that this approach only opens us up naïvely to violation by others who do not respect our sovereignty. That black and white view says more about the people who hold it than it does about reality. It assumes we must choose between opposing others outright and throwing ourselves open to destruction—a position that is naïve in its own way.

Whether we are talking about art or politics, the effort to neutralize polarities is not about abandoning our own sovereignty; it is about building consensus whenever possible. Whenever *possible*, not "under all circumstances no matter what." The effort to bring people together for a human exchange includes, in its very definition, the recognition that

compromise is part of reality. It is practicing "moderation in all things, including moderation," as the saying goes.

We will not always be successful in keeping things nice. We may in fact need to defend ourselves with force (shock tactics) *on occasion*. We may not get *everything* we want for ourselves or our family. But these failures will be less numerous and less severe than the paranoid, primitive perspective assumes. If we acknowledge the reality and humanity of people on the "other side," it will even come to make sense that we give up a little in order to meet their needs. And we will be constructing a network of support and stability that benefits ourselves as well as others.

A world free of conflict is something that will need to be built. No sweeping, dramatic effort or event will bring it about. Instead, we build it beginning with ourselves. For artists, that means in the practice of creative life. Leaving aside the consideration of how this might effect the form or content we choose for our work itself, we can see that polarization or the lack of it affects how we relate with our audience.

Unity is sometimes served by creative conflict. Like an argument between lovers that brings them closer in the end, diverse elements within a system can actually help define a whole. Divergent ideas define a living democratic system just as contrast within an artistic composition plays off harmony to give the entire piece a sense of life. Without internal diversity, democracies, biosystems and works of art lose energy. But it is the underlying ability to work together that gives the conflict meaning and purpose. The encompassing context of relationship defines the elements together, giving reality and relevance to the whole. Art is about discovering or building relationships between elements of a composition (in any medium) and, ultimately, revealing or creating relationships between people who make and witness art.

Self-Indulgence

Whatever liberates our spirit without giving us self-control is disastrous.

—*Johann Wolfgang von Goethe*

I have a motto, which is, "Self-indulgence is the essence of all bad art." This motto actually applies to any field, but the subjectivity inherent in artistic work makes it more poignant and urgent in its application. Whatever critique one might offer of any artwork, in any medium, the failings always boil down to some type of self-indulgence on the creator's part. Too sloppy, too precious, too subtle, too overt—naïve, cynical, cowardly, pretentious—and on and on.

My motto runs contrary to the stereotype many people still harbor of the great artist as self-absorbed egotist. To be sure, there are plenty of artists who place themselves in a position to fulfill the stereotype; but to the extent that they do so while executing their art, it will be bad. You can tell if you look closely. Bad art has the stink of ego.

By "bad" I mean obtuse, destructive or obstructed in its communication, shoddily conceived or formed, hollow or out of synch with itself; one might say "vulgar" if a certain moralistic implication could be left out. I

use "self-indulgent" as an umbrella term to encompass a lot of artistically doomed behaviors. The stereotypical primadonna character is a familiar and extreme form of the self-indulgent ego, but there are many others, less examined and more subtle. Self-indulgence usually boils down to being impressed with oneself, or the significance of one's personal experiences. The defining attitude is, "it's all about me."

To the extent that we indulge in a "self" in the first place, we are moving in the opposite direction of spiritual evolution. Or to paraphrase Carlos Castaneda, when we give *excessive importance* to the self, we are obstructing our spiritual connection with life.[1] The problem is not that we have a "self" (although there is evidence to suggest that there really is no such thing), but rather that we give it too much importance; we emphasize it too much, interpret our experience too obsessively through that lens—in short, we have an indulgent relationship with this "self," real or not. Self-importance, or self-indulgence, narrows our perspective and places our choices in a context of *why me?* Choices and attitudes cultivated in this soil bear bitter fruit.

In the context of creative life, the comments of the fourteenth Grand Master of the Urasenke School of Tea, in Japan, are relevant:

> To those who aspire to follow the Way of Tea, guard against jealousy. To place yourself at the center, to envy others, to tempt others—these are unpardonable. Know your duty, and as you immerse yourself daily in the Way of Tea, you will be rewarded with happiness. The more you look up to others, the clearer your own position in relation to them will become. Whenever something untoward happens, people try to make themselves look as good as possible. But if we remember the humble heart of the host in the tea room, for he knows the spiritual taste of tea, then this persistent clinging to power for its own sake will be seen for what it is. Know what you know and know what you don't know, for only then will the limits of your strength become evident. To attain spiritual power, seize the chance when it offers itself; devote

yourself to study and practice. In life are many who feign knowledge and lead others astray. No action can be more reprehensible. The Way is never exclusive. It is open to all to follow, but those who set out upon the path perforce need the help of those who have passed that way before.[2]

Self-indulgence can take forms that might be surprising. What looks like self-discipline, for example, can in fact be an indulgence. If the goal of one's discipline is to get "in shape" for the sake of vanity, this is not too difficult to see. The indulgence of vanity is the context in which the discipline is set. The same can be said for other forms of self-improvement. Self-importance—or excessive focus on the self—as Castaneda points out, is really something else. It is in fact self-pity, born of the disconnected feeling we have due to fleeing our own empty center. Self-discipline, then, can actually boil down to an excuse to feel sorry for ourselves. For this reason, while most spiritual paths recognize the value of self-discipline used rightly, the best teachers also encourage balance, so that discipline itself is not the be-all and end-all of practice. The same obviously holds true for the creative life generally.

> In the beginning, I throw the paint at the canvas and rough it up a lot. One gets rid of a lot of violence and tendencies toward undisciplined self-expression that way![3]—Andrew Wyeth

Self-criticism, which might also seem like the opposite of self-indulgence, can also fool us. (Actually, it usually only fools the person doing it; outside witnesses often have quite a clear sense of what we are up to.) Focusing on oneself with harsh critical judgment, as painful as it might be, is on some level reassuring and comforting to the fragile ego. We already feel sorry for ourselves, so why not make it look justified through abusive

reproach? And if (as is usually the case) such self-reproach is the internalization—that is, bringing into the self—of external authority figures from childhood, it carries the implication of importance or longed-for validity of the self.

Interestingly, harsh criticism of others is usually inspired by harsh self-criticism; they come from the same source. Abusive criticism of children by adults therefore represents an unending chain of future harshness toward self and others, continuing on through generations until someone is brave enough to stop it.

We practice self-criticism in this way because it seems to fill a psychological hole. In reality, that hole is best filled by expanding our perception to encompass more than our own little world. If we can relax enough to see a bigger picture (with less obsessive, indulgent focus on the self) our criticism might lose its strident edge and the hole we have been looking to fill will become less imposing.

Apparent acts of selfless service can also be motivated by an unexamined need to bolster the self. If we believe strongly that there must or should be a self present, but are unable to locate it in the way we expect, we may be terrified by the empty hole our search uncovers. Then we might try to fill that hole in any way we can, perhaps with a frenzy of "selfless" activity that is really meant to mask the emptiness we feel. While such service might in fact help other people, and be useful in the world, it is also a lie. The unexamined dishonesty at the core of such selflessness eventually comes to haunt the compulsive doer. The pain is all the worse when the person involved has convinced him or herself that they are accumulating spiritual merit for their service, only to realize that their concept of spirituality is hollow.

Really, what is hollow is the conception of the self. A thorough, even scientific, investigation of what appears to be the "self" reveals that there is really nothing solid there but a social construct. Certainly there is nothing that we can put a finger on ourselves.[8] Buddhism, for example, teaches that all experience is in fact fundamentally empty or groundless, despite the conceptualizations and labels we attach to it with our minds. The reason we

lack inner peace is that we are unwilling to allow such emptiness to abide as it is. We feel a need to fill it somehow, to create something solid, and in our frantic activity we "spin" an apparent self out of thin air.

Creative life is one form by which we might slow down our relentless rushing about and experience the groundlessness that is our authentic being. What's more important, it enables us to make peace with this groundlessness, which is at the core of the creative process. When we are able to rest in the silence between our busy thoughts and concerns about our "self," creativity arises spontaneously of its own accord. Creative life revolves around our ability to spin down our activity of self-creation. While this process is sometimes described as a turning inward, it is really a relaxation of concern with what is inside us that makes it possible.

Dogmatic Mind

*Anything that seems difficult to understand creates psycho-
logical discomfort. This malaise has sometimes brought great
losses to world culture through the wanton destruction of
artistic works. Some disturbed people take pleasure in muti-
lating or destroying art objects, just as pyromaniacs enjoy the
sight of architectural works going up in flames. Artists some-
times destroy their own creations in moments of anger or
despair. Extreme sensitivity to the reactions of their viewers
or an inordinate desire for perfection may impel an artist to
burn, slash or otherwise wreck a finished work.*[1]

—Moshe Carmilly-Weinberger

*M*any people expect art to be comfortable or comforting,
and there is nothing particularly wrong with such an
expectation of comfort, save its rigidity. Furthermore, to the extent that
comfort is sometimes just another word for beauty, we can hardly blame
anyone for pursuing it. And even if "beauty" is used as a code for "safety"
we can understand why a person would want to be surrounded with it. For
most people comfort, beauty and safety are enough to ask of life. On the
other hand, creative life calls for identifying and dissolving rigidifying ten-
dencies (both within the artist and the audience).

Beginning in the late nineteenth century, modernism challenged the
protocol that held art in the Western world to the obligation of pleasant
entertainment. Ancient Greek notions of order, symmetry and proportion
as fundamental elements of a divinely generated universe had for centuries
been the basis of much of Western art. Philosophers from Pythagoras to
Aristotle enumerated the foundation of what we now consider beautiful.[2]

Early on, Greek ideals were embraced as a standard to which European artists would aspire. As the painter Barnett Newman observed in 1948,

> The invention of beauty by the Greeks, that is, their postulate of beauty as an ideal, has been the bugbear of European art and European aesthetic philosophies. Man's natural desire in the arts to express his relation to the Absolute became identified and con-fused with the absolutisms of perfect creations—with the fetish of quality—so that the European artist has been continually involved in the moral struggle between notions of beauty and the desire for sublimity.[3]

Absolutism has been a major feature of Western civilization ever since. Plato insisted that art should conform to rather strict guidelines of style and content, so as to instill only desirable values like temperance and rea-son in the citizenry of an ideal state. His idea was to reduce social strife through censorship, eliminating degrading and sentimentalizing influ-ences. Plato's attitude—whether inherited or newly minted—is clearly manifested in artistic and political movements up to our time, despite repeated demonstrations that rationalistic utopian schemes often give dystopic results. One of the subplots in the development of modern art was and is the balance of power: between order and chaos, between artist and patron, critic and state, form and content, individual and group. These are issues that have been around for a long time, and probably will never be resolved conclusively, but how they are addressed at any time dis-tinguishes the ethics and aesthetics of an age.

Beginning with the Renaissance, a realistic, pictorial representation was held as the most appealing standard in Western two-dimensional art.[4] By the late nineteenth century, pictorial representation in the West had pursued this path to an extreme of romanticism and "imitation" that would have horrified Plato. Early modern artists rejected what were to them the stultifying limitations of realism in two- and three-dimensional art in favor of what they considered a higher level of reality: the inner

The viewer of Renaissance art is systematically placed outside the frame of experience. A piazza for everything and everything in its piazza....Art, or the graphic translation of a culture, is shaped by the way space is perceived. Since the Renaissance the Western artist perceived his environment primarily in terms of the visual. Everything was dominated by the eye of the beholder. His conception of space was in terms of a perspective projection upon a plane surface consisting of formal units of spatial measurement. He accepted the dominance of the vertical and the horizontal—of symmetry—as an absolute condition of order. This view is deeply embedded in the consciousness of Western art.[5]

—Marshall McLuhan and Quentin Fiore

experience of the artist made tangible through abstraction. Beginning around the turn of the twentieth century, modernism was a needed shakeup of the old perspectives, a challenge to what seemed a dead end, a refreshment of the tree of liberty with a little bit of metaphorical blood.

In their purest sense, the challenges presented by modern art were not so much about the limitations of any particular historical expectations, but about the hegemony of expectations themselves. The comfort of expectation fulfilled was the enemy even more than conformity (a fact perhaps borne out by the *de facto* conformity preached by some modernist movements). Modernism was a revolution for revolution's sake. As such, especially with its tendency toward a new kind of idealized purity, it impressed many observers as adolescent, without real direction and doomed to catastrophe. Indeed, some artists and some movements bore out their point.

While we have become more accustomed to shocking confrontation and lack of resolution in our art, comfort still remains a priority for the audience. Even jarring or confrontive stimulation can be a source of comfort for some, just as surely as Norman Rockwell is for others. But to the

extent that less convenient forms of expression are ruled out, we must be suspicious. Power that controls what art can be made or seen is always dangerous, and no less so when it has the best of intentions or artistic credentials.

It is natural for humans to pursue comfort, safety, security and a degree of power over their circumstances in art just as in any other field. Conflicts arise when our definitions of these perks become extravagant or paranoid, or when we pursue them obtusely, without regard to our fellow creatures. Variations on this resort to the power of the state or other institutions have been played out both by artists and the people who use them to further goals outside the artistic arena.

Power

The practical need for artists to acquire the resources for their work from the rich and powerful has been a consistent theme in the history of art. To the extent that artists have been compelled, either by conviction or practical necessities of their own, to place their talents in the service of greater authority, we are left with artifacts that are always bound to the context in which they were created. We can appreciate them for what they are in their historical setting, but less so as unqualified expressions of an individual artist's vision.

But isn't this always the case? Individuals always work within a cultural and historical milieu; this is certainly clear in retrospect, even if obscured at the moment. The fierce individualism attributed to the idealized modern artist can only exist with the benefit of a support structure that involves a lot of other people.

Strict modernists prefer to think of the artist as an independently powerful individual, although this ideal can only rarely (if ever, really) be achieved, even aesthetically. Artists are influenced by so many factors that it is perhaps grandiose to claim authorship of anything. And in the practical realm of carving out a living as an artist, independence is often a tenuous or dubious achievement. To act as a truly independent power, many

artists need to practice their art independently of the worldly power structure; that is, keep their day job or live off a trust fund. When we enter the marketplace, compromise begins immediately, but the rules of the market dictate that we not talk about that too much. We don't like the idea of art made with strings attached.

Such strings are not only financial, but often political as well. Plato argued that because art affects people's behavior, only art that encouraged desirable behavior should be allowed in the ideal state. Many politicians would agree, even today. In *The Republic*, using the voice of Socrates, Plato insists that,

> We would not have our guardians grow up amid images of moral deformity, as in some noxious pasture, and there browse and feed upon many baneful herb and flower day by day, little by little, until they silently gather a festering mass of corruption in their own soul. Let our artists rather be those who are gifted to discern the true nature of the beautiful and graceful; then will our youth dwell in a land of health, amid fair sights and sounds, and receive the good in everything; and beauty, the effluence of fair works, shall flow into the eye and ear, like a health-giving breeze from a purer region, and insensibly draw the soul from earliest years into likeness and sympathy with the beauty of reason.[6]

Before the advent of modern individualism, the artist's role as a member of a social group was given greater importance than the pursuit of his or her individual inspiration. Art was viewed by Plato as not only an element of culture, but an instrument of the state, a legitimate means of shaping the body politick according to the (ostensibly altruistic) desires of the powerful elite—including social planners like himself. Social control through the public media was therefore on the table long before widespread, instant communication made it a modern fact. The uses of art as a tool of power, both by artists and those who hold their leashes, makes an interesting study.

The use of art as a didactic tool by the Catholic Church is an inescapable example of moral and social manipulation exercised through the arts. Of the Church's instrumentalist patronage, the art historian Carmilly-Weinberger observes in *Fear of Art*,

> ...artistic creations became the *Biblia pauperum*, the Bible of the poor, illiterate people. In the beginning of the fifth century, Nilus of Sinai wrote that besides the cross, no man-made paintings "with hunting scenes, hares, deer, men pursuing them with dog, fishing scenes, flying [or] creeping beasts, and different kinds of plants have [any] place in the church." He recommends instead that paintings be executed by the hand of the finest painters with scenes from the Old and New Testaments, that the man who is ignorant of writing and unable to read the Holy Scriptures may gaze upon the paintings and gain knowledge of the fathers of all virtues....Art in Christian churches became a visual aid for teaching, and the painter became a tool in the hands of the church. He painted what the church ordered. He was paid to execute works according to regulations issued by church authorities.[7]

Whenever art is supported by institutions—whether long ago or even today—the situation is not much different. There is no use pretending that artists in the employ of an institution are not primarily propagandists. The entanglement of purse strings inherent in patronage can be relatively benign, as in a corporation seeking to boost its image through association—by sponsoring a concert or an artsy production on PBS, for example. Or in a straightforward way, an artist might be employed by a government agency to design posters promoting a program or policy. Further down the spectrum, in institutionalized advertising, payrolled artists manipulate the motivations of the audience (the product) so that it will more efficiently meet the specifications of the advertiser (the customer). More insidiously still, institutional and social pressures can directly censor alternative perspectives, as in the growing monopolization of

American print and broadcast media. It might even be that an artist finds herself in the position of needing to bend her output to the demands of a dominant political or philosophical system in order to find paying work— or simply to avoid retribution such as the blacklisting of writers and other artists during the "Red scare" in 1950's America.

In circumstances where the Catholic Church still holds sway, for example, deviation from accepted dogma and decorum can still get an artist in trouble. While the Church may no longer assert final say over every detail of an artist's production, the official opinion can still carry a lot of weight, as some artists learned in Mexico:

> The church also opposed Diego Rivera, who offended its sensi-tivity, with two works in particular. In 1948 he painted Sunday in the Alameda, a mural for the Hotel del Prado in Mexico City; it bore the inscription "God does not exist." Archbishop Martinez was not ready to bless such a painting. After eight years of strug-gle, Rivera gave in, and in 1956 he painted it over. The other mural, dealing with theatrical history, showed an outdoor scene of the Insurgente Theater in Mexico City. A Catholic political party accused Rivera of blasphemy for humiliating the Virgin of Guadalupe, the patron saint of the Americas. Rivera had painted her as a famous comedian (Mario Moreno), the central figure in the mural. Under steady attack, Rivera "eliminated" the question-able part by repainting it.[8]

Self-censorship under such conditions is also an issue, and can create a self-perpetuating cycle of compromise and mediocrity in the arts.

From an instrumentalist point of view, art is a tool with which to edu-cate, inspire, convince or manipulate its audience into a belief or course of action supported by the artist. Control and power are always involved in such art, even in the most well-intentioned educational or satirical efforts. We are all familiar with work that is thick with social criticism or the promotion of a clearly defined agenda. We may or may not enjoy such

heavy-handed lecturing, but such art often fulfills a necessary function in society and for the artist personally.

It is always risky when we expect an audience to engage art for its own good. Art is, at source, a kind of mystery, and it is an act of hubris to presume to really know its purposes and implications. At the risk of indulging in some heavy-handed lecturing of my own, I would compare the situation to humankind's approach to nature. If we respect the natural world and seek to understand it on its own terms, it reveals amazing mysteries to us and enriches our understanding of ourselves in the process. We come to appreciate how little we know and accept our place as perpetual students, working in harmony with a staggeringly complex system with a time-tested logic and stability.

If, on the other hand—motivated by a need to control things or turn a profit of some kind—we take the little we know and squeeze it to get value out of our investment, things can get pretty ugly. We start digging big holes and leaving big piles of poison lying about, stripping forests, damming rivers whenever it suits us, tampering with the genetics of agricultural resources, overusing antibiotics and so on.

Because natural resources have been approached as if we thoroughly understood them based on our greed, we have ignored the consequences of our actions. We are apparently surprised by long-term effects that did not fit into our original cost/benefit analysis. Mostly, we deny any responsibility for our actions. Had these undeniable costs been factored in realistically, much of our industrial "development" of the last two centuries could have been seen immediately for what it truly is: a costly experiment in short-term profit taking, quite literally paid for, through the nose, by future generations, starting about now.

In this respect, the so-called "free market" has never been free. The notion that corporate business interests should be allowed to "compete" in a global Darwinian world of buyers and sellers with no restrictions on trade is disingenuous. The business model—indeed the very accounting system—on which such claims are based conveniently and completely overlooks the real costs of doing business. Not only are many of the

industrial giants artificially propped up by corporate welfare, but the tangible, long-term costs of their practices (to public health, natural resources and quality of life in general) are simply left off the books, as if they did not exist. These untidy expenses are "externalized," or passed off to be borne by someone outside the corporation. That such costs are also difficult to quantify in our current system is proof that our system is faulty, not that the costs are irrelevant. A realistic, thorough accounting of the costs to society of modern industrial business practice would reveal that many operations are *very far* from being profitable, or even tolerable.

Of course, hindsight always has 20-20 vision. The early captains of industry were simply unable to see much of what is now clear to us. They operated within a worldview that believed wiping out the buffalo, for example, was good sport. Engaging a dialogue with people who might have a different sort of wisdom about nature was anathema to them. For our part, we can at best clean up the messes they have left us with and strive not to repeat the same mistakes in our current milieu. So far we don't seem to be doing so well.

And so it is in the social environment of which art is a piece. We have to agree in some measure with the postmodernist view that artists do not operate in isolation—that every work is a kind of group effort, from its conception through its execution and the interpretation of its meaning. Ultimately the impact of an artist's work upon its environment may not be clear even to the artist herself. The work's impact (its true meaning) is revealed over time. As someone once pointed out, the meaning of the message is the response it elicits.

This is not to say that artists live in a moral vacuum, that we lack choice or responsibility in connection with our creations. Any open society is a dynamic system of ideas and experimentation as well as formalized institutions, and attempts to codify what art should or should not be seen, heard, felt or read are rightly regarded with suspicion. At the same time, the artist who subjects his environment to aggression or self-involved adolescent outbursts without regard for the world outside his own skin may be in need of some soul searching. After having children of his own, for

example, he may decide, like the-artist-formerly-and-now-once-again-known-as-Prince, that a little bit of discrimination in the immediate environment is called for, after all.

While there is a place for any kind of expression in an open society, that place may not always be in the public square. The power inherent in art certainly bestows some level of responsibility upon the practitioner, and any artist with a conscience ought to consider the impact of her work, both in the short and long term, upon her community. If shaking things up is for a useful purpose, well and good. If shaking things up is really "all about me," if it is about craving attention or reveling in dogmatic self-righteousness, then it is a matter for one's therapist or support group, not necessarily the general public. Discretion is, sometimes, the better part of valor.

It may be enough to say that artists owe it to themselves to think about these issues, just as someone setting up a factory ought to give careful thought to the environmental consequences of his enterprise. The type of careless expression I'm referring to is no more "free" than the "free market" anyway; rather it is a predictable reaction based on mechanical psychological patterns of which the speaker simply isn't aware. It is the result of taking oneself a bit too seriously—a form of self-indulgence that ultimately serves as negative propaganda for the "cause" the prophet claims to support, just as so much of industrial and technological "progress" ultimately lowers the quality of life for everyone.

When we consider the natural world, it is hubris to think we can understand or know everything that is going on around us, and the same is true in human society. To bet too heavily on our assumptions about how things will or should unfold for ourselves or our art may be unwise. The beneficial effects of creative life begin to lose their benign glow when we plan their destiny too neatly. If the direction of such art is controlled by a committee or bureaucracy, or if the artist's own dogma is allowed to run amok—a form of self-indulgence—the consequences can be even less desirable. Inspiration easily becomes twisted as darkness creeps in unnoticed.

Functionality

The problem may boil down to domination of the creative process by the dogmatic mind, or the inflexible commitment to a preconceived idea rather than the ongoing discoveries revealed in creative work. When the purpose and form of the art has been thought out ahead of time with little room for discovery along the way, the very nature of creativity is compromised and something about it stinks. Much like raising a child from infancy with the insistence that he will go to Yale or be a doctor, such anticipation cramps the style of what the spirit really has to offer. The art and the artist can become twisted in the process. We know somehow that the artistic context is just window-dressing, like the flimsy plot in a pornographic movie.

The smugness with which dogmatists expect others to fall in line with their point of view is always in bad taste. As artists, we are all too familiar with this attitude, but its fallacy apparently remains invisible when one's primary aim is the cultivation of worldly power. Demagogues may not know much about art, but they know what they like, and those who vie for power in the social or political spheres often seek to enlist artists in their cause, to legitimize themselves by association.

In 1929 the American founders of the John Reed Clubs were impressed by the socialist realist style and its visual power as propaganda. They thought all art should conform to this style for the sake of their cause. In their manifesto, they called upon artists and writers to

> ...abandon decisively the treacherous illusion that art can exist for art's sake or that the artist can remain remote from historic conflicts....We urge them to join with the literary and artistic movement of the working class in forging a new art that shall be a weapon in the battle for a new and superior world.[9]

Politicians and power brokers want the power of art to serve their particular agendas. Art is viewed as a useful tool. But creativity intersects with

human experience at pivotal moments over which artists themselves have only limited control. In those moments, an able artist captures the scent of creative wonder and makes it tangible in his or her work. How far this is from the utility sought by power mongers!

One can argue that the difference between an object of art and of ordinary workmanship is that art is inherently useless. It embodies a spirit that is not necessary to any practical function. This reflects an inner need that is eminently pragmatic to the artist, but less so to those outside the creative process. While the benefits of art in an environment are undeniable, they are also hard to quantify in the terms by which the political personality measures utility. Utility, to a political personality, is about manipulating the flow of power to support one's own agenda. This underlying rationale can be applied to public appearances, deal making and other aspects of political life, but art is in a separate category.

Unlike a speech or broadside, it does not always work to assign a function to a piece of art before it is made. Art can certainly be bent to manipulative purposes, but something about it is always vulgar. The bulk of the population may even be impressed and swayed by the argument such work represents, but lovers of creative life will recognize the singing of a caged bird.

Elegance

As artists, we can ask ourselves if we want to have an impact, or just an outburst. An outburst is all about "me," whereas impact radiates beyond our immediate action. Outbursts tend to be clumsy, vulgar and short-lived, while impact has an artfulness that escapes the boundaries of the moment. That artfulness comes from seeing a bigger picture, an awareness of one's surroundings that could be called grace or elegance in its most fundamental sense.

Elegance in our social bearing or in our art is not much different from elegance as it is pursued by mathematicians. In mathematics, an elegant solution is achieved through the most direct and intuitively appealing path. Art that is elegant pleases us for the same reasons: there is no wasted

space, no wasted breath. Even work that seems ornate or complex bases its appeal on an underlying elegance of conception. Elegant poise is the hall-mark of energy conserved.

In ethical terms, real elegance is to know the limits of our needs and, knowing these limits, to place limits on the pursuit of personal desire. It is the opposite of self-indulgence. This is in fact a hard discipline to learn. But even a cursory review of history, whether in art, politics, science or any other field, impresses us with its usefulness. As artists, our most ethical contribution to society is to express ourselves elegantly. This does not pre-clude other forms of social action; rather it sets the context for an artistic ideal that leads forward instead of backward. If we artists cannot express ourselves artfully when we have a point to make, then who in society can be expected to?

For the most part, artists promote not social unrest, but inspiration. The more successful the work, and the more sensitive the observer, the more closely the observer's experience will resonate with the creative fire that inspired the artist. In the best case scenario, the audience members experience their own spark of inspiration, related to but different from that of the artist. This inspiration prompts the observers to act creatively in their own field, whether it is homemaking, politics, science or another form of art. In this way art does, in fact, serve as a transformational and revolutionary force in the world, even if it lacks the satisfying bluster of self-righteousness so popular among politicians and art school students.

This transformational influence is the impetus of creative life; it is big-ger than the fashions of political movements. It has its own patterns and aims, which we cannot always comprehend clearly. The artist's role in soci-ety is perhaps to crack the edges of our neat definitions of reality. As the literary critic and author George Steiner points out,

> Whatever enriches the adult imagination, whatever complicates consciousness and thus corrodes the clichés of daily reflex, is a high moral act. Art is privileged, indeed obliged, to perform this act; it is the live current, which splinters and regroups the frozen units of conventional feeling.[10]

Art reminds us that what seems impossible may somehow be possible —even necessary—after all, overturning the soil in which the seeds of new ideas can grow. By itself, art does not necessarily push society forward, but makes movement itself more likely. The health of a free society can be appreciated by observing the spaciousness and acceptance that surrounds the practice of art. Just as biodiversity is the mark of a healthy ecosystem, a well-stocked marketplace of ideas is the measure of a healthy society.

On the other hand, evolution makes a wrong turn when an ideology —whether dominant or subversive—conspires to mold the creative process to the purposes of a philosophical or political agenda.

Fanaticism

The philosophy of the futurist movement amply illustrated the extremes to which art can spin itself off center when perspective is lost. Futurism was founded around 1909 by the Italian poet, editor and publisher, Filippo Marinetti. The underlying dogma of futurism was that the past was dead, and artists of all media should look to the future in the form of "the vital, noisy life of the burgeoning industrial city."[11] Technology and movement were idealized as expressions of the "dynamism" inherent in modern life. Excitement, spontaneity and a level of chaos were embraced in an experimental effort to break with the moss-covered aesthetics and practices of the past.

In futurist philosophy, boldness, even ruthlessness, was its own reward, and the power of intuition to organize perception was emphasized. Early futurists included Luigi Russolo, Carlo Carrà, Umberto Boccioni and Gino Severini. The movement's embrace of irrationality influenced other movements in modern art such as Dada and surrealism. But there was something rather rigid and obsessive about all of this spontaneity. Writing in 1951 about artistic schools of thought in the early 1900s, the painter Willem DeKooning wryly observed,

The aesthetics of painting were always in a state of development parallel to the development of painting itself, they influenced each

other and vice versa. But all of a sudden, in that famous turn of the century, a few people thought they could take the bull by the horns and invent an aesthetic beforehand. After immediately disagreeing with each other, they began to form all kinds of groups, each with the idea of freeing art, and each demanding that you should obey them. Most of these theories have finally dwindled away into politics or strange forms of spiritualism. The question as they saw it, was not so much what you could paint but rather what you could *not* paint. You could not paint a house or a tree or a mountain. It was then that subject came into existence as something you ought not to have.

After singling out Kandinsky's Theosophical ponderings for a few sentences of special derision, DeKooning continues,

The sentiments of the Futurists were simpler. No space. Everything ought to keep on going! That's probably the reason they went themselves. Either a man was a machine or else a sacrifice to make machines with.[12]

Marinetti's early writings on futurism had the irrepressible devil-may-care attitude of a young Turk and a cheerful taste for the absurd. In a word, they were adolescent, which is not necessarily a bad thing. In retrospect, though, we can see the seeds of decadence in Marinetti's cocky insularity. Founded as it was on rejection of the past, futurism suffered from rootlessness. The futurist impulse also included a slightly creepy obsession with mechanization, theoretical abstraction and—yes—power, which could lead to a worship of destruction instead of creation. Over time, the overwrought zeal of Marinetti's dogmatism seemed to divorce art from humanity in favor of a sterile, control-oriented agenda.

Futurism had an inherent aggression, defined as it was in contrast to the past it sought to abolish, and by 1914 the early futurists were fighting among themselves. After the First World War, what was left of the

movement seemed to lose its sense of humor, and perhaps reflected an obsessive cultural milieu in which Fascism would later prosper.[13]

Shock tactics were to be embraced in painting, poetry and sculpture—even in the preparation of meals as outlined in Marinetti's *La Cucina Futurista* (1932), which were intended to shock guests into abandoning the provincialism of their past. Pasta, for example, was to be abandoned in favor of the more efficient and rational staple: rice. Subtlety and aesthetic warmth seemed anathema to the prophet of futurism. One of Marinetti's recipes was "*Equatore + Polo Norde*" ("Equator and North Pole"), described as "a sea of raw egg-yolks seasoned with salt, pepper and lemon. From the middle of this rises a cone of beaten egg whites, embellished all over with segments of orange, like juicy slices of the sun. The top of the cone should be studded with pieces of black truffle cut into the shape of *negro aeroplanes* conquering the summit."[14] All extremes and conquests and phallicism, and not particularly appetizing.

While creativity is in fact forward-looking, it can become twisted if we focus too much outside of the present moment. This tendency is amplified when art is made to serve another agenda as if it had no sovereign momentum of its own. Thus, one of the first manifestos of futurism by Marinetti included such affirmations as:

> We declare that the world's wonder has been enriched by a fresh beauty: the beauty of speed....
> There is no more beauty except in struggle...
> For art can be nothing but violence, cruelty and injustice...
> We want to glorify war—the only hygiene of the world...[15]

Pathology

It is probably in the nature of human consciousness that earnest creative impulses get mixed with pathological motivations. The psychotherapist and theorist James Hillman states that one of the functions of the mind is in fact to pathologize. That is, in the attempt to integrate and

make sense of our experience we create, unconsciously, tangible problems from the fertile and confusing compost of our psychological underworld.[16] This compulsory method of projecting our inner landscape onto the outer world enables us to resolve inner conflicts and loose ends through physical action, much as dreams can be the field in which to resolve psychological issues not easily confronted in daily living.

Normally mild pathological projections, which everyone has, can be resolved within the sphere of ordinary life and relationships if a person is willing. More dramatic pathologies compel their holder to seek more dramatic ways of living out and attempting to resolve the conflict. Without the benefit of a guide or a healthy vehicle for resolving such conflicts, a person becomes a greater and greater problem to himself and society.

In this regard, the example of Adolph Hitler is often cited by psychological theorists.[17] We might hesitate to sympathize with one of history's famous monsters; but it is only by trying to understand megalomania and pathological rage that we can ever hope to reduce their effects. The need for such understanding becomes greater as technology advances and increases the capacity of one individual to rain catastrophe on whole populations with the push of a button or the snap of an ampoule. In a technologically advanced age, when a single stroke of madness can devastate the world, the megalomaniac is simply one special case of a pervasive malaise born of the disconnect between our inner and outer lives.

Even without the help of psychopaths, the untethered advance of technology that we have seen in the last century—the period during which modern art came into being—has potentially disastrous psychological consequences for ordinary people. The philosopher of art Donald Kuspit observes,

> ...emotional suffering intensifies almost to the extent of seeming irremediable as society becomes more materially advanced. Deep down, and not so deep down, individuals feel old, unhappy, and dispensable—left behind emotionally—the more materially new and advanced society becomes. External advance imposes

hardship on inner life, which society regards indifferently in its determination to move forward materially. Those not emotionally up to the regimen of modernity are discarded with an almost Darwinian disrespect for their lack of fitness, as if they were irrelevant to material progress. In general, the more society invests in external progress as if it were the be-all and end-all of existence—or even its panacea—the more individuals tend to regress inwardly, expressing their alienation from society.[18]

Unlike the average Joe who must endure or resolve the humiliations and discomforts of inner conflicts within a limited sphere, the megalomaniac pursues a compulsion to achieve power over the external circumstances that seem to be the source of his suffering. Ordinary or nominally healthy individuals might eventually admit that much of their suffering stems not from circumstance, but from their *relationship* to circumstances. On the other hand, megalomaniacs seek power as part of a strategy to deny their inner conflicts.

It is too painful for deeply disturbed persons to accept profound psychological trauma or imbalance as part of themselves; therefore they must project their discomfort outside, assigning it a present-day cause in the external world, of which they are the unfortunate victim. While the ordinary neurotic might accept the role of helpless victim of circumstances, the megalomaniac assumes the heroic role of vindicator, seeking power for the purpose of wiping out the presumed causes of his suffering. Such was Hitler's relationship to the world, and in particular to the "Jewish problem."

Himself a frustrated artist, one aspect of Adolph Hitler's social agenda was the eradication of "degenerate art." He was not alone in his distaste for the challenges posed by the nascent modernist sensibility. What we look on fondly as the early works of modern art were famously reviled in their time. Early modernism was in general regarded as a hoax or a perverse digression from the established traditions of beauty and edifying influence to which artists had been expected to aspire.

Carmilly-Weinberger observed,

Generally, both Nazism and Communism viewed modernism, no matter what the form or style, with disdain and often outright hostility. George Lukàcs, the theoretician of socialism, declared that "modernism is escapism into nothingness. It is the negation and rejection of reality." In China, where Western art first became known in the middle of the nineteenth century, the Communists under Mao Tse-tung, and especially in the era of the Gang of Four, rejected modern art as "decadent" and foreign to the Chinese people. And while Communist Russia labeled it as "capitalist" and "bourgeois," and therefore anti-Communist, modern art was widely feared in the United States as a tool of Communist infiltration into American democracy.[19]

The public policy storm over modernism had been brewing for some time. The historic Armory Show in New York City in 1913 was the first chance many Americans had to view the results of artistic experiments that had been developing in Europe for some years. While we now accept the artist's prerogative to confront our comfortable sensibilities with images that jar our perception, most spectators of the time had to reject such an uncomfortable intrusion. The mind's standard technique for rejecting uncomfortable feelings, which is to project blame onto an external source, proved satisfactory for many people, from common curiosity seekers to the likes of Theodore Roosevelt, who wrote,

Probably we err in treating most of these pictures seriously. It is likely that many of them represent in painters the astute appreciation of the power to make folly lucrative, which the late P.T. Barnum showed with his faked mermaid. There are thousands of people who will pay small sums to look at a faked mermaid; and now and then one of this kind with enough money will buy a

Cubist picture, or a picture of a misshapen nude woman, repellent from every standpoint[20]

While Hitler was not the first to suggest that modern art represented a corrupted and corrupting influence on decent people, he above all others placed himself in a position to do something about it. Under his leadership, an exhibition of "degenerate art" was mounted in the summer of 1937. The idea was to highlight the contrast between the rather conservative pictorial and didactic "true German art" which was supported by the Nazi Party, and "degenerate, Bolshevik and Jewish art," including works by artists who participated in the experiments of early modernism.[21] Insisting that German art should focus on the virtues of Aryan culture, Hitler stated at the exhibition's opening,

Cubism, Dadaism, Futurism, Impressionism, etc., have nothing to do with our German people. For these concepts are neither old nor modern, but are only the artifactitious stammerings of men to whom God has denied the grace of a truly artistic talent, and in its place has awarded them the gift of jabbering or deception. I will therefore confess now, in this very hour, that I have come to the final inalterable decision to clean house, just as I have done in the domain of political confusion, and from now on rid the German art life of its phrase-mongering.[22]

Thus, in his own enthusiasm for the comforts of finality, the megalomaniac rejects the multiplicity of solutions proposed by experimental varieties of expression. He wants a monopoly in the marketplace of ideas. Instead of accepting the dynamic synthesis that ongoing evolution represents, Hitler cuts short the argument. Dialogue and the development of ideas is, to him, only "phrase-mongering," which distracts from the manageable purity of strict conventionality, and the convenience of government-endorsed propaganda.

Humor

The madness of the megalomaniac is an extreme case of an impulse that lives in all of us. If we are self-honest, we will have to admit that we all want, or are inclined to want, the world shaped in our own image. We want the world to reflect our concept of perfection or at least convenience.

It is well that this impulse is usually thwarted, it being most pronounced in our moments of frustration and rage. In popular jokes, it is at such moments that the genie pops out of the bottle and grants us the wish that we will wish we hadn't wished. Grandiosity, with its attendant lack of humor about oneself, is the enemy of sanity, whether in mediocre or creative life.

In political terms, artists are among those who are most comfortable with the mild chaos that characterizes a free society. The spirit of debate, of curiosity and the contingency of truth is familiar from our own explo-

> First you need a *sense of humor*, which is based on an understanding as to how things work. Ordinarily, people have the idea that humor means you must be laughing at somebody behind their back, or that you think everything is corny and funny and doesn't make any sense. There is immense aggression in that; such humor is crude and resentful. But in this case, humor is some kind of delight. We begin to learn something about how reality works, not by studying scholastically but by perceiving how humor exists within the cosmic world. With that kind of humor, we begin to see though the separateness of me and others, others and me. The separation between "you" and "I," you and your world, you and your God is cut through by a sense of humor. That is the basic point.[23]
>
> —Chögyam Trungpa

rations. The health of any society depends on the continual renewal of inventory in the marketplace of ideas. The broader the selection of ideas available—the greater the diversity—the better chance we have of evolving and prospering as a culture, even as a species.[24] This, not the "survival of the fittest," is an appropriate form of social Darwinism for our time. Like biodiversity, the overall variety of perspectives and ideas at play within a culture helps ensure the longevity of that culture and the systems of which it is a part.

As artists, we do well to cultivate diversity and fluidity within our own minds. These are the keys to ongoing success in creative work. Our extraordinary power in society is the ability to encourage or inspire that same culture within our audience. Such power is sometimes threatening to the political personality, which prefers neat solutions and an art that is compliant to the agendas of the powerful. In extreme cases, the perceived threat prompts people in power to censor, suppress or destroy artists and their creations. There is nothing new in this. Figures no less than Michelangelo have had to deal with detractors, opponents and editors over issues, which, with the perspective of time, seem laughably humorless to us. Carmilly-Weinberger lists some of the hassles Michelangelo faced in his time:

> Pietro Aretino, who was angry at Michelangelo because he had refused to prepare a drawing as requested, joined the critics by saying that the Last Judgment was indecent. Another critic, Giulio da Fabriano, also attacked Michelangelo's work in the Sistine Chapel. In his opinion, the artist did not follow the regulations established at the Council of Trent: Jesus is unbearded, angels without wings stand near each other and not in the four corners of the painting, the angel's robes float in the air; and among the women are nude figures. …
>
> To solve the nudity problem in the Last Judgment, Pope Paul IV in 1558 assigned Daniele da Voltera, a follower of Michelangelo, the job of placing "draperies" over the "problem sections" as well as in the ceiling frescoes of the Sistine Chapel. Pius

V, who did not fulfill El Greco's request to replace or destroy the work of Michelangelo, continued the repainting. Pope Clement VIII was ready to solve the matter by destroying the frescoes, but on the request of the Academia di San Luca, he changed his mind. The repainting process continued under Innocent X and Innocent XI, who were anxious to eliminate all nudity from religious art.[25]

But regardless of the worldly situation in which we find ourselves—whether we are supported or reviled—our practice is to nurture creativity within ourselves and others. We do not need Church sponsorship, large public commissions or NEA grants to do this. What we need is real elegance, which includes honesty, humor and the ability to know the limits of our needs. We can confront and subvert the power of dogmatism by cultivating its opposite.

What the dogmatic mind lacks is humor; it must see things in black and white terms. This is because the dogmatic mind is obsessed with its own comfort, the neatness of black and white definitions. Humor, in contrast, is a little prickly—a gray area. Humor is in fact a *joyful acceptance of discomfort in the mind*. When we hear or see some kind of gag, it is at first incoherent, fuzzy or puzzling. The mind cannot get a handle on the scenario through our usual interpretive mechanisms and we are stumped. It becomes funny when we relax and accept the contradiction. If we are too literal-minded, we usually fail to get the joke.

A personal friend of Marcel Duchamp recalled how well the artist understood this principle:

Duchamp's favorite weapon for undermining absolutes and certainties was humor; being humorous was another way to reaffirm his freedom, to defend individualism. A 'serious' person is a consistent person, and consistency leads to fanaticism, while inconsistency is the source of tolerance. Through humor, Duchamp also abolished the difference between that which possesses an

aesthetic quality and that, which doesn't. His "ironism of affirmation" naturally led to the "beauty of indifference."[26]

Irony is a pleasure of the mature mind. It requires us to grab life by the horns of a dilemma, which is too much to ask of a powerless or childish person. To the extent that we are entangled in and confused by unresolved emotional issues, we cannot mature and we cannot embrace the compromises and ambiguities that always come with power as handled by adults. The dogmatic mind is a childish mind, uninterested in a comprehensive perspective or compromise of any kind. The dogmatic person feels (secretly) powerless and seeks to compensate with willfulness, like a two-year-old stubbornly shouting *No!*

This makes dogmatism and rampant ideology all the more dangerous in persons with power over life and death.

Like all spiritual practices, art begins as a personal exploration and ends with universal value. The usefulness and beneficial effect of art is best measured within the consciousness of the artist. But if followed honestly, this exploration of oneself brings forth fruit that can benefit and affect others. The more deeply personal we make our explorations, the more universally they will resonate with others, because the deeper we look, the more all people are the same. Similarly, the more we accept or come into our own personal power, the less we will feel a need to use power to control other people. This is the kind of contradiction we have to embrace if we look at life with a bit of humor.

Dogmatism cannot survive this sort contradiction. An environment in which art is truly allowed to flourish undermines the foundations of dogmatism both in the practitioner and the audience, because it is both humbling and inspiring—another contradiction that is not conducive with dogmatism. And within this context, humor is a discomfort that puts everyone at ease.

Subconscious Sabotage

If you prefer one work over another, it is your privilege, but it does not interest me. The work is a statement of identity, it comes from a stream, it is related to my past works, the three or four works in progress and the work yet to come....I maintain my identity by regular work. There is always labor when inspiration has fled, but inspiration returns quicker when identity and the workstream is maintained.[1]

—David Smith

*A*n unfortunate percentage of what we do as artists amounts to outright sabotage of ourselves. The subconscious mind is an incredibly powerful instrument that we can use either for or against our stated purposes. Left to its own devices, it will generate scenarios in our life that play out our subconscious image of reality, whether we like it or not. The subconscious is always busy creating experiences that validate the conception we already have of life. The issue becomes then, not *how do we get what we want,* but *how do we make our choices?*

The subconscious filters the overwhelming barrage of sensory input our organism receives every moment. We can process only so much, and the function of the subconscious mind is to sort through the flood of perception and pass along only what is relevant to our decision making processes. This sorting takes place according to the training the subconscious mind receives early in life. Such training gives context to the child's experience, enabling him or her to establish internal habits and criteria that serve effective functioning throughout life.

In the absence of intentional training to give context, the subconscious is forced to draw conclusions in whatever ways it can. Such conclusions are often based on scanty evidence, first impressions, false assumptions, irrational emotional insecurity and other such errors that contribute to the general stupidity of human society in adult life. An untrained or poorly trained subconscious expresses itself in psychological chaos for its owner. Most of us suffer from this condition to one degree or another.

It is the subconscious that creates our "blind spots" by filtering out the otherwise obvious cues that a prospective mate is an abuser, for example. Or it may render us oblivious to the obvious fact that our business partner is a crook. In the event that our subconscious is in the habit of creating fulfilling, enjoyable scenarios in our experience, we may not want to tamper with it. But for most people, artists especially, there are usually conflicting impulses at work in the subconscious, which lead to problems we would like to address.

The subconscious mind is committed to self-fulfilling prophecies and dutifully creates them every chance it gets. The themes and moods of these prophecies, and the scenarios they create, are established in early childhood. Without an intensive effort at redirecting the subconscious mind, it will continue to fulfill its own prophecies by recreating the fractured, unresolved psychological themes of early childhood throughout our life, asserting itself constantly in the background as a little voice saying, "I knew it all along."[2]

The dramas we enact on a daily basis, which reflect our subconscious disposition toward life, can be either supportive or disruptive to our creative work. We come with a mixed bag of psychological tendencies, some of which support and some of which disrupt. Part of our work as artists is to nurture the supportive tendencies while identifying and dealing with the disruptive ones. "Dealing with" disruptive tendencies effectively can take the form of outgrowing them, confronting them directly, undermining their grip on our activity, and/or replacing them with more useful habits of mind. Often a combination of all these approaches is needed. In any event, denial, suppression and sublimation are not the most useful techniques even though we often resort to them first.

The first effective step in addressing our disruptive or anti-art tendencies is to recognize and identify them. Because these tendencies reflect the filtering assumptions at the core of our psychology, we are usually too close to see them. However, our environment will reflect them back to us if we are willing. Sometimes other people will come right out and tell us that we are "full of shit" in this way or that, but most cues are more subtle. We must *stalk ourselves* as Carlos Castaneda put it,[3] seeking clues to our inner life in the physical evidence of daily experience.

We can use ruthless self-observation to good advantage in this respect. Since the subconscious mind creates our experience, it must therefore be true that the experience we have is, in some respect, what we want. This is easier to recognize about other people than about ourselves.

Barring major events truly beyond our control, like earthquakes and terrorist attacks, as adults we mostly have just what we want out of life. Although we may not want to accept this truth, it follows directly from an understanding of the subconscious mind's power. For example, most of what we call "accidents" can be traced to causes that really are under our control. Ultimately, the "accident" can be traced to a mistake, such as poor judgment or lack of attention, that is in turn a result of how the subconscious mind has directed our attention. To the extent that we can accept this line of reasoning, we begin to gain useful control over our circumstances.

Certainly there are events we cannot control, and the point of this argument is not to lay blame on individuals for things that befall them through no fault of their own. But we are responsible for more than we generally recognize. The notion that we create our experience may or may not be literally true in every situation. Nonetheless, it proves useful to investigate our life with the assumption that we have created it ourselves. The practical utility of this notion is more important than whether it can be proven. The acceptance of this possibility will begin to reveal how we do in fact set up many of our circumstances. It is a key to unraveling what is truly going on in the subconscious mind, to *stalking ourselves.*

If we are financially, emotionally or artistically dissatisfied, we can begin to trace back the mechanisms of frustration that are in place. The

following questions can be useful in stalking ourselves; the more discomfort any one question generates for you, the greater the chance that you should take it seriously:

> *Under what circumstances do we accept failure? Success?*
> *Under what assumptions do we choose to operate?*
> *Who do we blame for our problems and why?*
> *What patterns repeat themselves over and over in our career?*
> *What recurring situations cause us grief? Is it possible we are setting up these experiences back at the beginning, before they even start?*
> *Does a colleague, gallery owner, critic or collector remind us of someone from our childhood? What might this tell us about the drama we are playing out in our relationship with this person?*

Sometimes we simply outgrow disruptive patterns in the subconscious mind. Life itself can simply chew up and digest our internal obstacles, even without our awareness of the process. False assumptions and prejudices get eroded over time through experience, if we allow. "Missing pieces" in our psychological landscape can be effectively filled in through relationships we develop or compensating activities that come our way in the natural course of life. This is how the process of individuation ideally works.

For example, having a child of one's own can, if one is willing and diligent, raise and resolve buried issues from one's own childhood through the "simple" process of loving and properly caring for a new being. Other examples we could name also reflect the way we sometimes work through internal obstacles by simply embracing what seems to come to us from out of the blue. Here the tendency of the subconscious to draw us into experiences that evoke our ingrained psychological themes serves its best purpose: we naturally individuate by addressing what arises out of the mind's tendency to "pathologize."[4]

When dealing with the subconscious, direct confrontation is not really possible. The subconscious mind operates symbolically, and we communicate with it through symbols. What we might call "direct"

confrontation of disruptive tendencies is really a symbolic process of telling the subconscious mind who is boss. Once we have identified patterns of behavior that undermine our conscious intentions, we can begin to break those patterns. While brute force is sometimes effective, we will generally have more success coming in at an angle.

By "brute force" I mean attempting to subdue an unproductive habit by sheer force of will. Some addictions do respond to the cold turkey cure, particularly when a person has hit bottom and is truly ready to leave them behind. But ingrained psychological habits will not usually go away unless the motivation of the pattern is addressed. One might quit smoking, only to find that another habit has taken its place. One might leave one abusive relationship only to discover himself in a similar situation rather quickly—whether that relationship is with a lover or a gallery. The limitations we encounter in one artistic medium may haunt us in other media as well, unless we cross the internal threshold that is holding us back. We need to recognize this limitation when confronting counterproductive patterns in our behavior.

As far as the subconscious is concerned, external manifestations—our habits and circumstances—exist only to express the meanings or themes of an internal drama. Therefore, when we set about to change an outer situation, our real intention should ideally be to address the subconscious need to play out the inner script.

Some situations are urgent enough that we might want to break the habit pattern without waiting for change on the inside. Smoking, compulsive fast driving, and abusive relationships can be life-threatening, for example. In these cases, it is probably appropriate to use brute force to overcome the habit before it causes too much harm, and deal with the inner motivations "on the fly."

At the other end of the spectrum, some patterns are simply habits we picked up along the way, which don't really have much subconscious weight behind them (except for the comfort their familiarity provides). Sometimes we are in a creative rut simply because we habitually hesitate to try a new approach. Or a habit might be left over from a time when it did

mean something internally, but now we have outgrown it. Habits like these can be effectively snuffed out by direct confrontation.

In this respect, the subconscious mind is like a flea in a jar. If fleas are placed in a jar they have the ability to jump out, being prodigious athletes. If a lid is placed on the jar, they will still try to jump out. After hitting the lid a few times, they will continue to jump, but less high, adjusting their efforts to avoid the pain of confrontation with the lid's authority. After some time, this pattern is established, and the lid can be removed. The fleas will continue to jump to the lower, adjusted height, even though the lid is now gone.

On one hand, the analogy of the fleas describes how we develop habits in the first place, and come to accept limitations that no longer apply to us. On the other hand, it also describes how we can use the hardwired nature of the subconscious to overcome its tendency to dominate our behavior from behind the scenes.

What we have called direct confrontation or brute force overpowers the momentum behind a habitual manifestation using will power. An effective way to do this is to start small. Because the subconscious source of the habit operates symbolically, we can begin to get a handle on the pattern with small, symbolic steps. Before we tackle big obstacles, we can build up a "muscle" of intention.

Our intention to act consciously—that is, outside the habitual dictates of the subconscious mind—will be challenged at every step by the subconscious. Who has not had the experience of making a grand New Year's resolution only to realize a month later it has been completely forgotten? On the other hand, if we make small, realistic promises to ourselves and keep them in spite of the distractions and temptations offered by the subconscious, the subconscious will grudgingly begin to respect our intention. If we persist, that respect will itself become a habit to the subconscious. The flea will lower its aim, although it may continue jumping. This new habit will then hold true even as we gradually up the ante to larger commitments. In this way, we stepwise become master of our own subconscious, instead of the other way around.

Some of us are challenged by an apparent inability to be consistently productive. While there are any number of effective work patterns an artist can follow (prodigious spurts followed by a period of quiet renewal is certainly valid, for example), we can also get caught in a completely unproductive pattern, unable to break writer's block or uninspired (even frightened) to face the blank canvas. Confronted with this situation, many will respond with a vow to become suddenly, decisively more productive. The mood of such vows is usually a mixture of frustration, shame and an authoritarian disposition to do what is difficult "for your own good." Like New Year's resolutions, such vows meet with mixed success.

Instead of attempting a dramatic change, another approach can be more effective. It is helpful first of all to realize that we are dealing with a pattern of behavior that is under the control of the subconscious. It is the subconscious mind that comes up with the distractions that seem to make it impossible to work (that is, it is the subconscious that so arranges our life that the distractions intrude as problems the way they do). It is the subconscious that clamps down on the flow of inspiration.

Therefore, since we are dealing with subconscious patterns, we should proceed symbolically, starting with small steps. Rather than completing a mural-sized composition in a flurry of guilt, it might be more realistic to say, "I can produce a small sketch a day, every day." This more manageable commitment represents a foot in the door of inspiration, and it is not unusual to find that having made the day's small sketch, the creative juices are starting to flow again, and a more expansive productivity is possible.

The key is consistency, not the size of the effort. As Julia Cameron points out in *The Artist's Way*, it is a good practice to keep producing something, almost anything, as a way of maintaining the artistic process. She gives a number of useful exercises and practices for supporting the momentum of one's creative output, in spite of the subconscious obstacles we might encounter.[5]

My own spiritual teacher is fond of using cigarette smoking as another example of how this practice of confronting the subconscious works. If one smokes a pack of cigarettes a day, quitting completely, all at once, can

be difficult—or practically speaking, impossible. However, one can proceed in steps. One can agree with oneself to smoke only nineteen cigarettes a day for the next week, then eighteen and so on. Such an approach lacks the satisfaction of drama that surrounds more flamboyant pledges to quit altogether all at once, but then again it also lacks the forceful subconscious resistance such pledges engender.

If we are honest, we will have to admit that there is something suspicious about our impulse to make a big, decisive gesture to eradicate our addiction. It is useful to recognize that addictive behavior is cyclical in nature. Binging is followed by guilt, which leads to a vow to break the habit, followed by a period of abstinence during which tension mounts. When the tension level reaches its satisfactorily dramatic peak, the vow is broken with another binge and the cycle repeats. This is true whether the addiction is to cigarettes, alcohol, chocolate, pornography or rage.

The addictive cycle also applies to self-destructive habits in our practice of art. Do we have a pattern of scattering our creative energy, and then feeling frustrated by our lack of focus? Do we long for a sanctuary of time or space in which to do our creative work, but somehow undermine it when the opportunity arises? Do we project rejection onto our environment, maintaining a self-fulfilling prophecy that we are under-appreciated or just not good enough? Do we have other ways of suppressing or disconnecting ourselves from the flow of creativity because we find it somehow threatening or just too life-changing? With careful inspection, we may find that these behaviors follow the same addictive cycle.

Addressing an addictive pattern takes place outside the cycle of the pattern itself. Self-hatred, judgment, guilt and rejection of the behavior are actually part of the pattern. In fact, any effective method for overcoming the habit must begin with acceptance. One must accept the behavior itself as it is.[6] We may not like it, but we need first of all to reduce the charge it carries in the physics of our psyche. Instead of a highly energized, planet-sized focus of our attention, the habit has the possibility of becoming a small, neutral particle—part of who we are right now, but not the whole of who we are, and certainly not the most meaningful part.

Practicing a simple acceptance of the behavior as part of our inner landscape begins to "unburden" the pattern. We do not need to indulge it, but we need to accept it as a fact, with as little judgment as possible. Consciously softening our impulsive rejection of our own behavior begins to break the cycle of addiction more effectively than wishful thinking ever could. In this way, boldly facing a disruptive subconscious pattern takes the form of complete nonconfrontation, an ironic twist that any artist should be able to appreciate.

This is the technique for undermining the grip that such a pattern has on our activity. It is not so much confrontive as it is subversive. *By removing the psychological payoff associated with a particular pattern, we remove the fuel on which it operates.* Eventually it will run out of gas. This is a subtle approach that will not usually occur to us when we are occupied with frustration, shame or rage at the pattern and the havoc it reeks in our life. But if we can think about this approach occasionally, when we don't feel particularly "under the gun," we can give it a foothold in our awareness. Then, when remorse strikes, we can consider subversion as an option, instead of thoughtlessly jumping to the kind of red alert that only rekindles the cycle of behavior we don't like.

The process of starving disruptive behavior patterns is supported and accelerated by creating positive alternatives. If we can replace a negative pattern with a positive one, we can crowd out the old behavior. But again, the context of this strategy has to be acceptance of who and how we are now. If the attempt to replace a negative pattern is enrobed in guilt, shame or some other form of self-rejection, it will fail. Instead, we must realistically, and in a self-friendly way, see clearly the entire cycle of addictive negative behavior. The form that bingeing takes will be clear to us by now, but we must also learn to recognize the ways in which we carry out the pattern of self-hatred and vehement abstinence. Once we see the big picture, our efforts to replace the negative pattern will be more successful.

Having said this, we should also accept that the effort to replace an old behavior pattern may feel mechanical at first. Because a new, positive habit (a change in diet, a regular practice of sketching, or daily exercise, for

example) lacks the subconscious psychological payoff that the old habit engendered, it will probably not feel very satisfying at first. There is a threshold of resistance that must be crossed for any intentional change in our behavior. Just as in physics, we tend to remain in motion in the old pattern unless acted upon by an outside force. That outside force is our intentional effort, the force of our will. One of the benefits of studying with a teacher is that the teacher can lend us a bit of his own developed will, like training wheels of personal power.

Will *is* somewhat heartless, for its job is to be one-pointed. On some level we might be inclined to disempower our own willful efforts because they seem cold and authoritarian, and we want to be free and whimsical. But make no mistake: it is our old self-destructive habits that are authoritarian and truly heartless. They undermine our inspiration, obstruct our relationships, frustrate our intention and may even kill us, all for no good purpose.

This is another reason why our efforts to change must begin with self-acceptance. Willful efforts that include a fundamental acceptance of ourselves are easier to swallow than those that carry a charge of self-hatred. We need a certain amount of mechanical force to build a new habit that nurtures our creativity. We need not be concerned at the lack of warmth this force seems to possess. This is how discipline supports the free-ranging power of the creative spirit. Discipline is not in opposition to creativity; embraced in the right context, it is the greatest friend we can have in creative life.

Typically, we will need to build discipline gradually. Because change meets resistance from the subconscious, we will have more success if we take small steps. The small steps build momentum, or condition the "muscle" of discipline so that it can tackle bigger and bigger challenges. In building positive habits for ourselves, we should start small and progress definitively, incrementally forward.

To the extent that our subconscious mind was trained properly in childhood, we will already have the skills to do this. But if that training is lacking, or if our tendency to self-sabotage is strong, we will need to

acquire those skills through conscious effort. The efforts to gain the skills we need may seem inartistic, or in some way contrary to the creative spirit. But a professional attitude toward our practice will help us recognize that we need to acquire such skills as part of our larger aim. Supportive psychological skills are no different than any other skill we might need to develop, such as drawing, composition, finishing techniques or presentation.

Perhaps the biggest form of self-sabotage practiced by artists in our time is the presumption that artistic merit is supposed to arise spontaneously, like luck, with no training or effort required. For some people this seems to be the case, but there are also forces at work behind the scenes. Training can happen in unexpected ways, inspiration often comes from a place that seems to be outside the self, and forces outside us render much of the help we need, but work that has merit is never an accident. There are many forces that come together to create a work of art, and the artist has a degree of control over most of them. By that I mean that one can thwart them.

Whatever our inherent level of talent, we have more potential than we might realize, locked up in our patterns of behavior. If we are willing to overcome some of the inertial barriers to seeing ourselves clearly, recognizing destructive patterns, and building positive ones, we can fulfill more of our potential and have more fun doing it.

On Being and Becoming

*Presumptuous is the artist who does not follow his road
through to the end. But chosen are those artists who pene-
trate to the region of that secret place where primeval power
nurtures all evolution.*[1]

—*Paul Klee*

*I*t seems that everyone wants to be an artist these days, although the
process of *becoming* an artist is less attractive. The difference says a lot
about our culture. On the surface, it appears as if the *result* of creative work
is the point, while from the inside, an ongoing *process*—the creative expe-
rience—is what matters. This is true not only for artistic output in partic-
ular, but also the artist's career generally. When there is a conflict between
these views, between our image of the ideal and the process of living the
life represented by the ideal, it can cost a lot of creative energy.

There is an inherently conflicted attitude about creative life in a con-
sumer culture like our own. While we naturally value creativity, it is hard
to bottle; it cannot be summarized or packaged neatly. Although it is freely
transmitted and exchanged between people, it is impossible to quantify or
assign an objective value. This inherently subjective quality is both a bless-
ing and a curse for the creative practitioner. Of the many snares and pit-
falls to be negotiated along the path of creative practice, a healthy (or

unhealthy) percentage can be attributed to our lack of clarity in this area. When we approach creativity as if it were something tangible to be obtained and consumed, we sideline ourselves from the creative process itself.

Success in most fields is referred to as "having made it," but if we operate creatively, we know that there is really no such thing; success is never permanent, and resting on one's laurels usually leads to stagnation and decline. Creativity is in constant motion, and what outsiders label "advancement" or "success" is really just operating at a higher level of risk—or as Werner Erhard put it, upgrading to a higher level of problem. The scale on which we face challenges increases, but the nature of the struggle is not fundamentally different. The fact is that nothing is really secure in a creatively engaged position, and when things become too secure, creativity can dry up. Crossing the finish line is anticlimactic because it means we are no longer in the race.

In our culture, notions of "having made it" are often tied in with consumerist fantasies and assumptions that have nothing to do with creative work. While creativity itself cannot be packaged, there is a package of ideas about the creative life that is regularly sold to the general population. Standard marketing hooks such as glamour, prestige, comfort, leisure and expertise are attached to the romanticized, bohemian artistic lifestyle, contrasting it with the grinding work-a-day existence of the average Joe.

These intangible values can then be assigned to physical objects or performances, giving them a higher perceived worth than could be obtained from their material components and other direct costs. The artist's output can therefore be neatly fit into an economic system based on added value and the exchange of tangible goods. Unfortunately, there is an inherent lack of realism to this trade in images. While parts of the image we have of the artist are accurate, much of that image is attributable to market forces—including intentional manipulations by people with investments to cash in.

The artist or would-be artist is subjected to the same image-making apparatus that is directed at consumers of art. Part of the commodification

of creativity is concretization, that is, mentally solidifying "artistness" into an object that one can project outside oneself and put in a box. This is the basis for assigning a numerical value to something that is inherently intangible, such as an artist's reputation.

The crystallization process also enforces the notion of exclusive expertise, the idea that art is something that someone *else* does. We cede our creative authority to recognized experts, and even to unrecognized experts— the vague, diffuse dictatorship of "they," whoever *they* are. Of course, as soon as we crystallize creative expertise outside ourselves, we start to cut ourselves off from it. We are all reduced to wannabes.

Practitioners must navigate a road full of potholes like this image dilemma. Once or twice around the block and we begin to recognize their location, and we adjust our path accordingly. In other words, we begin to develop a realistic perspective. The identity that was attracted to the glamour, prestige and wealth of outrageous success gets worn down by actual creative practice, so that even if our circumstances do become glamorous, prestigious and wealthy, their implications for us, and our experience of them, are not what we expected when we had stars in our eyes. In some cases, by the time we are successful, we are no longer even able to enjoy it as we had expected, which can be a good thing or a bad thing, depending on the details. This scenario is common both in the arts and in spiritual practice, for similar reasons.

The average person thinks of success as an opportunity to relax and enjoy oneself in leisure. That is the message of our consumer culture, and leisure is the carrot held out at the end of the stick to keep us going until Friday. In general, the message is that success means we can stop. The creative practitioner has no such luxury. Of course there is breathing room, but enjoyment must come through the practice itself, not just the time off. Putting off enjoyment until we are done with our labor is a symptom of mediocrity. Creative life is distinguished by joy in the midst of it. Fantasies and projections, like judgments, are actually *obstructions* to enjoyment for the creative person, and idleness is a fool's holiday.

The idea of "having made it" can be deadly, as it puts creative output in the past tense. We are always continually "making it," that is, doing our creative work. The creative practitioner simply keeps going, because there is no limit to what can be done, what *needs* to be done—in fact, what one *wants* to do, even at the expense of convenience and leisure, two of the favorite commodities in our consumer culture. This is part of the meaning behind the bodhisattva vow, in which Buddhist practitioners pledge to forego the enjoyment of their own enlightenment until all other sentient beings have been saved from suffering first.

Meanwhile, back on earth, the process one goes through in order to have a creative career sometimes looks like a necessary evil, or a mundane intermediate step to be skipped over if possible. Weaned on consumer values from the get-go, what neophyte aspirants want is the success (and its emotional connotations), not the process of paying dues to get there. In terms of image, we want everything that success implies; in terms of actual labor, we're happy to skip the homework. Experts will even tell us we are right to do so: seminars and magazine articles on business promotion, for example, advise us to act bigger than we are, in order to create an image consumers will trust.

Taking such advice to heart, we can forget why we are creating an image in the first place. Often enough, people will involve themselves in wishful thinking that places their accomplishments (meaning really, their status) at a higher level than real objectivity would allow. Then, instead of actually trying to improve the quality of what they do, they invest the bulk of their time, energy and money in simply convincing others that their work is worthwhile. In short, they try to buy respect like a commodity. Vanity, impatience and greed can lead to foolish mistakes—for artists and their patrons, too. Consumer values and market pressures, including competition, intensify this tendency.

This phenomenon is not unlike what can be observed in the contemporary new-age movement from time to time. Whether for outright chicanery or more innocent, unexamined motives, charismatic characters sometimes proclaim their adepthood as if that assertion was, in and of

itself, enough to make one a "master" of some metaphysical or spiritual technology. The self-proclaimed enlightenment of many new-age teachers and "guides" amounts to little more than wishful thinking. A person might fervently believe that we are all irreducibly one with manifest creation on some level, but that is profoundly different from really embodying such knowledge, even guiding others to that realization. The superficiality instilled by consumer culture encourages us to build an image at least a fervently as we pursue the wisdom that the image implies.

It is particularly ironic that this tendency is so little questioned in new-age circles, because it goes against an actual metaphysical principle, which has to do with the difference between imagination and manifestation. Whenever we imagine a goal or process as fulfilled or completed, there is a danger of dropping the ball, energetically speaking. Having already fulfilled our wish in imagination, we subconsciously stop containing the energy of possibility implied in our goal.

It is the dynamic energy of possibility (including hard work!) that brings visualizations and other desires to fulfillment. Imagination is so powerful that if we imagine we have finished our work, the energy of manifestation is cut off. Wishful thinking is just this kind of sabotage. It actually takes a lot of guts to apply metaphysics in a meaningful way, which is why in traditional cultures it is only one part of an extended training in personal spiritual discipline, undertaken for the benefit of one's community, not just oneself. In such a context, wishful thinking loses its attraction. The practitioner deals with reality, rather than with dreams.

There is a problem with dreams, in that they are oversimplified and neat. A dream in one person's head, or even shared among a group, usually leaves out a lot of the messy details of life that cannot be avoided in the real world. And when we dream golden visions for ourselves or the world in general, we don't often notice the psychologically meaningful undercurrents in our fantasies: undercurrents that may run counter to our stated ideals. For example, an ostensibly benign, peaceful and airily spiritual vision of human potential might actually reflect a controlling, dogmatic impulse in the dreamer. In fact such darker impulses tend to assert

themselves once the vision is given a chance to manifest. Jim Jones founded the People's Temple as a social service organization that actually helped poor people for years before it became a suicide cult isolated in the jungle. Lesser examples of good intentions gone wrong abound in new-age circles, and in the history of utopian movements generally. Naïve idealism can be a very dangerous thing.

As the devil is in the details, the problem with wishful thinking is not the wishing, but in the thinking—or rather the lack of clear thinking. Real progress is impossible if we leave unexamined the gap between an isolated ideal and real world manifestation. If we do not come to terms with that gap, it generally gets filled in by denial, and integrity from that point on becomes questionable. Stubbornly wishful thinking is a form of denial, hoping to ignore the disappointing facts. Just so, an artist who is unwilling to evaluate his own effectiveness objectively fails to grow, and sometimes fails to communicate altogether.

The nature of art is that the maker's intention is in dialogue with the creative process itself, so that the final result might be quite different from what the artist had in mind at the beginning; nonetheless, the artist is in harmony with the work and that harmony evokes a response from the audience that is more meaningful than intellectual agreement. Art is most successful when there is a close resonance between the artist's intention and the audience's response and this sort of communication requires vulnerability on the part of the artist as well as the audience. The artist needs to be vulnerable enough to receive feedback and to value the truth over his own ego. We need to be vulnerable to the messiness of potential disappointment, because it is in fact a secret treasure.

Successful visions are usually tempered by disappointment from the very beginning. A certain heartbreak is at the core of the artist's experience, just as successful progressive social visions seem to be fueled more often by gritty realism than by cheerful ideas that come from top management. It is by embracing the disappointment of the learning curve that we really move forward. The struggle in life is to bring a vision (which might come very easily, full-blown, in a flash of inspiration) into tangible expression.

Patiently and persistently, we forge links between our dream and the reality in which we live. In the process we will hit our thumb with the hammer a few times, the metal will sometimes fail, and we might even singe a few onlookers with flying sparks, but the forging process continues. And the vision itself is usually refined based on our experience at the forge. In the end, success comes from the dynamic interaction between the vision and the forging process. It is in fact a compromise in the best of circumstances.

This element of compromise is what wishful thinking leaves out. Fantasy is something one indulges alone; vision-building requires one to relate with others and with the world of hard facts, over a period of time. There is something suspicious about agendas that are too neat and clean. They are rigid and can only be carried out by overwhelming force. Some part of life gets crushed by this aggression, and such aggression is, in the end, contrary to creative life.

Crossing the Line

There is a common belief that one's status is what one makes it. We should be free, the reasoning goes, from the stifling evaluations of others who can never really understand us. It's true that a reliance on external authority can be suffocating. In the creative life most of our individual potential lies dormant anyway, and our level of "attainment" is largely just a matter of how much truth we are willing to be responsible for, standing on our own two feet. Therefore, a tacit rejection of authoritarianism might seem natural, especially in our "enlightened" age.

But it is not so simple, really. Somewhere between imagination and manifestation there is a line to be reckoned with. To the left of the line we can have our wishful thinking, and it is good that we do. Visions must start somewhere. On the right side of the line, things get more serious as we move to make dreams into reality. On this side, we have a responsibility for whether we are kidding ourselves or not, and we learn to accept this responsibility over time. The place of the most effective artist is at some

distance to the right; her mastery is the result of experimentation and refinement that takes place on the journey from wishful thinking to responsibility.

We make a mistake when we try to skip the reflective self-examination and vulnerability to feedback needed for crossing the line thoughtfully. There is wisdom to be gained by advancing steadily and incrementally toward an ideal, even giving our heart a chance to break along the way. Sudden, large, dramatic opportunities and transformations generally happen for reasons outside our control anyway. If we attend to the daily discipline of the creative work that is right in front of us, we will actually be better able to meet fantastic opportunities when they do come our way. We should embrace the need for small cumulative steps, recognizing them as a sign of respect for ourselves and others.

A retired art professor I know tells the story of visiting with a group of students at another university. They asked him if he considered them artists. His response shocked and dismayed them when he said, "you are students." Why should studying art, he went on, be so different from studying engineering or medicine? One begins as a student (apprentice) and develops over time into a practitioner (journeyman) and perhaps eventually a respected expert (master). No one but an imaginative child or charlatan would claim, by the mere wishing, to become an engineer, doctor or physicist. How is it we accept such behavior in creative life?

At least part of the problem is in our definition. If we use the term "artist" broadly, then yes, art students certainly fit the category. They are, to whatever degree, doing what it is that artists do. But if we leave it at that, we might miss the point. When one asks for validation as an "artist," one is usually looking for some kind of definitive credential, something one can rest on. But does that have anything to do with art? Using the term broadly, an artist is someone who is doing art at any given time. Well and good. What distinguishes "doing art" from any other kind of behavior? An inclination to explore, refine, question and move forward is essential to artistic activity. What does that have to do with hanging a title above one's door, resting on one's laurels?

The question "am I an artist?" addressed to another is either a request for permission or for validation. Either we are living in wishful thinking and we want permission to assert our place as an artist, or we are uncertain of our stepwise progress and wish for verification that we are succeeding. In either case, the professor's answer is a good one. We are in fact all students forever and it is best to think of ourselves that way. The wishful thinker needs to be thrown back on himself, and the insecure student needs to accept a certain level of insecurity as part of the job description. In most important fields of study, no one presumes to know it all at the beginning. For some reason, the subjective nature of creative life leads us to think we can or should do otherwise.

This is not a new situation by any means. It was not even new in 1912, when Wassily Kandinsky observed,

> In practical life, one will hardly find a person who, if he wants to go to Berlin, gets off in Regensburg. In spiritual life, getting off the train in Regensburg is a rather usual thing. Sometimes even the engineer does not want to go any further, and all of the passengers get off in Regensburg. How many, who sought God, finally remained standing before a carved figure! How many, who sought art, became caught on a form which an artist had used for his own purposes, be it Giotto, Raphael, Dürer, or Van Gogh![2]

For better or worse, there is no solid certification process for artists except how they perform over time. The same is true in spiritual life, although titles are often given in both fields. We naturally come to respect and trust the work of practitioners who continually challenge themselves, who keep to the practice itself regardless of worldly success or distractions and stay on the train all the way to Berlin. The practitioner's job is to keep doing the practice. As the Zen master Wu Lei said, before enlightenment, chopping wood and carrying water; after enlightenment, chopping wood and carrying water.

Art Has Nothing to Do With Money

Things become a bit complicated when the ideals of art and spirituality are plunked down in the middle of the marketplace. Evaluation, investment, deal making and shortcuts swirl in the air. In the end, everything is reduced to a dollar value. The euphemism for such an environment being "pragmatism," it can be hard to distinguish from the realism discussed earlier. In its purest form, creative life really has nothing to do with money concerns, but purity is hard to find in nature, and we need financial support to survive. If the integrity of one's practice is actually reduced to a commodity to be bought and sold however, then real value is lost—although speculators might be happy enough to make a buck in the short term.

The old opposition between liberty and security is at work here as surely as in the domain of politics. One must typically sacrifice one for the sake of the other. Creative life and real human progress gives greater weight to the pursuit of liberty. So, while a support system, including financial resources, is a real benefit, we might also observe that the best practitioners insist on pursuing their passion to the best of their ability with or without the security and support of the marketplace, the state or any other external authority.

In any case, the marketplace serves other purposes for the creative practitioner that may be more interesting than making money. It can be a good testing ground in unexpected ways, a source of feedback more precious than dollars can measure. For example, some works of art can be considered successful only if they consistently make viewers somehow uncomfortable. What better way to evaluate one's success than to receive a particular kind of rejection? And in terms of spiritual practice, trustworthiness in the face of distractions and temptations is a valuable asset than can only be verified under market conditions. In Zen, the idea of testing the strength of one's insight is expressed in an image of returning to the marketplace after a period of solitary practice, to see how one's ability to embody enlightenment holds up among other people. Exposure to the market is useful in the ongoing process of becoming, of "making it" in all

forms of creative life. The marketplace trains us in dispassion, which, in right measure, is just as necessary as passion for the practice.

Money and other resources need to be held in the right context: a good to be used as needed, but without emotional implications. When we harbor an unexamined, unconscious commitment to use money as a prop in a psychologically meaningful personal drama, we create obstructions to the right use of money for creative life. Losing sight of this reality, we can be overwhelmed by issues that have nothing to do with our real intentions and needs.

Our culture trains us to relate to an appealing yet contradictory image of the artist, which we rarely question. He is to be both hero and rogue, unassailable, yet somehow embodied in objects or experiences that we can acquire. The romanticized fallout of this image is largely the creation of commentators on art, and especially marketers of art. Nonetheless, successful artists are often loath to poke holes in the balloon that carries the weight of their tenuous livelihood. A bland smile and change of subject is the most response one can expect from some artists when this topic is raised. Neophytes and outside observers are left to contend with their own projections while the status quo is maintained with relatively little harm done, or so one hopes. Tact, at the very least, requires that we not confront certain contradictions too directly.

And so the stereotypical image of the artist's role persists, like a gargoyle over the entrance to the practice of art as a livelihood. Intimidated by the image, would-be practitioners who have other viable options choose a different career, and curious observers eventually back off from pressing their questions. The audience for art is also meant to be a bit intimidated by the gargoyle's dramatic features. In consumer culture, insecurities born of intimidation foster an impulse to buy something in order to infuse oneself with confidence and status. Overall, this dynamic keeps the art world spinning for yet another day, so that tenured positions and market values remain stable. The gargoyle therefore serves a function that few professionals in the arts would really want to eliminate, as much as they might criticize.

The gargoyle's influence can be problematic even for those who successfully sneak past his glowering form. Believing in the authority and status implied in slick presentations of various kinds, we can lose track of our creative purpose. Confronted with what seems to be the practice of art "on the highest level," we forget what creative life is about in the first place, and we are stopped dead in our tracks in a subtler way. Impulses and observations get filtered through an image of what we expect creative life to be like. An aversion to risk nurtures itself in the back of our mind as we look outside ourselves for cues to follow.

Coming to believe the hype that surrounds the marketing of art is one of the tempting train stops on the way to Berlin. If we keep to the practice itself, however—that is, if we stay on the train—our insecurities and presumptions get taken care of. The practical demands of bringing our dreams to life lend a realistic nuance to the original vision. Repeated disappointments toughen our practice, and the difference between creative life and wishful thinking becomes clearer. Eventually we understand that the motive for wishful thinking is actually *outside the field in question*, outside the practice. In fact, it boils down to one of the basic human imperatives: the desire, once again, for power.

When we dream naively, we are usually seeking power in a tangible form of some kind. Creative power is slippery and hard to pin down, so the dreamer may settle for a more tangible consolation in the form of money or recognition. Practitioners know that the making of art or the endurance of spiritual discipline has nothing to do with such power. In this sense, whatever level of power we might attain is none of our business. Those who would use the trappings of creative life to advance their hunger for prestige and power generally miss this point.

One *is* empowered by creative practice, but not in the way one expects, and by the time worldly power and success begin to accumulate one has, with any luck, developed a strong distaste for their conventional implications. Instead of wanting to indulge in the comforts of "having made it," one is too busy with the ongoing process of making, of doing, and of being.

Community

*If we think about it, we find that our life consists in this
achieving of a pure relationship between ourselves and the
living universe about us. This is how I "save my soul" by
accomplishing a pure relationship between me and anoth-
er person, me and other people, me and a nation, me and
a race of men, me and the animals...This, if we knew it,
is our life and our eternity; the subtle, perfected relation
between me and my whole circumambient universe.[1]*

—D.H. Lawrence

*W*hen Sir Isaac Newton was praised for his groundbreaking discoveries in physics, he said that if he was in fact able to see further than others, it was because he was standing on the shoulders of giants.[2] Practitioners benefit from knowing themselves as members of a lineage, or a community that exists across time. This is no less true for artists than for scientists and religious devotees. While unique, heroic, seminal figures arise from time to time, apparently fully formed out of Zeus's forehead, most of us are shaped by a variety of influences for which we can claim no credit. (In fact, one can argue that even those to whom history attributes spontaneous genius were schooled by influences that history has simply neglected to record.)

Furthermore, we each leave behind influences that will have subtle or dramatic affects on future generations. This is the nature of things, and humility is to know oneself as part of this flow. If we step back and look at the flow as a whole, it is quite satisfying to be a small part of it, but this

is only possible if we are willing to appreciate and connect with a process that takes place beyond our individual self.

Many people view humility as a loss of power or a diminishment of oneself, but this is a superficial view. Real humility is to know one's true place, to touch the ground of reality without fear. It is the opposite of grandiosity, which is a compensatory mechanism for fear of failure or annihilation. Contrary to appearances, true humility is in fact a confident response to the real world situation, while grandiosity is a smoke screen meant to obscure the view of an insecure self. The self which is isolated from reality must resort to imagination to find meaning. Grandiosity expresses the frustrated search for meaning in a world that has been rendered hollow by personal isolation.

Community is the experience of human connection. In contrast to the isolation of grandiosity, community is humble and realistic. Monastic communities are meant to embody this especially, but the principle applies to all connected groups. Community, as a human value, recognizes the world that exists outside our own skin and kin. We find ourselves accidentally within some communities by birth, and we join others by virtue of attraction to common values or practice.

Artists share a sense of community because we have a particular view of the world—of forms, relationships, rhythms and creative possibilities. We share values that give credence to the imperatives of creative production, and we find sanctuary in a certain spirit that we share, regardless of our medium. This natural sense of community is a source of strength for living the creative life, which has challenges that are not always understood by those outside it. We draw on this strength often unconsciously, and just as unconsciously, we sometimes undermine it.

The imperatives of ego gratification tend to intrude upon the integrity of all communities, and artists are hardly immune to this tendency. Insecurity, competition, and a compulsion to control intrude as politics. Ironically, the forces that undermine our sense of community are often presented as the guardians and champions of artistic credibility. Defining the boundaries of community based on egoic motivations creates an internal

contradiction that must surface from time to time in the form of conflict, because ultimately, the personal ego finds community profoundly inconvenient. Maintaining a sense of community in the face of these issues requires self-honesty, flexibility and a sense of humor from everyone involved. The same is true when we look at the place of any community in the larger world. Ultimately, the whole world is itself a community.

Beyond the value and comforts offered by family and intimates, we share a world with others whose company we might or might not choose based on personal chemistry or ideology. While many "intentional communities" are created specifically for ideological purposes or defined by shared social values, a successful definition of community must include elements that don't fit into the original mission statement. That is, real community is reflected in the ability to deal with what is inconvenient for its members, because surprises always come up. This is the essential realism of community: relationship embraced in spite of inconveniences.

Human connection is not just about defining a group and clinging to it. Rather, it must include tolerance, compassion and fair treatment even for the "outsiders" within its range. Otherwise, "community" is just a tool for the exclusion of what we don't like, a totalitarian impulse which, like grandiosity, says more about our insecurities than our idealism. The "arts community" is subject to these tendencies as surely as any other social unit. Competition, games of power and other manipulations take center stage only when awareness of the community itself, and its creative meaning, are lost.

On the other hand, if we focus on the practice of creativity itself, we naturally discover who our friends are. Definitions of who is "in" and "out" happen moment by moment, but not through any kind of social snubbing. We simply recognize each other in response to the work that is being done, the actual purpose of our community. We may even notice that individuals operate on different levels at different moments, and that what ultimately matters is the fruitfulness of the ongoing creative process of which we are all a part, not the current standing of any individual within it. The best sort of community is built spontaneously in the midst of doing

the work that defines it, and it is experienced through the doing of that work. Personal ego and its drives go on the back burner.

Human communities are built and reinforced by shared ritual. In religious communities, shared ritual is of a religious nature. We can also see ritual in the rhythms of agricultural work, the attendance at festivals, concerts and conventions, or other cyclical activities that unify a community's attention and build a sense of continuity over time. It doesn't take much imagination to see monthly, annual and biennial patterns of ritual within the arts community as well.

Artistic practitioners also perform a kind of ritual on a daily basis. The experience of art is, in its best sense, a form of worship. It satisfies an inner craving not unlike the devotional impulses of the saints. And while this craving is deeply personal, our practice can connect us with other people and empower human community when we share it with others. The most successful art is, in fact, something like a call to prayer. We enjoy experiencing art this way, even if we never use religious terminology to describe what we feel.

Getting Personal

A community and its members have limited control over outside forces that may work against them. This heightens the need to do what we can to reinforce rather than undermine community from the inside. Internal destructive forces usually boil down to one form or another of taking things personally. Taking offense, bullying, scheming and competing all rest on a too-narrow perspective of what is important in our work. If our definition of what is important always revolves around our personal self, then we can only be described as self-important. And if our definition of a successful career is based solely on our cash income or political power, we are probably in the wrong field anyway.

Much of what happens in the art world has little to do with the creation of art. Perhaps because art is valued subjectively, gray areas seem to gather around it like tumbleweeds blown in off the prairie. While we

might want to ignore such distractions completely, it is rather common for practitioners in the arts to have their focus compromised by the siren song of art scene politics to one degree or another. Often enough, it seems impossible to avoid such dealings if one intends to make a living in an artistic field.

Some artists even seem to thrive on the challenges of political maneuvering, as if it were part of their creative process, or an underlying motivation for their embrace of art in the first place. To an artist like Christo, for example, the logistics and relationships surrounding large projects are very much part of the work. But, conceptual inclinations aside, most practitioners would rather allocate as much of their time and energy as possible to the making or performing of art rather than the secondary phenomena I have referred to. For the most part, the making of art and the politics that surround it represent two distinct priorities and two worlds of experience.

An antidote to the distracting influence of political concerns might lie in our sense of mission. Taken as a spiritual practice, art is a discipline of service: artists have the job of bringing inspiration (including beauty, subtlety and the occasional kick in the butt) into existence. In this context of service, we seem to have a choice of whom to serve. It is instructive to consider whether we hope to serve ourselves only, or some larger priority. We should also look at the emotional basis for our motivation. Do we feel like an isolated agent in a hostile world, or are we, ultimately, part of an ongoing creative process that enriches human experience as a whole? Our self-definition and interpretation of our identity determine our priorities more than any philosophical stance ever could.

Political maneuvering, and the emotional dramas that surround it, take place in the domain of ego gratification. We are either busy placating the ego of others, or massaging our own through a contrived interpretation of events. For the most part, when ego gratification is our priority, subtler spiritual, aesthetic and interactive considerations get the short shrift. When our practice is "all about me," there is little room left for the impersonal demands of artistic excellence, and if our experience of art (whether as artist or audience) is dominated by political intrigues, we can

...the projects are larger than my imagination, than the imagination of anybody, and they build their own identity in a complex life or world where this has happened. In the case of the Running Fence, it involved directly half a million people, and in the case of the Reichstag it involves complex national and international relations.

A project grows like a child and is like a giant monster. We hire a lot of specialists who give us advice, but there is no way to know where the project is going because nobody did a Running Fence before and nobody did Valley Curtain. And I will never do another fence or another Valley Curtain. This is the basic importance of this project. It is like experience which is lived and after that cannot be repeated, and there is no routine, no precedent. And of course that is the challenge of the work. There is no reference in the courts to building permits, no reference when you go to the public hearings and trials in the different courts, and that of course really makes the project build itself and be its own invention.[3]

—Christo

be pretty sure that art's spiritual possibility is also compromised for us. Instead of participating in the universal flow of creativity, we are stuck inside our own private, paranoid world, even if our posturing seems to be for the benefit of others. Therefore, while politics seems to take place within the "arts community," obsession with politics is in fact a great way to stay out of community itself.

Addressing Sensitivities

The artistic personality is inherently sensitive. Sensitivity combined with an inclination toward self-importance is a dicey combination, leading

to the kinds of dramatic blowups that occur between artists (famously, Van Gogh and Gauguin) or between artists and patrons from time to time. In ancient Japan, the tradition of Tea Ceremony or *Cha-do* was founded in the fourteenth century by Sen-no-Rikyu. After a falling out in 1591, the tea master's friend and patron, Shogun Hideyoshi ordered him to commit *hara-kiri* (ritual suicide). The exact reason is debated by scholars, but a conflict of egos is implicated in most of the possibilities.[4] Such examples are extreme, which is good because they can put our day-to-day conflicts into perspective.

Pain and perhaps even humiliation in life are unavoidable, but the degree to which we actually suffer under their influence is proportional to our insistence on taking things personally. To take personally is actually an indulgence that adds little to the quality of our experience generally, and detracts greatly when events are not going in our favor.

There are many ways in which we can work against our own tendency toward self-importance, and no lack of opportunities in which to apply ourselves. For example, we can simply cultivate a habit of good manners, dignity and elegance, which go a long way toward minimizing conflicts and keeping everyone focused on the task at hand. Two specific practices that can be brought to bear are suggested by the spiritual teacher Lee Lozowick: "Be That Which Nothing Can Take Root In" and "Draw No Conclusions Mind."[5] They are both, at bottom, about not taking things personally.

The practice of "Being That Which Nothing Can Take Root In" is meant to create a conscious gap between ourselves and the stimuli in our environment. It is to be conscious in situations where our unconscious impulses can get us in trouble. So often we get "hooked" by stimuli that seem personally designed to match our psychological triggers. In fact, we are not just passive victims in this process. If we are self-honest, we will discover that part of us is actively looking for hooks to impale ourselves on most of the time. We get a perverse pleasure from the pain it causes, and it seems to make us feel somehow more alive. An awareness of this dynamic creates the possibility of sidestepping it.

For example, in a politically high-strung environment, rumors and gossip circulate freely, even fiercely, among people with a motivation to cultivate personal gain and settle old scores. In this soap-opera world, careless offhand comments, oversights and unintended slights are imbued with special meaning, made significant by virtue of their interpretation. But it always takes at least two people to keep this game afoot. Gossip dies when it is not passed along, just as a nuclear chain reaction fails when it lacks critical mass. The fear of missing out on something—a form of paranoia— is usually what keeps us hooked into the drama of the situation.

The artist's inner landscape can become quite complicated, since a little bit of paranoia goes a long way in the creative imagination. Authority figures, outside invaders, judges, comrades, dupes, conspirators and naïve sycophants are the symbolic roles taken on by otherwise ordinary persons in the environment. Projection and psychological transference in unexpected directions lurk behind every corner. Small acts and incidents take on extra meaning in an imaginary political calculus. We fabricate this calculus in an effort to feel some control in the situation, a schema of interpretation that is somehow reassuring even as it provokes anxiety. When more than one person in a situation is operating under this kind of a calculus, it becomes a more tangible reality, with real consequences that seem to confirm and elaborate the originating paranoid impulse.

With such a muddied stream of consciousness babbling in the background, it is hard to interpret any given circumstance, whether it involves teaching a weekend workshop, submitting a grant proposal or mounting an exhibition at a gallery. While there is plenty of evidence to suggest that substantial success in any of the arts depends in no small measure on chance, we want to believe there is something we can *do* about it, something that has nothing to do with our art itself. But such a belief implies the anxious corollary that it is possible to do the *wrong* thing.

What to do? As at the moment of buying a lottery ticket, we must agonize whether to play the digits of our spouse's birthday, our own social security number or the "lucky numbers" in the fortune cookie that came with last night's dinner. The game of art politics, in which it is probably

impossible to know all the relevant information anyway, is only a partial explanation for the opportunities and success that come our way. This game is at best a limited window on our creative life, a glorified form of gossip that is painful even at its best moments.

A return to first principles is probably the best antidote to this kind of misery. Why are we doing art in the first place? Returning to this impulse as a conscious practice purifies and restores creative vision. It cuts through a lot of the confusion born of the intersection of art and money. While strategizing and manipulating situations for the sake of our desired career path is sometimes seen as necessary, it is evil in the sense that it distracts us from what we really need to be doing.

To "Be That Which Nothing Can Take Root In" is to decide not to be fertile soil for the seeds of discord that fall our way. While we cannot control other people or what they say and do, we can keep our own composure and stay focused on the real purpose of our actions. Secondarily, we may even act like a control rod in a nuclear reactor, cooling things down and preventing a runaway reaction by deflecting and absorbing the momentum of individual excited particles.

The state of "Draw No Conclusions Mind" similarly creates a gap in the momentum of our paranoid mental gyrations. Much anxiety and aggression is born of the assumption that we know exactly what is going on. From the position of thinking that we know how things will go, or the feeling that we *should* know, we make hasty judgments. Experience shows that these judgments are quite often wrong, based on misunderstanding or misinterpretations. If we act on such judgments without questioning them, we create a lot of suffering for ourselves and others.

It's not unusual to hear failure stories of artists who judged the wrong way and either missed an opportunity for advancement (by hesitating) or who alienated people essential to their advancement (by being too aggressive). With the benefit of distance and hindsight, we can see what they did wrong. But such post mortem analyses are of limited use in new situations. The most we can probably say is that, because of the filters through which the artist was interpreting the situation, he or she misunderstood what the

consequences of a particular action would be. This argues not for more shrewdness on the artist's part, but for the ability to step back from interpretations that might seem to be written in stone (such as habitual paranoia or self-involvement). In other words, we can benefit from "Being That Which Nothing Can Take Root In," and the practice of "Draw No Conclusions Mind." You would think that artists, bursting with creative flexibility and always on the lookout for new perspectives and angles, might have an easy time with such a move, but that is not always the case. Nonetheless, the discipline of these practices will benefit not only one's emotional outlook on life, but one's creative output as well.

One of the roots of our problem is thinking that we know what's what, based on limited information. In short, we are jumping to conclusions because we don't like the uncertainty inherent in knowing that we don't know. Uncertainty has an unresolved, kinetic quality that is inherently unsettling. But as artists, we might be able to recognize this state of mind from our work. It is the same rarified, edgy state that the best artists cultivate and make friends with in their creative process. In fact, to be creative is to embrace this state, to willingly walk a razor's edge of uncertainty as long as necessary to bring a new solution into being. To resist this uncertainty, to insist on a quick resolution—to jump to conclusions—is in fact the opposite of creativity.

If we understand this is in our creative work, why not apply the same principle to our relationships with people. Instead of taking someone's comment as a personal affront, we can postpone interpretation of their actions. This creates the opportunity to discover if there is a misunderstanding, and to clarify things before acting on a mistaken conclusion. Just as in the creative process, we feel a bit tense. Part of us would like to get out of the discomfort by bringing our opinion to a rapid conclusion. If we understand the benefits, however, we will come to value the inconclusive position. With some practice we may be able to maintain this refined energetic state for extended periods of time, but even a moment of disconnection from our habitual drama can be enough to make a difference, to keep our foot out of our mouth.

Breaking the momentum of unconscious habits of paranoia and aggression is often the best way to build and maintain a sense of community and creative lineage. That sense is the feeling that we are all in this together instead of competing with each other. On some level, we embody the compassion of the Buddha, or the forbearance of Christ. Granted, we should not think too highly of our accomplishment: the danger of grandiosity becomes even greater as we pursue a path that leads self-consciously away from grandiosity. But the lineage of practitioners lives on as a gift to support us. We can tap into this tradition just as easily whether we are talking about art or about meditation.

How differently we would conduct ourselves if we could remember to disengage from paranoid and aggressive impulses all the time, even when faced with career challenges, competition, and the politics of self-promotion, which seem to be a zero-sum game. Rather than viewing colleagues as potential rivals, we could just let them be who they are. We could let ourselves be who we are, as well. The energy once spent on paranoid speculation about who is getting on the good side of whom would then be available for our creative work. And our definition of ourselves would revolve less around our personal position and more around our shared experience as artists, part of a community of practitioners who are ultimately working together for the same aims. This is not so very different from the definition of enlightenment one finds in spiritual traditions thousands of years old.

Objective Art

*Although from its beginnings Modernist art had preten-
sions to being universal, it was nevertheless in real terms
chiefly a manifestation of Western European culture, which
afterwards took root in the United States.*[1]
—*Edward Lucie-Smith*

*I*n the West we think of art as a particular kind of refinement in our
environment. That is, we reserve the designation "art" for what is
most praiseworthy—or evocative of a sublime or important experience—
as opposed to our everyday, prosaic encounters with life. Like most cul-
tural predilections, we generally fail to notice how this reservation colors
our thought. Unaware of our history in this respect, we are doomed to
repeat much of it.

Like other forms of spirituality in the West, our approach to art
expresses conflicting impulses. Not only is the artist regarded as a kind of
priest of high culture, but also an iconoclast, a character of dubious stabil-
ity, operating on the fringes of what is acceptable. In the midst of this con-
flicted landscape, both the artist and his audience expect art to bring us a
sublime experience, a resolution to an existential conflict that we recog-
nize, on some level, as self-created. In the West we claim to seek what is
pure, essential or transcendent in art, but we also like to hear the artist
"talk dirty" from time to time.

The conflicts we experience about art are not necessarily universal on the planet. There are many parts of the world in which boundaries between art and everyday life are vague, fluid or nonexistent. Relatively speaking, there is less self-consciousness about art in the East, and less of an internal split. The precious concept of high art is not entirely missing, but respect can be held without the kind of grudge we see in the West. In the East (and, more generally, in cultures where Western European traditions have not taken over), the poetic experience of art is more tacitly accepted as a dimension of ordinary life, frequently anonymous, and quite likely to appear around the next corner. Artist and audience can exchange roles without much comment. With less of a need to talk *about* art, people are freer to pursue artistic inclinations at the oddest times, in the smallest ways, without the need to invest in a gilded frame of mind.

In dominant Western cultures for the most part, art is separated from daily existence by virtue of the philosophical (and financial!) speculation

> Formerly, periods of culture arose when a particular individual (standing over and beyond the people) awakened the universal in the masses. Initiates, saints, deities brought the people, as from without, to feel and recognize the universal; and thus came the concept of a purer [more universal] style [of life as well as art]. When the power of one of these Universals was spent, the sense of the universal decayed, and the masses sank back into individuality until new power from other Universals could again enter them from without. But presently because of this relapse into individuality, individuality matured within *man-as-individual,* and he developed a consciousness of the universal within himself. Thus in art today the individual can be expressed as the determinately-universal.[2]
>
> —Piet Mondrian

that surrounds it. Teased out of the fabric of ordinary life—ostensibly all the better to appreciate its grandeur—art becomes a subject unto itself. With this distinction comes the thorny issue of defining artistic validity, and as the object of rarified contemplation, art is defined and evaluated with an analytical bent that is undeniably Western. Since *more* is presumed to be *better*, we are inclined to favor whatever we deem to be most pure, most essential or most transcendent. Our compass is set, and an historical stubbornness settles in.

Pursuing this line rather logically, some Western artists since the emergence of modernism have made it their aim to embody or communicate something about the irreducible core of human experience in universal aesthetic terms. The artists Charles-Édouard Jeanneret (aka Le Corbusier) and Amadée Ozenfant wrote in 1920,

> It does not seem necessary to expatiate at length on this elementary truth that anything of universal value is worth more than anything of merely individual value. It is the condemnation of "individualistic" art to the benefit of "universal" art.
>
> It then becomes clear that to realize this proposed goal it is necessary right now to make an inventory of the plastic vocabulary and to purify it in order to create a transmittable language.[3]

In other words, when the cultural context or personality of an artist impose boundaries that a particular work cannot cross, the experience we seek is fleeting, or not to be found at all. We experience art as limited when it embodies a view that falls short of a comprehensive perspective. Interestingly, a narrow perspective is usually the result of an unwillingness to go deeply into one's own personal experience. A second paradox here is that the reductionist pursuit of what is most transcendent, pure or universal (that is, free of psychological or social bias) is itself a culturally-based imperative. As in *Planet of the Apes*, we are operating in curved space, and when we travel far enough along a chosen line, we end up back where we started. The more things change, the more they stay the same and we are

brought face to face with ourselves over and over again. This has been a recurring problem within modernist theory in the West.

But regardless of our cultural leanings, humans want to feel our place in an order that makes sense of our existence. As Le Corbusier and Ozenfant said in their essay "Purism" (quoted earlier), "The highest delectation of the human mind is the perception of order, and the greatest human satisfaction is the feeling of collaboration or participation in this order."[4] This does seem to be the universal drive that inspires rigorous, creative passions—from sculpture to skateboarding, mathematics to meditation. That science, for example, a field seemingly antithetical to art and spirituality, can engender the same experience of transcendent order is to be expected, even if most practitioners avoid the language of mysticism. Albert Einstein, never one to feel threatened by subjectivity, described the transcendent experience in these terms:

> The most beautiful emotion we can experience is the mystical. It is the sower of all true art and science. He to whom this emotion is a stranger…is as good as dead. To know that what is impenetrable to us really exists, manifesting itself as the highest wisdom and the most radiant beauty, which our dull faculties can comprehend only in their most primitive forms—this knowledge, this feeling, is at the center to true religiousness. In this sense, and in this sense only I belong to the ranks of devoutly religious men.[5]

As in physics, there comes a point, according to much of recent art theory, at which subjectivity cannot be eliminated. The artist cannot anticipate every quirk of her own personality, and shouldn't try to. Trying too hard to evaluate and neutralize idiosyncrasies in one's creative process can be it's own kind of subjective self-involvement. Furthermore, fruitful creative work ought to bring out things the artist didn't know were there in the first place. In that respect, it is rather vain of an artist to claim to understand or control her own work anyway.

Then there is the experience of the audience, which is rightfully considered as part of the work. How can an artist ever hope to control what the audience brings to their participation? And, beyond the individual viewer's experience, there is also the issue of the broader cultural context in which the work sets. A piece of art not only reflects its times through content and stylistic qualities; its real meaning actually depends on those times, including the interpretations implicit in the culture to which it belongs.

Viewing art in this way, as a "text" in which many hands necessarily participate, and which can be "read" in a number of different ways, is a very useful tool. Certainly such a view seems to address some long-standing conundrums and injustices in Western practices of interpretation, promotion and creation of art. What a relief! But to the extent that this postmodern view is a provisional, mechanical reaction against what came before, or rather, to the extent that it denies that it is such, it is a dead end in its own right.

Postmodern theory also opens the way for an exploitation of a different kind, which is the cooptation of authorship. By asserting our right as audience to edit and compose new pages to a "text," we can handily avoid dealing with works that critique our own agendas, thereby disempowering the artist in a kind of dogmatic revenge. In any event, this conflict, along with the inclination to dwell intellectually on the validity of artistic media, techniques or subject matter, was a growing driver of artistic discourse in the West from at least 1800 into the modern period.

The Quest for Purity

Creativity became increasingly self-conscious with the onset of modernism. In all the centuries since Plato, how many artists even *wrote* manifestos before the turn of the twentieth century? Starting in the early 1900s though, art students have had a lot of reading to do. Successive movements have defined themselves as the logical conclusion of art's evolution. The search for an essential and comprehensive basis for art-making became a

search for something irreducible, final. In the name of purity, previous theories were written off as debased.

The avowed universality of modernism has often been pursued through a reductive process—the "purification" referred to by the purists quoted earlier. Piet Mondrian described his own rationale in the pursuit of universality or objectivity, in his essay, "Plastic Art & Pure Plastic Art" first published in 1937:

> If all art has demonstrated that to establish the force, tension and movement of the forms, and the intensity of the colors of reality, it is necessary that these should be purified and transformed; if all art has purified and transformed and is still purifying and transforming these forms of reality and their mutual relations, if all art is thus a continually deepening process: why then stop halfway? If all art aims at expressing universal beauty, why establish an individualist expression?[6]

The transformation and purification Mondrian refers to is, of course, abstraction, the elimination of the recognizable objects and figures from the ordinary world. Although the tendency toward abstraction could easily seem overly cold, intellectual or calculating, Mondrian did argue for its warmth and emotional richness, emphasizing the role of intuition. He further said,

> To love things in reality is to love them profoundly; it is to see them as a microcosmos in the macrocosmos. Only in this way can one achieve a universal expression of reality. Precisely on account of its profound love for things, non-figurative art does not aim at rendering them in their particular appearance.[7]

In a similar vein, Wassily Kandinsky had earlier described key emotional experiences that led him toward his own brand of abstraction. Writing in 1913 he reminisced:

I was once enchanted by an unexpected view in my studio. It was the hour of approaching dusk. I came home with my paintbox after making a study, still dreaming and wrapped up in the work I had completed, when suddenly I saw an indescribably beautiful picture drenched with an inner glowing. At first I hesitated, then I rushed toward this mysterious picture, of which I saw nothing but forms and colors, and whose content was incomprehensible. Immediately I found the key to the puzzle: it was a picture I had painted, leaning against the wall, standing on its side. The next day I attempted to get the same effect by daylight. I was only half-successful; even on its side I always recognized the objects, and the fine finish of dusk was missing. Now I knew for certain that the object harmed my paintings....Only after many years of patient work, of strenuous thinking, of numerous careful efforts, of constantly evolving ability to experience painterly forms purely and abstractly, and to penetrate even deeper into the immeasurable depths did I arrive at the forms of painting with which I work today, on which I work today, and which, I hope and desire, will develop much further.[8]

Despite the emotional vitality experienced by abstract artists at work, a tendency toward a conceptually-defined purity is nonetheless present in the discourse surrounding modernist art. Like alchemists seeking the philosopher's stone, artists and writers seem to want to boil things down to their essence, using the reductive analysis we love so much in the West. Even in questioning the tendency toward dogma, we can't help but create more of it, as the pages in your hands prove. Ultimately in the modern view, we are to pursue refinement as a kind of cerebral buzz at the aesthetic center of the cosmos, like something from *Star Trek*. That there is a reductionist cultural bias at the foundation of such a self-conscious search seems to elude most of the participants. Sweeping statements about what all art throughout history in all parts of the world had failed or succeeded in achieving are tossed off with a certain arrogance that makes us wince in

retrospect. It was, perhaps, only a matter of time before people started to say "enough!" and cast doubt on the whole notion of achieving the most irreducibly perfect kind of art.

> Belief in avant-garde art's therapeutic intention and power has been lost, for whatever psychosocial reasons. Perhaps it has been abandoned in recognition of the fact that avant-garde art has not been therapeutically effective, has not strengthened the will to live—or no longer can. The emergence of decadent neo-avant-garde art suggests that art today no longer even tries to rejuvenate the self, in unconscious acknowledgment that there may no longer be any way of doing so, any way of strengthening the will to live. This emergence also implies that the pathology of the self to which modernism was a response, perhaps only a stopgap, has become epidemic, because the world itself has become irreversibly decadent, pathologically possessed by the death wish, beyond cure. No one in such a world has any wish to live or be cured.[9]
>
> —Donald Kuspit

To be sure, such questions were certainly raised even within modernist discourse. In 1954, the artist and critic Clement Greenberg reminded students to have some perspective on dogmatic rules governing artistic practice and experience:

> It is granted that a recognizable image will add conceptual meaning to a picture, but the fusion of conceptual with aesthetic meaning does not affect quality. That a picture gives things to identify, as well as a complex of shapes and colors to behold, does not mean necessarily that it gives us more as art. More and less in art do not depend on how many varieties of significance are present, but on

the intensity and depth of such significances, be they few or many, as are present. And we cannot tell, before the event—before the experience of it—whether the addition or subtraction of conceptual meaning, or of any other given factor, will increase or diminish the aesthetic meaning of a work of art.... To hold that one kind of art must invariably be superior or inferior to another kind means to judge before experiencing; and the whole history of art is there to demonstrate the futility of rules of preference laid down beforehand: the impossibility, that is, of anticipating the outcome of aesthetic experience. The critic doubting whether abstract art can ever transcend decoration is on ground as unsure as Sir Joshua Reynolds was when he rejected the likelihood of the pure landscape's ever occasioning works as noble as those of Raphael.[10]

Evolution and Postmodern Despair

Art, as a cultural phenomenon, evolves through a Hegelian dialectic, for better or worse. Every artist or group of artists presents a *thesis* in the form of their style, their foundational content or their statements about the work. Challenges to that work, in the form of critical commentary and work by other artists, are *antitheses*. Ideas and images collide, blend and cook together. Out of this stew comes a *synthesis* that is the new thesis, subject to the next round of attack and interpretation. And so on.

This process is not limited to art, but underlies progress generally. No big secret here, and no surprise—the inexorability of the dialectic may even be a bit boring, lending itself to the kind of philosophical resignation one shares with one's favorite bartender or a reasonable stand-in. Sitting in front of the evening news, after the martini she sipped to unwind from her stressful day as a social worker, my own mother would wax philosophical about the "swing of the pendulum" in our nation's politics, hoping to wisen me up to the disappointments and narrow threads of hope I could look forward to as an adult. Looking around, I think we can all agree that she was right.

To some extent, postmodernism, which is a broad umbrella term, and not limited to the field of art, has been an attempt to outsmart the dialectic. What is more pathetic than watching an argument in which both parties insist on having the final word? The self-perpetuating round of conclusive theories about art in the modern era has some of this quality. Out of frustration with the repetitive ethnocentric cleverness of modernist debate, people began to rebel. The mood and subject of discourse shifted toward critique and savvy commentary on the nature of modernism itself (itself a predictable development of the dialectic). Important questions were asked, and challenges were mounted against unexamined assumptions. For instance, the smug way that modernist interpretation sometimes imposes itself on works from other cultures and other times was rightly criticized in support of a more honest cross-cultural view. The notion that we can credibly interpret artifacts from another culture—including whether we should even call them "art" when their native context may have nothing to do with our concept of such—has been generally called into question in the postmodern context.[11]

Possibly the most famous example of this was the controversy which erupted over the 1984 exhibit at the Museum of Modern Art in New York, "'Primitivism' in 20th Century Art: Affinity of the Tribal and the Modern." This exhibit juxtaposed famous modern works with tribal objects that were understood to have inspired them in some sense. Some accused the exhibit's curators of harboring a neo-colonialist attitude, co-opting works from tribal cultures and re-contextualizing them for the express purpose of supporting modernist doctrine regarding the universality of certain images.[12]

Postmodernism has also brought other important issues to the fore, including an embrace of feminism with an implicit investigation of issues concerning access, inclusiveness and control. Postmodern theory also questions our precious notions of uniqueness and originality, that fixation on newness that might be more a reflection of our self-consciousness—or our consumer culture—than of anything meaningful about art. The process of engaging the audience is seen as more important than the valued

exclusiveness of an art object. As the artist Philip Yenawine put it, the post-modern attitude

> …assumes that originality is impossible, anyway, given that there is nothing new under the sun. Therefore, invention and unique-ness are no longer essential in making art. Originality might, in their terms, be an egoistic grasping for individual recognition in a world that is ever more needful of the opposite—cooperation and integration.[13]

In all these respects one has to appreciate postmodernism as a breath of fresh air. But something about it also stinks. Under the umbrella of postmodernism we also find less savory elements that color the move-ment as a whole. Postmodernism has a smugness of its own, an implicit presumption that it is somehow above the fray of the dialectic because it understands the nature of the debate itself. Worse yet, the postmodern attitude anticipates this very criticism with a position which says some-thing like, "yes, it really is pointless, isn't it?" Postmodernism presumes to have seen it all before, to have things figured out with a kind of deca-dent, wishful finality. Examined more closely, this finality reflects a bit-ter cynicism, even a death wish, as the art critic Donald Kuspit has pointed out:

> Behind post-modernist celebration of the copy and mockery of modernist originality is disbelief in primordiality and its transmu-tative power. Simulation is one postmodernist strategy of discred-itation and mockery of modernist primordiality, and destruction of the boundary between avant-garde and kitsch—between the authentic and inauthentic, the high and low—is another.[14]

In its worst forms, postmodernism manifests a kind of cowardice. The postmodern attitude seems to want to call the game finished, to take the ball and go home. *We have reached the end of what art can be, and we*

know it. The dialectic has finally run its course, and as we look backward with a sardonic eye, we can at least take satisfaction in knowing that we are doomed. Although this imperative tries to differentiate itself from the modernist-intellectual pursuit of purity and control through an imposed universality, it is really more of the same—just another form of one-upsmanship and re-contextualizing of what has come before for the sake of current theory.

The self-satisfied cleverness of postmodernism is a claim to exemption from an ongoing process of evolution that is out of our hands, as if we knew better, as if we could decide where this evolution will lead, and end. It reflects an unacknowledged drive to kill evolution, ending it prematurely so that we can claim the privilege of giving the eulogy on our terms. It is a reflection of our self-absorption and more deeply, our self-pity as Carlos Castaneda pointed out in a broader context.[15]

Postmodernism reflects an unacknowledged death wish in a broader cultural context as well. The resignation and veiled cynicism with which we consign ourselves to the decadent effects of the unbridled corporate profit motive bears this out. The direct consequences of our cynical "free markets" include the destruction of our habitat, the loss of cultural diversity, the dumbing-down imposed by our mass media, enforced conformity, the erosion of self-determination, the impersonality and dependence-training fostered by the Internet and other examples one might contemplate over an expensive drink at one's neighborhood Starbucks. Even our "advancements" carry the stink of death.

Fertility

Among the most chilling manifestations of our racial death wish is the corporate control and promotion of genetic engineering. Under the impersonal guise of shareholder interest, a deeply cynical impulse to wrestle the mechanisms of evolution into human control reflects a deeper, unrecognized motivation to wipe out the unmanageable diversity that is the basis of life itself. The highly simplified PR-spin defining genetically

modified food organisms (GMOs) as creative "improvements" only thinly conceals the fact that we are ham-fistedly crashing our way into the fundamental structure of nature without care for the consequences.

No doubt the scientists doing the GMO-research are much inspired by their flashes of insight, their momentary contact with the basis of life; who can blame them for going wherever they need to for the funding and resources to carry on their ostensibly creative exploration? And in the modern corporate world, who can blame managers and committee members for seeking exclusive control of resources that give them market advantage, benefit their shareholders and ensure their own individual promotion in the hierarchy? But all of this corporate, impersonal, dispassionate, "objective," amoral, blameless market-driven activity is leading us in a direction for which our grandchildren may have cause to lay serious blame at our feet.

In fact, the mechanisms by which the relatively limited genetic information we can nail down generates the profoundly complex biochemistry of even simple life forms are not well 'understood. Complex, mutually dependent cascades of causality, unaccounted for by DNA coding as we understand it, lead to the production of enzymes and other compounds that govern the chemistry of life.[16] The techniques of genetic engineering for commercial use are primitive, unpredictable and highly inconsistent.[17] But profit incentives require that some kind of product be brought to market *this quarter* nonetheless.

That the aggressive hubris of such efforts (in the face of how little we actually understand) meets with so little resistance may reflect our willingness to literally roll over and die. We have absentmindedly climbed aboard the *Titanic* of biotechnology, lulled into complacency by vague assurances that the ship is unsinkable. Those who seem to be in control care little about the long-term consequences of their venture, as they believe there are just enough life boats to take care of them. The rest of us are third-class passengers and can be left in the hold to fend for ourselves, along with the monarch butterflies and the salmon.

But we digress…

In terms of art, probably the worst fallout of the postmodern view is the cynicism that says that since subjectivity cannot be screened out anyway, why bother trying? This slippery slope leads to the progressive abandonment of the artistic impulse itself. The "primordiality" Kuspit refers to, which is the healing experience of contacting a wholeness or a higher sense of order, is discredited in the postmodern view. The map has been thrown out the window, and we drive about aimlessly with a vague sense that our journey is bound to be fruitless. But what the hell, we have a full tank of gas and might as well burn it up!

Excellence, as a servant of the primordial experience, is no longer pursued either, but disregarded, even mocked. The pursuit of excellence in previous eras is derided as naïve, subject to our ridicule or cooptation. In some respects, this direction was already being pursued through an adolescent modernist rejection of earlier concepts of beauty. The psychotherapist James Hillman has observed,

> The narcoleptic effect of the usual discussions of aesthetics, the disguised moralism that beauty is "good for you," in fact, is Good itself, have turned an entire century against anything to do with beauty, classic and romantic, and have banned beauty from painting, music, architecture, and poetry, and from criticism too, so that the arts, whose task once was considered to be that of manifesting the beautiful, will discuss the idea only to dismiss it, regarding beauty only as the pretty, the simple, the pleasing, the mindless, and the easy. Because beauty is conceived of naïvely, it appears as merely naïve, and can be tolerated only if complicated by discord, shock, violence, and harsh terrestrial realities.[18]

In this postmodern climate, criteria for the valuation of art can get revised downward, and self-serving entrepreneurs close in for the kill. The result is that, in some quarters of artistic practice (as in the culture generally), a hellish "free market" mentality reigns, in which "the good" is whatever one can get away with for today.

That is why he is called a poet. And his responsibility, which is also his joy and his strength and his life, is to defeat all labels and complicate all battles by insisting on the human, to bear witness as long as breath is in him to that mighty unnameable, transfiguring force which lives in the soul of man, and to aspire to do his work so well that when the breath has left him the people—all people—who search in the rubble for a sign or a witness will be able to find him there.[19] —*Sunday Observor*, London

Artistic "success" is also reduced to a commodity, something that can be bought for the price of a slick advertising campaign, regardless of the actual quality of work produced.

This is the predictable dead end inherent in a particular approach to art. It is not, however, the end of art, or of the real human needs that art addresses. It is certainly not the end of the primordial healing experience that art serves. While postmodern despair may mark individuals' break with what they thought art was about, it does not preclude a renewed or redefined pursuit of the core artistic experience. What is needed is not necessarily a new art; rather, an objective (that is, ruthlessly self-honest) reevaluation of our unexamined motivations and assumptions can show us where to go next.

The growth of a more pluralistic approach to art may reflect a final exhaustion with movements and "isms," but we probably shouldn't hold our breath. In any case, a deeper investigation of ourselves as individuals is needed to make any direction, approach or attitude more than a passing fashion of the times.

Hope

The effect on art of our paradoxically self-righteous cynicism is only a specific example of a broader cultural malaise. Whether the field is art,

politics, science, national security or "social values," dogmatism based on insecurity expresses and reinforces denial of the real issues that face us. This sickness ought to be addressed, regardless of whether we have any investment in the health of the arts. Fortunately, art is a powerful tool for the healing of individuals and society, both.

We who pursue art have the opportunity to contribute to a healing not only in our field, but in our society as a whole, and perhaps of the world. This healing is not a sweeping, revolutionary movement, for that is the approach that got us into trouble in the first place. Rather, it is a humble individual effort to humanize our approach to the work at hand. Albert Einstein described it beautifully in 1972:

> A human being is part of a whole, called by us "Universe." A part limited in time and space. He experiences himself, his thoughts and feelings as something separated from the rest—a kind of optical delusion of his consciousness. This delusion is a kind of prison for us, restricting us to our personal desires, and to affection for a few persons nearest us. Our task must be to free ourselves from this prison by widening our circle of compassion to embrace all living creatures and the whole nature in its beauty. Nobody is able to achieve this completely, but the striving for such achievement is, in itself, a part of the liberation, and a foundation for inner security.[20]

The widening of compassion that Einstein suggests is a different kind of universality than the dogmatic theorizing for which modernism has been faulted. Rather, his view and his life demonstrate that even the most rigorous pursuit of objective scientific and mathematical verities, to which undisciplined personal subjectivity is anathema, has no inherent conflict with the broadest ethical inclusiveness. In short, a fruitful pursuit of what is universal is based on inclusivity, not exclusivity. Through the most thorough spiritual openness, we find a thread of resonance with everyone and everything we encounter. That thread is compassion.

Compassion is not a panacea; it does not protect us from every possible calamity, but it is a thread we can strive to hold onto under all circumstances. As Einstein pointed out, the struggle on behalf of compassion is itself liberating. And liberation renews our energy. Thus the capacity to act on higher principles is maintained and increased through regular use. In a strictly practical sense, without any moral implication, we can say that, in

Works of art are storehouses of psychic energy, and they transmit this energy according to the quality of attention we bring to them. The effects of this energy can be described as happiness, awareness, tranquility, or a willing surrender of our private concerns to a universal experience. This energy is extremely volatile and frequently we dissipate it the moment we receive it. Every now and then, we experience certain works of art so deeply that the memory of them returns again and again to persuade us the energy is not lost but has been transferred to us and stored in the depths of our nature. There is a certain point on coming into contact with a work of art when one seems suddenly to connect with its emotional or symbolic message. Unless there is this connection which rivets attention upon the work, it makes no more than a shallow impression. A further state follows which depends on the enjoyer surrendering himself to the impressions received and attending at the same time to the effect these impressions have on him. This is the equivalent of the discriminatory functions of interpreting and selecting which the artist brings to his inspiration. Beyond this is another stage, in which the barriers separating the inner life of the enjoyer and the essence of the work of art seem to dissolve, and the enjoyer is conscious of being united with the particular mood and insight out of which the work was created.[21]

—William Anderson

pursuing strength in our art, we may find the greatest success by weaving the thread of compassion through what we do.

The compassionate practice of art is a two-way communication in which we feel connected with our audience before they ever witness our creation. This is perhaps a more useful take on the postmodernist assertion that the artist can never wholly own their work. The audience is in fact part of our creative process from the beginning, in the sense that we hold their benefit in mind as we work. If we view art as a social phenomenon that specifically aims to uplift, empower or enliven human culture and individuals, many of the intellectual conflicts of theoretical discourse drop away. Universality, purity and the confidence of validity are all handled by pursuing a spiritual (not simply political) inclusiveness in our practice of art.

In this context, if we ultimately shock, offend, disappoint, satirize or otherwise distress our audience, it is out of necessity, not an adolescent need to kick someone in their conceptual teeth. Authority, and the rebellion against it, ceases to be an issue. Rather than analyzing rules to be followed or broken, we simply consider the tangible consequences of our actions from the broadest perspective we can. Rather than acting out of self-involved isolation, we assume that we are powerful actors within a valuable cultural milieu. When we encounter ideas and images through our creative work, we develop sensitivity toward their actual, practical use. We can then use what we discover *on purpose*, rather than haphazardly.

The Oriental Angle

Spontaneous expression is profoundly narcissistic in import, as Breton implicitly acknowledged. It is an attempt to heal the narcissistic injury the world carelessly inflicts on the self. Spontaneous expression is a reactive, secondary narcissism, an attempt to exist without relating to the world's objects, and ultimately to deny being-in-the-world. Or rather, it is an attempt to turn the world so completely into a symbol of the self that the world seems to have no other reason for existing than to empathically reflect the self.

But this magical metamorphosis of the world into the good mother shows that art has become a way of lying to oneself.[22]—Donald Kuspit

The essence of a work of art is not to be found in the personal idiosyncrasies that creep into it—indeed, the more there are of them, the less it is a work of art—but in its rising above the personal and speaking from the mind and heart of the artist to the heart and mind of mankind. The personal aspect of art is a limitation and even a vice. Art that is only personal, or predominantly so, truly deserves to be treated as a neurosis.[23]—Carl Jung

It is in just this context that the Armenian philosopher and teacher George Gurdjieff talked about art. Speaking around 1915, he said that all art is either *objective* or *subjective*. The term *objective art* referred to works conceived and constructed on the foundation of higher consciousness; all other art suffers, in its transmission, from the static of random or personal subjective influences. This terminology has since been taken up by a number of spiritual teachers, and even some artists, including Piet Mondrian.

In some respects, this perspective sounds like the rationalistic purity we have been critiquing in the modernist sensibility. But Gurdjieff himself had little interest in what he called the "*bon ton*" artists with their highfalutin philosophies. Most of the best modern art would still fall in the subjective category, as far as he was concerned. He would have been similarly unimpressed with postmodernist assertions that universality is impossible and irrelevant. In terms of Gurdjieff's definition of objective art, such assertions would be seen as a subjective cop-out.

The issue for Gurdjieff was not the philosophical rationale of an artist's work, but the actual level of consciousness at which the artist operated during the process of creation. In what seems like a contradiction of selfless idealism and spiritual transcendence, Gurdjieff defined real art this way:

I do not call art all that you call art, which is simply mechanical reproduction, imitation of nature or other people, or simply fantasy, or an attempt to be original. Real art is something quite different....In your art everything is subjective—the artist's perception of this or that sensation; the forms in which he tries to express his sensations and the perception of these forms by other people. In one and the same phenomenon one artist may feel one thing and another artist quite a different thing. One and the same sunset may evoke a feeling of joy in one artist and sadness in another....

In real art there is nothing accidental. It is mathematics. Everything in it can be calculated, everything can be known beforehand. The artist knows and understands what he wants to convey and his work cannot produce one impression on one man and another impression on another, presuming of course, people on one level. It will always, and with mathematical certainty, produce one and the same impression....

Imagine some scientific work—a book on astronomy or chemistry. It is impossible that one person should understand it in one way and another in another way. Everyone who is sufficiently prepared and who is able to read this book will understand what the author means, and precisely as the author means it. An objective work of art is just such a book, except that it affects the emotional and not only the intellectual side of man.[24]

On another occasion, Gurdjieff said,

You say—an artist creates. I say this only in connection with objective art. In relation to subjective art: that with him "it is created." You do not differentiate between these, but this is where the whole difference lies. Further you ascribe to subjective art an invariable action, that is you expect works of subjective art to have the same reaction on everybody. You think, for instance, that a funeral march should provoke in everyone sad and solemn

thoughts and that any dance music, a komarinsky for instance, will provoke happy thoughts. But in actual fact this is not so at all. Everything depends upon association. If on a day that a great misfortune happens to me I hear some lively tune for the first time this tune will evoke in me sad and oppressive thoughts for my whole life afterwards. And if on a day when I am particularly happy I hear a sad tune, this tune will always evoke happy thoughts. And so with everything else.

The difference between objective art and subjective art is that in objective art the artist really does "create," that is he makes what he intended, he puts into his work whatever ideas and feelings he wants to put into it. And the action of this work upon men is absolutely definite; they will, of course each according to his own level, receive the same ideas and the same feelings that the artist wanted to transmit to them. There can be nothing accidental either in the creation or in the impressions of objective art.[25]

Gurdjieff's definition of higher consciousness seems at first contradictory with the transcendental experience many artists describe. For Gurdjieff, the highest aim was not the *dissolution* of a personal self in a higher divine reality. Rather, he viewed man in his ordinary condition as a dysfunctional and randomly influenced contraption with *no integrated sense of self to begin with*. The point of "the Work" that Gurdjieff proposed was to forge an integrated self through specific practices aimed at building awareness, attention, stamina, will and so forth. Consciousness can only really be said to exist when an integrated "I" is built as a result of the Work. Whether or not one agrees with Gurdjieff's assertions, which he claimed to have culled from esoteric traditions dating back many centuries in the near and far East, they cast an invaluable light on creative work. They are, at the very least, an alternative coordinate system from which to view the process of human evolution and the creation of art.

According to Gurdjieff, most art is subjective, i.e., subject to influences that muddle communication—even of the artist's inspiration itself:

In subjective art everything is accidental. The artist, as I have already said, does not create; with him "it creates itself." This means that he is in the power of ideas, thoughts, and moods which he himself does not understand and over which he has no control whatever. They rule him and they express themselves in one form or another. And when they have accidentally taken this or that form, this form just as accidentally produces on man this or that action according to his mood, tastes, habits, the nature of the hypnosis under which he lives, and so on. There is nothing invariable; nothing is definite here. In objective art there is nothing indefinite.[26]

In more recent times, the Indian teacher Osho (Rajneesh) made basically the same point with a blunt analogy:

Subjective art means you are pouring your subjectivity onto the canvas, your dreams, your imaginations, and your fantasies. It is a projection of your psychology. The same happens in poetry, in music, in all dimensions of creativity—you are not concerned with the person who is going to see your painting, not concerned what will happen to him when he looks at it; that is not your concern at all. Your art is simply a kind of vomiting. It will help you, just the way vomiting helps. It takes the nausea away, it makes you cleaner, makes you feel healthier. But you have not considered what is going to happen to the person who is going to see your vomit. He will become nauseous. He may start feeling sick.[27]

The functional objectivity Gurdjieff endorsed is different from the attitude that hauls out anything and everything for ostensibly artistic display. There is a lot of raw material in the artist's personal underworld, but it must be processed to become useful. That there is so much work involved, just to uncover the rich ore, tempts one to display the raw stuff itself as a prize. But we should not be surprised when the audience fails to

be inspired by our coarse, unprocessed diggings. Manure can be compost-ed into a fantastic fertilizer, but without the investment of time and care, it remains shit.

For Gurdjieff, the essence of subjectivity is the associative nature of the mind. The mind constantly makes associations between stimuli it is cur-rently receiving and stimuli previously processed. This is its natural func-tion, which carries on automatically—mechanically, as Gurdjieff would say—without any consciousness on our part. The ordinary, unintegrated person takes the mind's associative interpretations as fact, because he lacks the wherewithal to really observe reality directly. The confused subjectivi-ty of the mind stands between him and his experience.

One of the first tasks of a student in the Work outlined by Gurdjieff is to learn the skills of objective self-observation. Only with this basic capacity in place can one begin to notice the discrepancies between what one believes about life and what is really going on. For artists too, such self-observation is necessary in order to avoid the traps of one's own subjectiv-ity. Otherwise, how can an artist know if she is expressing a real feeling about life or just the effects of lunchtime indigestion?

Taken as a map, objective art describes a clearly defined route leading to a definite destination determined by the artist. To be objective, a work must make a consistent communication, independent of the context in which it was conceived or is experienced. Art that fits this criterion has an extraordinary power, even the ability to affect incremental transformation in its audience. Gurdjieff considered this the only real art.

Only through the discipline of self-honesty can one discover the gaps between a lovely art philosophy and one's actual handiwork. And only through the strength of "being" developed with the help of such discipline can one hope to forge work that is consistent with one's original inten-tions. Although this scenario of artistic practice and spiritual evolution seems at first contradictory to self-transcendence, in actual application one finds they boil down to the same thing: an ultimately uplifting pursuit of the experience and expression of truth without compromise. The same aim can be found in any spiritual approach to art.

The Buddhist teacher Chögyam Trungpa spoke of an ideal in artistic discipline that he called "dharma art." "Dharma" refers here to a higher truth or normative principle of wholeness. Although described in Buddhist terms, the principles of this approach can apply to anyone engaging in creative practice. Art and the refinement of awareness overlap in the discipline of dharma art, which Trungpa described in these terms:

> The dharma artist is not a self-styled artist painting a picture out of his own shit and piss and selling it for a million dollars, but an upright person, a good, gentle, and well-meaning person who is willing to cut through his or her subconscious gossip completely so that a straightforward, brilliant, precise, clear mind takes place. An artist doesn't have to moan and suffer and roll in neurosis all the time. Unfortunately, that perverted version of the artist has evidenced lately, particularly in the Western world. People tend to appreciate those artists who tune in to their particular style of expressing neurosis. They like that neurotic style, so they buy their work of art and cherish it as though they were collecting a pet. Likewise, some people might prefer a three-legged dog for a pet rather than a four-legged dog, because they think it's cute. In that way, art becomes corrupt and decadent, and the whole thing goes down the drain....What that comes down to, again, is one's basic state of mind.[28]

Like Trungpa and Gurdjieff, Osho stressed the importance of one's state of consciousness when creating art. And while acknowledging the personal benefits of using art therapeutically, he emphasized the difference between such practice and the creation of art for others to see:

> Look at the paintings of Picasso. He is a great painter, but just a subjective artist. Looking at his paintings, you will start feeling sick, dizzy, something going berserk in your mind. You cannot go on looking at Picasso's painting for long. You would like to get

away, because the painting has not come from a silent being. It has come from a chaos. It is a byproduct of a nightmare. But ninety-nine percent of art belongs to that category.

Objective art is just the opposite. The man has nothing to throw out, he is utterly empty, absolutely clean. Out of this silence, out of this emptiness arises love, compassion. And out of this silence arises a possibility for creativity. This silence, this love, this compassion—these are the qualities of meditation.

…Unless you are a creator, you will never find real blissfulness. It is only by creating that you become part of the great creativity of the universe. But to be a creator, meditation is a basic necessity. Without it you can paint, but that painting has to be burned, it has not to be shown to others. It was good, it helped you unburden, but please, don't burden anybody else. Don't present it to your friends, they are not your enemies.[29]

Other teachers, including Chögyam Trungpa Rinpoche, have also recommended meditation practice as indispensable to the work of the artist. And contrary to Gurdjieff's use of language, the result of this discipline is the disappearance of the artist. Although the terminology seems opposite, both are ultimately speaking of the same phenomenon. The creation of a real, conscious self in Gurdjieff's terms corresponds quite closely to the un-self-consciousness Trungpa recommends. The key is in understanding the profound depth of the "ordinary" or seemingly casual experience cultivated in Buddhist practice. When a Buddhist master speaks of encountering life as it is, he refers to a simple but extraordinary immediacy that is born of rigorous practice and study. In Trungpa's words,

The whole philosophy of dharma art is that you don't try to be artistic, but you just approach objects as they are and the message comes through automatically.…when you see a painting by a great artist, it doesn't look as though someone actually painted it.

It just seems to happen by itself. There is no gap, no cracks at all—
it's one unit, complete.[30]

This unity and completion opens up the experience of connection
with a higher order that we have always sought for in art, both as creator
and audience. The pursuit of truth, whether through "artistic" or "spiritu-
al" practice leads to the same result, which is the objective (that is, tangi-
ble) experience of objective (unadulterated) truth.

The conflict inherent in much of Western artistic discourse may boil
down to a simple misrepresentation, or a mistaken assumption that is
familiar to students of spiritual philosophy. The search for objectivity is, in
a sense, self-defeating. It is self-defeating because in searching for objectiv-
ity, we deny its presence in our current experience. It is like looking for
enlightenment everywhere except its true location, which is in the imme-
diacy of our own awareness. This has been compared to frantically search-
ing for one's eyeglasses when they are perched on top of one's head all
along. We cannot find what we are looking for because we overlook it as
soon as we presume it is elsewhere.

In other words, we fail to grasp or manifest objectivity in art because
our attention is on everything except the immediacy of the present
moment. Our attempt to grasp the objective reality dissipates the sensory
mechanism we have for perceiving it. Isolating objectivity, like a com-
modity outside our present experience, serves only to isolate ourselves.
Only by being truly present in the moment—whether one calls this hav-
ing a real self or losing oneself completely—can we bring an objective
work into being.

According to Gurdjieff, flashes of this consciousness can be enough to
lead to objective work from time to time. And passion directed into one's
work can also generate a state of vulnerability and intention that bring
extraordinary work into existence. The connection works both ways, and
for many artists, an ostensibly "unspiritual" interest in the arts can lead to
real wisdom even if it is never expressed in terms of a religious dogma. But
without the context of an intentional practice, many artists fail to make

the connection between the experience of passionate creativity and the basic sanity of enlightened awareness, the liberation that Einstein referred to. The gap persists, and many tears of frustration have been shed over the disparity between the joy of creativity and the grinding, prosaic challenges and psychological conflicts of an unexamined life. The university professor and Islamic scholar Seyyed Hossein Nasr described the phenomenon this way:

> Today, for many people what is called creativity is really a substitute for finding their own center. They place their center in that work which is outside of them. That's why oftentimes you have people producing remarkable works who themselves are terrible people to be with, and whose works in a sense are not them, because they have no center within themselves. The most important thing is to discover one's center.[31]

The basic conflict inherent in the Western search for objectivity may simply be that we presume to place objectivity outside ourselves. From that starting point, the harder we look, the farther we are from our goal. We seek an experience of objectivity, transcendence, and supreme order because we know, on some level, that such an experience is our birthright. That experience is the essence of feeling that things are somehow "right" in the world, even when external circumstances face us with endless challenges and indignities. And we all know that experience when we find it, because in fact it is ourselves—or as the painter Mark Rothko put it, our "not-selves"—that we encounter there. When we find our own center, whether through creative work or some other practice, we know that we have found what we were looking for all along. Discursive, analytical processing, rationalistic strategies for "purifying" artistic practice, workaholic fanaticism and wishful sentimental outbursts all pale in comparison to the simple experience of the truth we have been hiding from all along.

Sometimes the only way we can get to this experience is to go through the steps of constructing a huge edifice of discourse, judgment

and speculation, and then seeing it collapse under its own weight. The dialectic of Western art theory represents this process in slow motion. Another alternative is to use proven means to cut through the layers of pretension we have built up around our own basic sanity. In either case, we must eventually come to accept the objectivity that lies obscured within our own experience. Chögyam Trungpa's advice to artists is practical in this regard, whether one appreciates a Buddhist point of view or not:

I would like to encourage everybody to practice meditation so we can actually see and look more. If we don't understand ourselves, it will be very difficult to appreciate anything else that goes on in our world. And on the whole, please cheer up. Don't analyze too much.[32]

Journey Between the Worlds

It is the idea of the struggle to exalt existence, to invoke the mysterious totality of life, which links the seemingly disparate worlds of modern art and shamanism. The shamans of pre-industrial cultures often had to suffer personal illness and psychic breakdown, as part of their preparation for an eventual breakthrough to transpersonal levels of visionary wisdom and healing activity. Equally, many modern artists have experienced the crisis of 'meaning' in industrial society with the sort of painful intensity which has prepared them for the struggle to respond (whether consciously or not) to the ringing, late-nineteenth-century call of Nietzsche's Zarathustra: "Truly, the earth shall yet become a house of healing!"[1]

—Michael Tucker

*T*he artist who is more than a commercial decorator or a casual aesthete takes upon himself or herself perhaps even consciously, some aspect of the suffering of humankind. This is because the artist seeks to close a fundamental gap between the inner and outer world. There may be no simpler way to state the commonality between artistic and spiritual practice, the shared creative devotion to an aim that takes many different forms: to identify and close the gap between the outer form and the inner essence of experience.

The dilemma posed by this gap is universal; it is what Christianity refers to as "original sin" (albeit without the moralizing dogmatism some American churches in particular like to attach). The artist closes this gap by bringing forth images (two, three or four-dimensional) from his inner world, manifesting what the Armenian spiritual teacher G.I. Gurdjieff referred to as "impression food." Whether these objects are tangible

sculptural forms or memories of a performance, they are best similarly regarded as artifacts or documentation of a process that is itself intangible.

The artistic object is evidence of the artist's skill, both as a voyager between dimensions and as a sympathizer with his fellow humans, for it is only in sympathy that one being can communicate to another. It is truly the artist's sympathy that moves us, for she reminds us thereby that we are not really so different from her. It is also the artist's sympathy that compels her to make the journey between worlds, a journey not unlike that of the healing shaman.

Since at least Paleolithic times, cultures have included members whose role is to bridge the inner and outer worlds. In fact, this role has the quality of an archetype: it seems to arise spontaneously, out of necessity, in most or all groups. Although the spiritual dimension is available to everyone, the health of any group seems to require one or more specialists who can address imbalances, oversights and other forms of "dis-ease" that manifest in the culture and in individuals. The curing of physical ailments may be one element of the shaman's function, but his attention is primarily on the deeper causes of suffering, which stem from conflicts and errors in the realm of spirit.

While we easily recognize the traditional role of shamanistic healer in tribal cultures, and the counseling role of some professionals in our own, the shamanistic function can take many forms. Operating on the fringes of normal society, men and women have often served the health of their group through shamanistic means. Religious renunciates, orators, ceremonial clowns of various kinds, dramatists, bards, minstrels and other entertainers have met this calling, as have artists through the centuries. We are attracted to the healing force embodied in the efforts of society's shamans. We know on some level that their compulsion to break the momentum of our predictable daily grind is good for us. Their disruption of our routine prevents the accumulation of entropy, the shadow side of culturation. The shaman literally saves us from death. To do so, he or she must willingly enter into death itself, in one form or another. We are grateful for this, but

it also gives us a chill. The shaman is the original underworld character. This is the root of culture's conflicted relationship with its shamanistic members.

Regarding the shamanistic function art in the modern world, Kuspit observes,

> Shamanistic art is a sorceress especially expert in healing, for it warms the cold truth, bringing it to life. More to the point, shamanistic art shows that there is a warm and a cold truth: the truth of disorder and unreason, as warm as life, and the truth of order and reason, as cold as death. Only through shamanistic immersion in disorder and unreason can the human being depersonalized and dehumanized by order and reason be repersonalized and rehumanized. Shamanistic art subtly transforms reason and unreason, reequilibrating them in the process. Reason becomes magical ritual, initiating the self into irrational chaos, which becomes possibility and which legitimates personal pleasure in an impersonal, unpleasurable rational world. Only shamanistic art can anarchistically melt hardened, authoritarian reason, allowing the individual to find creativity and happiness in unreason. Only shamanistic art can reintegrate reason and unreason, order and disorder, in recognition of art as the primordial origin and alembic of both. It reconciles the reality principle, which uses reason to survive in the world, and the pleasure principle, which insists that orgasmic joy is necessary to love life, which would become depressing and oppressive without it. Art not only gives pleasure its due, but insists that it is realistic to do so.[2]

Subversion of Boundaries

The artist can be thought of as a shamanistic shape-shifter; that is, one who can change into a different kind of being. Our experience of alternation between inner and outer worlds changes us in ways that are perma-

nent and ways that are ephemeral. Our perspective is not quite human anymore, in the ordinary sense of the word. Furthermore, the heightened awareness of the gap between the worlds, which accompanies the artist's vocation, evokes a sometimes overwhelming sense of injustice. How is it that we can experience these two worlds, the inner and the outer, with so little reconciliation between them? How can we be expected to live this way, tortured by sporadic intersections of inner and outer reality that tease us with awe, horror, and unspeakable sweetness? And how can we allow a situation to persist in which the bulk of humanity resolves this conflict, usually unconsciously, by attempting to deny the moments of intersection, even the existence of the inner world itself?

Having already compromised, in some sense, the integrity of her personality through a willingness to "shape-shift" consciousness into another dimension of experience, the artist must also qualify her communication to an audience that is often paradoxically hostile to the experience of spiritual boundary-crossing. This is a confused audience, which experiences a universal longing for the sense of completion engendered by artistic communication, but whose members generally reject the stress of an ongoing confrontation with that experience. As the artist Ben Shahn put it, "It may be a point of great pride to have a Van Gogh on the living room wall, but the prospect of having Van Gogh himself in the living room would put a good many devoted art lovers to rout."[3]

This is the injustice to which the creative practitioner is privy, and we feel a certain moral imperative, a calling, to redress it. Every artist is a conspirator in a coup that is waiting to unfold. Successful works of art are Molotov cocktails hurled against the edifice of a sleeping world.

The crossing of an interdimensional boundary cannot be captured in a physical object. Nonetheless, an object can resonate so strongly with the artist's exploratory experience that a sympathetic resonance is induced in the viewer. Such resonance is subversive to the conventional experience of life. The artist seeks to shock us into wakefulness—through beauty and awe, or if necessary, through horror. When the veil that separates us from the shamanistic underworld is rent, even for a moment, we are enlivened

by an experience of connectedness within ourselves. This is the experience of healing that we all need.

The shaman rends this veil by discovering and heightening an intuitive resonance between his own spirit and the world from which spirits originate. Traditionally this process involves a symbolic transit through death, dismemberment and resurrection.[4] The stations of this transit can take many forms. Every artist, every creative practitioner, necessarily finds his own techniques and support structure for the journeys he must make. In finding our own way, we can benefit greatly by considering not only the lives and methods of artists who have come before us, but also the forms that shamanism takes in different cultural contexts.

Just as Picasso, Modigliani and other artists have drawn inspiration from their contact with artifacts from tribal cultures, we can enrich our creative process by setting it in the context of shamanistic praxis. Specific techniques may or may not apply to us, but we need to understand the strategic entrance into the archetypal underworld. When life and ritual are closely aligned, otherwise prosaic experiences and events can provide trigger points for transformation in consciousness, piercing the veil between the inner and outer worlds. Storytelling, drumming, chanting, ritualized dance, the use of prayer beads and ceremonial prostrations are among the techniques used to engage the senses and the body as a whole in the journey between the worlds. These and other techniques have been available to us since humans first began to notice striking points of intersection between our world and that of the spirit. It is in this context that we can best appreciate the cave paintings created between fifteen and twenty thousand years ago in what is now southern France[5]:

> The painted halls in the great European caves are extraordinarily difficult for us to reach; to enter them must have been even more difficult for Paleolithic men. Only after a formidable and exhausting journey, groping their way by the light of fat and mosswick lamps along endless narrow, clay-slippery corridors, where they might encounter the giant cave bear or lion, down chimneys or

waterfalls, through vaulted chasms and tiny crevices barely pass-
able by the human body, perhaps for three hours or more, could
they reach the halls and corridors where the painting was done.

It is clear from the customs of modern primitives that the
long winding magical journey to encounter sacred objects is an
integral part of ceremonies meant to rehearse the pattern of cre-
ation. And the Paleolithic caverns were clearly intended as creative
ritual centres....the evidence all suggests that the caves were
thought of as the creative centre of the fertile earth, the womb
from which animal creations mysteriously sprang. The ritual jour-
ney to the spiritual source is a characteristic of the religious phe-
nomenon still known today among the hunter peoples, called
Shamanism.[6]

Saints, mystics and teachers throughout time inform us that we will
only know real happiness and peace of mind in the state referred to vari-
ously as enlightenment, awakening, realization, union, actualization or
self-transcendence. While this state is our ultimate destiny—even our pres-
ent reality, on some level—most of us feel far from it. Our current condi-
tion includes varying degrees of suffering originating in our felt discon-
nection from the "actualized state." One of the healing shaman's functions
is to remind us of that state as an ongoing potential. In breaking the
momentum of ordinary, rational, disconnected life, the shaman empowers
us to experience the awakened state, all things being equal.

But in order to give this empowerment to others, the shaman must
experience some measure of it himself. The creative life, of which shaman-
ic practice is a potent example, is ultimately a path of service to others
through serving one's own evolution in consciousness. The University pro-
fessor and author John Curtis Gowan analyzed the evolution of creative
consciousness in three general stages, asserting that trance phenomena rep-
resented the most primitive. The production of art represents a second
stage, leading finally to a truly creative relationship to life and conscious-
ness, the actualized state. In the terms of this analysis, Gowan compared

the psychological utility of art for the Paleolithic "savage" and the modern practitioner as a means for reconciling the confrontations posed by the uncertainties of human existence and the overwhelming experience of numinous phenomena:

> As the savage started by creating the first art (as in the cave drawings) as a kind of magic, which sacramentalizes the numinous (and traumatic) experience by presenting an outward and visible form for an inward and spiritual state, the modern artist does the same in trying to tame fearful and obsessive archetypes from the collective unconscious. As he gradually brings these ideas into the preconscious (that is within the spasmodic control of the ego) we say he becomes creative. What have been disturbing private archetypes (menacing because not understood), are transformed to creative expression in the artist and to public delight in seeing his art. For truly the artist has worked magic, but in a different and more enlightened way than the cave-magician foresaw. For what has happened is that impulse reaction to a disturbing image has been transformed by creative function into actualization for the artist and aesthetic appreciation for the spectator. The inner has become outer, the private image a public statement, the trauma a creative product, the psychic tension a productive emotional release.[7]

The point for creative practitioners, clearly, is not necessarily to copy the cultural forms of the ancient and contemporary peoples who are sometimes labeled as "primitive." Rather, creative life is about identifying our own need to shamanize and applying the principles of transformation to our own situation, ultimately for the benefit of others who are open to the fruits of our efforts. Viewed creatively, every moment presents the opportunity for a transformative relationship with experience. An ordinary spoon can be a ritual tool or a musical instrument. A glass of water can be turned into a sacrament. The Cherokee/Shoshone medicine man Rolling Thunder offered the following advice:

I want to warn you not to copy me, but work out your own method. Our people tell us to be original. If you can watch the method, though, and the way I go about it, maybe that would give you some thoughts about what to follow, what it's all about. Then you work out your own substance, your own songs, your own prayers and things to go with it. It's not good to copy.[8]

It is in this context that we consider the principles of creative journeying between the worlds, techniques that can close the gap and empower the awareness of the unitive state. The vision quest practiced by the original people of the North American plains—known as "lamenting" (*hanblecheyapi*) or "crying for a vision"—is another example.[9]

Vision Quest

Like many rituals, the traditional vision seeker prepares by sharpening the personality's appetite on various levels through purification. Alone, naked on a hill or mountain top for one to four days and nights, the lamenter makes tangible his or her inner condition of longing. A spiritual hunger is expressed, validated and amplified through the conscious commitment to a physical experience of austerity and constant mindfulness. One chooses to suffer in order to see more clearly, passing through despair into surrender and rebirth as one guided by a unique sense of purpose. The natural anxiety of the human condition, rather than being denied, is focused through the conditions of the visionary experience, like sunlight through a lens. The successful quest takes human discomfort and tightens it into a point of uncanny heat, which welds a bridge between the spirit world and the world of ordinary experience.

That bridge is the vision, the meaning of which unfolds poetically in successive layers throughout one's life. It is a map, not merely of the outer world, or the visionary's inner world, but of the intersection between the two. It is the experience of the intersection that provides the guiding light. Crying for a vision, in one form or another, is traditionally available to,

even expected of, all men and women of the tribe. However, the shaman, holy man or priest in particular may be marked for his role by the extraordinary quality of his vision.

While many members of the First Nations of North America embraced (and still embrace) the mystery and contradictions of the visionary state in open daylight, the practice of closing the gap within oneself, between inner and outer worlds, is subversive to the currently dominant, mechanistic worldview and its crystallized notions of the egoic self. Native Americans are quite familiar with the need to preserve one's values and culture through secrecy and a practiced invisibility, but they are hardly alone in this. Many people, of varied backgrounds, practice their shamanistic exercises in private or in the small cracks to be found in our paved modern *zeitgeist*. Even today, tiny enclaves of religious ascetics and other small communities of practitioners take it upon themselves to pray, meditate and perform specific rituals for the benefit of humankind—and all of creation—without seeking any credit. All they ask is to be left alone to do the work that calls to them, even in the face of relentless homogenizing encroachments by the globalized corporate monster embodied in our modern economic system.

The Sioux medicine man Lame Deer compared the position of the artist to that endured by Native Americans in the context of modern America, a culture which measures all value in terms of "frogskins"—his epithet for the green dollar bill. Speaking to the author and artist, Richard Erdoes, he said,

> Artists are the Indians of the white world. They are called dreamers who live in the clouds, improvident people who can't hold onto their money, people who don't want to face "reality." They say the same things about Indians. How the hell do these frogskin people know what reality is? The world in which you paint a picture in your mind, a picture which shows things different from what your eyes see, that is the world from which I get my visions.

I tell you this is the real world, not the Green Frog Skin World. That's only a bad dream, a streamlined, smog-filled nightmare.

Because we refuse to step out of our reality into this frog-skin illusion, we are called dumb, lazy, improvident, immature, otherworldly. It makes me happy to be called "other-worldly," and it should make you so. It's a good thing our reality is different from theirs.[10]

Shamanism in the Marketplace

Others feel a need to offer a more public healing—whether through political action or aesthetic confrontation. The artist Joseph Beuys (1921-1986) embodied these latter ideals. A founder of the Green Party in Germany, he also created objects and performances with the aim of provoking individuals and society shamanistically. While some of his works alluded specifically to shamanic ritual and materials, they were designed for their cathartic impact within a modern Western context.[11] He was also sometimes quite outspoken in his verbal critique of the dominant culture. His comments about consumerism and its devastating effects on human dignity raised hackles when he compared our modern economic system to the Nazi death camps:

What has an effect today is no longer this primitive method, namely throwing people into fires and thus destroying them; instead, today they are destroyed by the contemporary type of the economy, which hollows people out inside and makes them slaves of consumption…and in doing so tears their souls out of their bodies…In other words, the souls of humans have already been destroyed internally by Auschwitz methods.[12]

That any artist, political figure or creative practitioner might feel inclined to speak in such bluntly provocative terms is understandable. When confronted with the real importance of the issues at hand, as well as

the inertia of one's audience, subtlety often feels like an unnecessary delicacy. And since we are speaking of people who have been blessed and cursed by a sense of mission, urgency may seem to trump diplomacy. Nonetheless there is a range of methods available with which to make the necessary communication. A skilled practitioner knows how to apply force, and how to use subtler means to real effect as well. Such a practitioner also learns to tell the difference between impact and outburst.

To have an impact is to make an effective communication. The techniques of shamanism are all designed to maximize the impact of the healer's communication. An outburst, on the other hand, is simply a venting of frustration. Impact results from energy focused with intention, while outburst is an uncontrolled dispersion of that same energy. To have an impact, one must focus on the other, the recipient of the communication. To have an outburst is "all about me." Creative life in any field requires an intimate understanding of the difference.

Still, the artist has a job to do, not only for the benefit of others but for the sake of her own inner necessity. The dream, the vision, continues to call whether there is an audience or not. The forms and patterns that the artist perceives in the world around her daily call for the birth of new forms and patterns to complete or extend the ongoing evolution of the universe. At the height of her game, the artist is sparked to new creation by even the smallest stimulus in the environment. Like a mad saint who falls into ecstasy upon hearing the name of God, the artist can become blissfully distracted in the possibilities of new forms or ideas that parade before her. But the artist's job, while somewhat mystical in its origins, is not to be a mad saint. Rather it is to manifest what she can of the vision that has been entrusted to her. The journey between worlds is not complete until the traveler returns to the earth we know with what has been gained, bearing a message that escapes the boundaries of the present moment.

The test of art is whether it can invoke for us some sense of the artist's experience while sparking a unique experience of our own. The most successful artistic practice bridges the gap between the artist and audience as

well as between the inner and outer worlds. We each carry the healing potential of art within us, backed up by traditions of application that go back tens of thousands of years. The daily question that remains is how faithfully we will serve that application.

Resistance

Many painters are afraid of the blank canvas, but the blank canvas is afraid of the real passionate painter who dares.

—*Vincent Van Gogh*

*A*rt begins as something fun or spontaneous, but doesn't necessarily stay that way. If we do more than dabble, we will be led from an innocuous starting point down a trail with unanticipated turns, just as Alice chased her rabbit and wound up in an unexpected and unpredictable underworld. As in any good game, the challenges get bigger and more complex the further we proceed, until it may cease to feel like a game anymore.

Real artistic pursuit is a bit sketchy. By definition we are loosing the tether of rational constraints, to one degree or another. We are wandering in unmapped territory, to one degree or another. We love doing this and at the same time it has, to one degree or another, a threatening element. If we are self-honest, looking deeply, we will discover pockets of powerful resistance against artistic exploration, just as spiritual evolution in general runs into a wall of stubborn self-definition at some point.

Most of us decide to stop somewhere, at a point where we are comfortable. The quality that separates great artists from the rest of us might

be an unwillingness (or even inability) to stop halfway. The greatest artists always keep moving, undiminished in their striving regardless of obstacles, including success. This is true of creative life generally. The path is infinite; any limitations we encounter are only within ourselves. The willingness to settle for relative accomplishment represents a compromise that the greatest practitioners seem unwilling to accept, at least for themselves. It may be this attitude itself that defines greatness.

Carlos Castaneda described the uncompromising impulse toward evolution, and the uncertain circumstances surrounding the enterprise, using the image of a spiritual warrior. He quotes his mentor, don Juan Matús:

> The spirit of a warrior is not geared to indulging and complaining, nor is it geared to winning or losing. The spirit of a warrior is geared only to struggle, and every struggle is a warrior's last battle on earth. Thus the outcome matters very little to him. In his last battle on earth a warrior lets his spirit flow free and clear. And as he wages his battle, knowing that his will is impeccable, a warrior laughs and laughs.[1]

Life and Death Struggle

Don Juan also described the nature of internal resistance on the spiritual path with an apt metaphor. He said that, on the path to knowledge one encounters four "natural enemies," each of which endeavors to stop the warrior in his or her tracks. It seems clear that the same enemies lie in wait for any creative practitioner. It is worth quoting don Juan's description at length:

> When a man starts to learn, he is never clear about his objectives. His purpose is faulty; his intent is vague. He slowly begins to learn—bit by bit at first, then in big chunks. And his thoughts soon clash. Learning is never what one expects. Every step of learning is a new task, and the fear that the man is experiencing

begins to mount mercilessly, unyieldingly. His purpose becomes a battlefield. And thus he has stumbled upon the first of his natural enemies: Fear!…if a man, terrified in its presence, runs away, his enemy will have put an end to his quest.[2]

Fear is overcome, according to don Juan, by persistence. Even in the midst of one's fears, while experiencing them fully, one must insist on taking the next step in the learning process, and the next after that. Then, he says, fear retreats and knowledge ceases to be terrifying.

Once a man has vanquished fear, he is free from it for the rest of his life because, instead of fear, he has acquired clarity—a clarity of mind that erases fear. By then a man knows his desires; he knows how to satisfy those desires. He can anticipate new steps of learning, and a sharp clarity surrounds everything. The man feels that nothing is concealed.[3]

This clarity is an admirable accomplishment, but its limitations cannot be overlooked. In fact, don Juan asserts that clarity itself is the second natural enemy of the man of knowledge:

[Clarity] forces the man never to doubt himself. It gives him the assurance that he can do anything he pleases, for he sees clearly into everything.…If the man yields to this make-believe power, he has succumbed to his second enemy and will be patient when he should rush. And he will fumble with learning until he winds up incapable of learning anything more.…

His second enemy has just stopped him cold from trying to become a man of knowledge; instead the man may turn into a buoyant warrior or a clown.…He will be clear as long as he lives, but he will no longer learn, or yearn for, anything.…

He must defy his clarity and use it only to see. he must think above all, that his clarity is almost a mistake, and a moment will

come when he will understand that his clarity was only a point before his eyes. And thus he will have overcome his second enemy, and will arrive at a position where nothing can harm him anymore. It will be true power. His ally is at his command; His wish is the rule. He sees all that is around him.[4]

If clarity is a necessary evil on the warrior's path, the solution to clarity is only a little better. To overcome the limitations of clarity, one must become grounded through real power—the ability to act as a spiritual warrior in ordinary and extraordinary ways. But again, this solution is a problem in its own right. Power is in fact the third natural enemy on the path. Don Juan continues:

Power is the strongest of all enemies....A man at this stage hardly notices his third enemy closing in on him. And suddenly, without knowing, he will certainly have lost the battle. His enemy will have turned him into a cruel, capricious man....A man who is defeated by power dies without really knowing how to handle it. Power is only a burden upon his fate. Such a man has no command over himself and cannot tell when or how to use his power.[5]

As with the previous enemies, the warrior can only succeed against this enemy by defying it. As long as one persists in the face of the natural enemies, the battle is on; the warrior loses only when he gives up and gives in. For the warrior to defeat the enemy that his own power represents, according to don Juan,

He must defy it deliberately. He has to come to realize that the power he has seemingly conquered is in reality never his. If he can see that clarity and power, without his control over himself, are worse than mistakes, he will reach a point where everything is held in check.[6]

By this time, don Juan observes, the sorcerer's apprentice will have become an old man. Old age, therefore, is the fourth natural enemy of a man of knowledge.

> This enemy is the cruelest of all, the one he won't be able to defeat completely, but only fight away....
>
> This is the time when a man has no more fears, no more impatient clarity of mind—a time when all his power is in check, but also the time when he has an unyielding desire to rest. If he gives in totally to his desire to lie down and forget, if he soothes himself in tiredness, he will have lost his last round, and his enemy will cut him down into a feeble old creature. His desire to retreat will overrule all his clarity, his power, and his knowledge.
>
> But if the man sloughs off his tiredness, and lives his fate through, he can then be called a man of knowledge, if only for the brief moment when he succeeds in fighting off his last, invincible enemy. That moment of clarity, power and knowledge is enough.[7]

One has to appreciate the poetic justice in this model of natural enemies. Fear, Clarity, Power and Old Age are also the enemies of the artist-warrior. What artist has not faced possible defeat by at least a couple of these? Any one of them can seduce an artist away from her real objective, posing either a dangerous distraction or a permanent dead end. Excessive confidence in gains made, as if they represented some kind of permanent accomplishment, can be fatal. But as long as the struggle continues, the warrior is worthy of the name.

The challenges of the path are both frankly obvious and deviously subversive. The quality that enables a warrior to overcome one enemy is in fact the next challenge. The necessity of advancement is therefore built into the path itself. Overcoming an obstacle automatically raises the stakes of the game and bumps one up to a new level, in which the next obstacle presents itself, usually without mercy. The elegance of a description like this

makes it ring true, no less in the evolving practice of art than in the warriorship of an apprentice sorcerer. Nonetheless a description is only a description; its usefulness lies in where it leads.

Linear stages are a useful way of describing a process, but reality does not always operate so neatly. In life, linear progressions more often operate like a spiral. That is, one does not perfectly and neatly complete one step before moving on to the next. Instead, one finds oneself returning to an earlier stage later on, but at a higher or subtler level. The discreet stages described in many philosophical or metaphysical systems are more like archetypal situations that we master after repeated encounters. Although Castaneda recounts the description of this process in strictly linear terms (each step happens only once), in principle one suspects that things are not so simple, and that the man of knowledge can never really rest on his laurels. The enemies on the path are vanquished when the warrior builds and maintains a solid habit of defying them invincibly whenever they appear. But I am putting words in don Juan's mouth here.

Nonetheless, according to don Juan, the final limitation of the path is determined not by the spirit of the warrior, but by the inevitable fact of physical mortality. No attainment on the path is absolute, and in the end it is only the continued striving itself—in fact, a defiant attitude— that defines success. Evolution is not defined by a specific goal; rather it is an ongoing process. We either stubbornly engage the stream of that process or we succumb to inertia. That is the only choice we have in the matter.

In his satirical essay, "The Divine Path of Growing Old," Lee Lozowick makes this same point by taking an opposite (or apposite) view of death. Rather than viewing old age and death as the final nemeses of spiritual advancement, he defines them as the glowing fulfillment of human incarnation. After a lengthy and humorously pontificating description of successive stages of advancement represented by various ages in life, offered in the style of a yogic guidebook, Lozowick delivers a punch line that critiques the whole notion of advancement as spiritual seekers tend to view it. Death is in fact the culmination of a life well lived:

All paths have a promised end result that is not necessarily a natural outcome of the path, but rather an artificially designed, imagined, or implied goal or level of attainment that must be worked for and efforted at with intense one-pointedness. If one should die before this artifice is reached, this individual who has just died suffers great frustration and turmoil once they are safely on the other side. ...

However, as you can most clearly and stunningly see, in the "Divine Path of Growing Old," if one should die at any time, at any age, in any stage, one has only realized the culmination of this Path anyway so the only possible outcome is the joy of completion and transcendence.[8]

This attitude toward the spiritual path—that it is a natural and inevitable process—is a healthy counterpoint to the ideal of striving that Castaneda describes. In practice, these two seemingly contrary views do not contradict each other at all. *Striving itself can be a form of resistance if it is unquestioned.* This is another universal principle of the creative life. The practitioner needs to hold both perspectives at once: to strive, and yet not to take the whole thing too seriously. As don Juan put it, in his last battle on earth the warrior laughs and laughs.

Opportunities Outside the Box

We do resist. The daily need to overcome the resistances that seem built into us is a large part of the artist's practice. Sometimes we jump eagerly out of bed in anticipation of the project at hand. Other days are not so easy: the spirit to continue must be summoned from within ourselves as we groan and creak our way out of bed, anticipating the failures, frustrations and humiliations that await us in the studio.

Someone once said that there is no greater burden than a tremendous opportunity. It is fear of this burden that drives us from the embrace of creative possibility. Like a casual friendship that turns a bit more serious

and intimate than we were ready for, the creative life can sometimes feel like a case of bait-and-switch. Every new creative project has the potential to lead us somewhere we might not prefer to go, and at the very least, we could have to expend resources of time, energy and even materials far beyond our initial budget. If we are serious, we may find that we do in fact start to approach the blank canvas with mixed emotions.

Operating creatively opens a Pandora's box of options. Who has not felt stunned by a sudden rush of possibilities that flood the senses in a moment of inspiration? It is more than the mind can process at once. It feels a little bit crazy and certainly "outside the box." Most humans are content to slam the box shut again because of the challenges implied in recognizing each of the possibilities. The artist's job is to remember that Hope was the secret prize, the last of the spirits stashed at the bottom of that famous carton. It, too, must be allowed to make its way into the world, and creative work is one of the most powerful means through which it manifests.

There is definitely something to be said for ignorance and conformity: they are simple, and therefore require little energy to pursue. The offer an easy way out of challenging, stressful or uncomfortable situations. When in a crunch and feeling pressed for time, we can count on them—like a TV dinner—to silence a certain internal grumbling. This is why totalitarian political systems (even those posing as democratic) like to keep as much of the population as possible under economic stress. When workers are compelled to struggle just to get by, a goodly number find themselves with little energy left, at the end of the day, to do more than pop open a beer and absorb the propaganda and numbing "infotainment" provided by the mass media. Under these conditions, people are not likely to consider realistic alternatives to their situation, and even less likely to muster the energy to manifest such options.

This regimen is self-reinforcing. With disappointingly few exceptions, even desperate wage slaves act as if they were attached to their denial. If someone brings up the subject, that person is ignored or suppressed. Sometimes it seems better not to know what we are capable of seeing,

doing or being. To know is to have a degree of responsibility. Plausible deniability requires that we dumb ourselves down, and for too many people, dullness stands in pretty well for peace of mind.

The mediocrity most people experience and perpetuate in their work and social lives reflects this imperative, which usually takes the form of just not thinking things through. It is too depressing to look deeply into most of what goes on around us. Instead, we ask ourselves if the *status quo* isn't good enough after all.

Accepting the bare minimum from ourselves and others is the key technique of defense against the challenges (i.e., burdens) posed by creative thinking. Conversely, to work creatively, we have to work against denial, if only in ourselves. The opposite of denial is accountability, or the tangible acknowledgement of truth through action.

To be ourselves, we must accept responsibility for ourselves as we are, and for the goals we would like to pursue. Accepting responsibility for ourselves, whatever our current level of ability, integrity and compassion, begins the process of gathering energy with which to move forward. Lack of accountability (keeping things fuzzy), on the other hand, leaks energy. At a certain level of evolutionary striving, this starts to feel like a bleeding wound.

To rigorously pursue the creative life is to locate oneself in a world of expanding possibilities. The rarified atmosphere of such a world does not tolerate much pollution in the form of vagueness, buck-passing and other forms of denial. Accountability to oneself, at the very least, is essential to building and maintaining this world. Using his unique linguistic style, and with his particular rigor, the human potential teacher Werner Erhard[9] argued for accountability as an essential virtue within the culture of the people who participated in his programs:

> Accountability is the opportunity to live at choice rather than accidentally. Accountability is the opportunity to carve out the future rather than to sit back and have it happen to you.

Accountability held from a stand as one's word is the ground from which one's own transformation is created ongoingly.

Transformation lives in accountability. Without accountability, without committed speaking, without promises and declarations, there is no transformation; there is, at best, peak feelings. A promise has real power. A promise made from the stand that who you are is your word, engages you as participant. You cease to be spectator, and your words become actions that actually impact the world. With a promise you create a condition that supports your commitment rather than your moods.

When motivational dialogue comes up about your preference versus your commitments, and you disregard the dialogue in favor of doing what you said you would do solely because you said so, you distinguish yourself from your psychology. In that moment you are your word as an action, rather than only as an idea you have. In that moment the promise becomes who you are rather than something you said; and your relationship to the world shifts. You find yourself producing results that seem discontinuous and unpredictable from the point of view of the spectator. The experience is one of joy, fearlessness, irrepressible energy and satisfaction.[10]

This experience is what creative people live for, but it is a freedom born of discipline. The vague, naïve image of the artist as a kind of child-like slob, who just does whatever "feels right" at the moment, comes at the whole thing backwards. Rather, the artist is accountable to her muse, who sets inspiration at work within the artist.

From one point of view, it is the muse, not the artist, who gets to have all the fun here. The artist just does the legwork, including all the drudgery of manifesting a potentially complex vision into tangible reality. As the servant of her muse, the artist is dedicated, surrendered and proactively supportive of that inspiration. Keeping the inspiration alive and happy is the artist's real mission, and that means being accountable to the

inspiration's needs. Through that accountability itself, the artist builds the vessel or vehicle that can hold the inspiration and deliver it uninjured to the world.

> It is by long obedience and hard work that the artist comes to unforced spontaneity and consummate mastery. Knowing that he can never create anything on his own account, out of the top layers, so to speak, of his personal consciousness, he submits obediently to the workings of "inspiration;" and knowing that the medium in which he works has its own self-nature, which must not be ignored or violently overridden, he makes himself its patient servant and, in this way, achieves perfect freedom of expression.[11]
>
> —Aldous Huxley

In fact, this kind of responsibility is not limited to artists and other creative specialists; it is in the fine print of everyone's job description. Every human being has a muse to which he or she could be accountable. The creative dynamic between a muse and her caretaker is what makes any person feel most alive and most human. All of the entertainments with which people stimulate and distract themselves can probably be classified as surrogates for this experience. We want the inspiration of feeling at our best, but the accountability involved seems expensive. *How about going to a movie instead?*

Nowhere is the failure to engage real accountability more evident than in the unsustainable economic practices dictated by the status quo of the modern corporate profit motive. Long before the corporate accounting scandals, dirty deals and infrastructural breakdowns of the early twenty-first century, death was built into our financial system. That markets of various kinds settle into an equilibrium of competing forces is sometimes

touted as proof of the validity and efficiency of unrestrained markets to improve the quality of life. But fat and happy analysts usually fail to notice how often all the forces at play are *entropic* forces.

The effect of unregulated business-as-usual is to seek equilibrium in the lowest common denominator of market imperatives. Unrestrained markets reduce the quality of life (especially other people's quality of life) to a minor variable in an amoral formula. The "good" is defined simply as anything one can get away with, and greed is counted among the highest of virtues. A market is considered successful when it achieves the noble middle ground between the avarice of the seller and the bad judgment of the buyer. Unrestrained markets cheapen life, destroying it in the end, and this situation persists because, for the most part, people don't have the energy to think things out beyond the end of their own nose. The corruption of artistic pursuits by purely commercial influences is just one particular example of this entropic sickness that plagues our society as a whole.

Excellence, on the other hand, requires an extraordinary expenditure of energy. Evolution wants an excess beyond what is required for home-ostasis. Those who pursue excellence find that they must cultivate excess energy in the form of will, stamina and prowess. Habits that deplete energy become anathema—and mediocrity, in all its forms, is one of these.

To seek creative solutions, whether in science, economics, business practice or art, one must become unwilling to cheat, to "cook the books." All costs, all along the supply chain, ought to be accounted for and evaluated realistically. To claim a profit, for example, because the only people dying for the sake of our stock portfolio live far away and have dark skin, becomes untenable. Similarly, to call a work of art "finished" just because we are the only person dissatisfied with it also becomes impossible. Whatever our field of endeavor, we have the choice to have integrity or not. Simply to pursue integrity as a practice in what we are already doing goes a long way toward improving everyone's situation. This is because mediocrity is a leaky vessel in which to gather and store the energy we need to pursue excellence.

For artists, the practice of art builds within us a container or vessel that storehouses the energy we need to pursue art further. Along the way, what used to be difficult becomes easier—we do in fact get more efficient, but there is a hurdle, an energetic threshold that must be crossed first. The successful practice of art needs a conversation between our personality, our muse and the creative powers that we access in the work. That conversation grows out of the *relationship* that we build through consistency. Once the terms of the dialogue are established, communication (and communion) becomes less forced, but the investment of time and energy can't be avoided. The difference between an amateur and a professional might be the willingness to make that investment as a matter or course—a routine business investment—rather than to dramatize one's resistance as if it were a romantic virtue.

The Feminine

We may also feel at least a hint of threat when confronted with a certain feminine quality of the creative enterprise. It is no accident that the Muses were depicted as females. In a culture in which the feminine has been degraded for so long, we may not trust our luck to be a lady tonight. This is a challenge for men and women alike.

The deeper we delve into creative work, the more we find ourselves smitten by a muse who is unpredictable and at times uncompromising. Negative archetypes of the feminine lie in wait at the back of our mind. What if she engulfs us, like a smothering mother? What if a Siren lures us to our downfall? What if we lose ourselves and are unable to come out of the enthrallment into which we are invited? In short, what if the feminine betrays us?

To the extent that we are inclined to feel betrayed anyway, such questions take on exaggerated relevance. They reflect a retreat into the masculine mode of systematizing experience, breaking it into manageable little chunks that we seek to control. Smaller chunks seem easier to manage when we are afraid, and if our fears are strong enough, we may feel the

need to smash our whole world into tiny pieces. This kind of fear is at the core of Western civilization, and the refusal to confront it honestly is the basis of much of what is crazy and hellish about our world as a whole. A certain dread that the artist in our culture experiences is therefore at least partly a reflection of unresolved conflicts at the heart of society. The artist in Western society is to some extent a kind of microcosm of his or her environment.

At the same time, the individual conflicted personality under stress harbors a strong tendency to reject specific aspects of experience. In such a case, we do not simply respond as needed to actual threats; instead, we adopt a wholesale defensive posture. That is, we feel threatened, even subtly, and so push away or deny elements of life that seem to embody the threat. It matters little whether the threat is real or perceived, or whether it resides where we think it does; an automatic response within us sets up a defense perimeter. Such a perimeter lacks the finesse with which to identify real threats, and tends to respond like a rigid bureaucracy, shutting down options for a dynamic, flexible response to the actual situation.

Esoteric spiritual traditions, especially in the East, offer an alternative to the hard-edged paranoia of the West. An essential principle common to these traditions is the pursuit of an internal union between masculine and feminine elements. Each practitioner, man or woman, has elements of the archetypal Man and Woman that can be accessed by the personality. Deeper than this, primordial masculine and feminine polarities can and must be revealed, purified and reconciled through the individual's spiritual practice. Better scholars than myself should be consulted for more details on these traditions, but it is enough here to say that such traditions exist, and that they offer an alternative for the conflicted Western temperament. The most useful point is that an internal resolution of masculine and feminine energies can be pursued by any individual, and such a pursuit can heal and subsume psychological dynamics that conflict with creative work.

Creative work itself can bring these elements together if we let it. Recognizing the nature of internal conflicts and divisions can help us to

Stage Four of the "Divine Path of Growing Old" is the stage in which the key to the whole Path (aging) begins to be grasped and seen in its true light an inevitability. Slowly it dawns on the earnest practitioner of this Path that their entire life's experience all led perfectly to their present form and state of consciousness and the Powers-That-Be cannot even change this dynamic aspect of Life-As-It-Is, aging (not that they would want to for any reason whatsoever). In this fourth stage one realizes one of the most inspired and unimaginable facts (that is almost never seen in stage two or three) ever to be realized: That those who had always been called older and wiser were truly That. And specifically, the rare and precious gem and most central point and core of that very insight: One's Mother was right. In other words she really did know what she was talking about.[12]

—Lee Lozowick

sidestep them in the midst of the work, forging an infrastructure that the personality can use in other situations as well. What we learn in the studio can be brought home to all of our relationships.

Particulars

As a starting place, or as a reminder, it is helpful to consider some common, specific forms of resistance to creative work.

One favorite is losing focus. This can take the form of simple avoidance, such as conveniently "forgetting" to keep a creative project rolling along, or finding other things to do that seem to be more interesting or more important. (I blush to think of how many times I played out this one

while writing the page you are reading.) Scattering one's energies among too many projects to bring any of them to fruition is another way of losing focus. Focus is necessary to achieve depth. Distractions such as premature market considerations, impossible expectations and unfinished business in other areas of life make it harder to achieve a satisfying depth in creative work.

Leaving projects unfinished is a great way to dissipate one's energies and focus. Sometimes, it is a matter of having too many irons in the fire. A new creative impulse, or a real need or a request from a client, can be the occasion for dropping what one is already doing and starting the new project. Often one never does make it back to the original project, because on the way even more interruptions assert themselves. Sometimes it really is fruitful to have several projects in progress at once; the logistics of one's medium may necessitate this, or it may make creative thinking easier. On the other hand, things can get out of control. Failure to draw things to a conclusion can be a psychological "racket" for avoiding the responsibilities that come with success.

Gurdjieff said that there is a point approximately seven-eighths of the way through most tasks at which we encounter special resistance, or simply run out of energy. People often quit there, abandoning the investment made. Speaking personally, if I were to walk from my desk here in my studio to the bathroom—a distance of about thirty feet—with a clipboard in hand, I could probably note the artifacts of at least a dozen half-finished (or seven-eighths-finished) projects stashed in corners or up on shelves. The awareness of these incomplete episodes of my life, both conscious and unconscious, can create a subtle mood of frustration and self-reproach every time I have to get up and pee.

Sometimes the effect is just that, and I find myself stomping around the studio looking for someone else to blame for my irritation. The way out of this bind seems to require acceptance, and it usually takes one of two forms. The first form is to realize that I am just acting like my father on a bad day. Although the recognition stings a little bit, it also has a certain humorous quality that can break the spell of frustration. The tenden-

cy to "become our parents" is truly invincible and we can only struggle on eternally in a daily battle—the same way that a warrior must struggle against Old Age in Castaneda's terms. Every battle is our last battle, and we must accept our obligation to laugh and laugh. The other form of acceptance I use is to remember an astrological reading I once was given, which pointed out that my nature is to return to projects over and over, to rework and refine them. From that perspective, my incomplete projects are not necessarily dead—they may be, as in that old Monty Python sketch, "just resting," waiting for me to give them one more level of refinement. (This is well and good if I actually do get back to them.)

While it may never be possible to eliminate all unfinished business in a creative life, the way we manage our attention can have a big impact on how much we actually get done, and what kind of atmosphere we create in which to work. Awareness of this tendency, at least, can help one push through the barriers that separate completion from mediocrity.

Fear is another way to scatter one's energy. Fear is a dispersal. Whether we fear failure, criticism or even success, the result is to dissipate our energy and focus. While it may seem that fear just comes upon us and we have no choice about it, there is often a moment of choice, fleeting and subtle, in which we decide whether to be afraid or not. But even if we miss this moment, we need not be crippled by fear. The defiant, persistent approach recommended by don Juan can in fact overcome the effects of fear, if not the fear itself. Courage is not the absence of fear, but the willingness to proceed even in the face of it. To act courageously, we need to gather back some of the energy that has been scattered through fear, reconstructing the vessel that was compromised when fear took over.

Sometimes it is necessary to step away for a moment, to catch a breath or get one's bearings. Losing focus happens when we step too far back for our own good. An analogy would be taking a break while hiking a trail. A break of the right length refreshes; a break that is too long actually encourages inertia. We start to get stiff and it is harder to achieve the previous momentum.[13] Stepping back emotionally follows this same pattern. A little bit is good; a little bit too much can be way too much.

Cynicism, it should be noted, is an expression of fear, an emotional refuge from the vulnerability of a situation in which we feel unsure. If we find ourselves feeling cynical about some aspect of our creative process (including our dealings with the marketplace) we should recognize this as a self-destructive behavior, and treat it as a form of fear.

Self-judgment, especially what is below the conscious level, can be an especially devious and damaging form of resistance. As a teacher of glass-shaping techniques, I regularly encounter a type of student who seems unwilling to learn. They are a kind of paradox, because they have made the commitment to come to a class (usually at the cost of several hundreds of dollars), they are interested, intelligent and they make the gestures appropriate to a dedicated student. But something isn't getting through. In a way, they seem obstinate, because they make certain mistakes over and over despite repeated explanations and demonstrations. The problem goes beyond the simple differences that students manifest in learning style. And while each case is unique, it seems generally that there is a drama being played out behind the scenes.

Usually that drama involves sabotage based on self-judgment. At some point, probably long ago (and in any case, *too soon*), the student was taught to criticize his or her own accomplishments in a way that engendered panic and despair. If a person has a self-definition that requires him to fail in some way, it can, and generally will, play itself out despite the best efforts of student and instructor.

Often the best an instructor can do, especially in the limited time of a workshop, is to let some steam out of the sabotage mechanism. The teacher is not responsible for the student's psychological state, of course, but neither is he obligated to play out the drama that has been dumped on his doorstep. The specific means for doing this vary with the situation, but generally speaking they involve valuing the student and presuming that their presence in the class is a contribution to the best end result, regardless of how they are "showing up." The student in this situation fears to be some kind of problem. If the instructor gently refuses to buy into that, he

creates an opportunity for the student to sneak out from under the weight of negative expectations.

In fact, many students seem to approach training in art and/or crafts specifically to obtain this emotional nourishment. Perhaps the most (or only) sympathetic adult in their school experience was an art teacher; or art was the only class in which they were not burdened with unrealistic expectations, boring rote memorization and the humiliating stress of tests. One can hardly blame them for seeking solace in the practice of art now, although sometimes insensitive instructors and other students manage to do so, only making the problem worse. Negative attention is better than none as far as the hungry inner demons are concerned.

If the student seems willing or asks specifically, a skillful mentor can begin to point out some of the outlining features of the tendency. This is a risky business however. What seems like a silly, expendable affectation from the outside can carry a big investment for the bearer. When we think we have someone figured out, we may have the urge to unload all our critiques about them or their work in one session. But we should only give what the receiver is able to digest.

To give a person one's opinion and correct his faults is an important thing. It is compassionate and comes first in matters of service. But the way of doing this is extremely difficult. To discover the good and bad points of an individual is an easy thing, and to give an opinion concerning them is easy too. For the most part, people think they are being kind by saying the things that others find distasteful or difficult to say. But if it is not received well, they think that there is nothing more to be done. This is completely worthless. It is the same thing as bringing shame to a person by slandering him. It is nothing more than getting it off one's chest.

A good way to avoid going too far is to pose questions rather than to impose conclusions. Asking questions, as Plato was fond of doing, draws the other party into conversation and gives a direct, tangible indication of how well she is processing the information. We can tell when she has hit a wall, and then it may be best to back off and let her process on her own

To give a person one's opinion one must first judge well whether that person is of the disposition to receive it or not. One must become close with him and make sure that he continually trusts one's word. Approaching subjects that are dear to him, seek the best way to speak and to be well understood. Judge the occasion, and determine whether it is better by letter or at the time of leave-taking. Praise his good points and use every device to encourage him, perhaps by talking about one's own faults without touching on his, but so that they will occur to him. Have him receive this in the way that a man would drink water when his throat is dry, and it will be an opinion that will correct faults. This is extremely difficult. If a person's fault is a habit of some years prior, by and large it won't be remedied. I have had this experience myself. To be intimate with all one's comrades, correcting each other's faults, and being of one mind to be of use to the master, is the greatest compassion of a retainer. By bringing shame to a person, how could one expect to make him a better man?[14]

—Hagakure, *The Book of the Samurai*

for a while. This technique makes the necessary communication while keeping resistance to a manageable level.

Resistance to creativity also reveals itself in an unhealthy obsession. While real obsession is identical with happiness, obsessions that reflect an avoidance of life are destructive, and can be recognized by their rigidity. Over rationalization, and the tendency to systematize out of fear, are easy examples. Obsession with novelty, difficulty, cleverness, specific techniques or forms, audience response, recognition and other particulars can also be signs of stagnation and fear. Again, some obsessions are part of the creative

process and some are not. One must ask what the obsession serves. If we honestly inspect the goal of our obsession, we will be able to tell if it benefits creative life or only an egoic self-image (whether negative or positive).

The creative person truly is in a battle, and Castaneda's image of the spiritual warrior fits the artist rather well. Whether the resistance we encounter is external—in the form of physical circumstances, the dullness of our audience or the lack of resources, for example—or internal (in one or more of the forms just considered above), our persistence in the face of adversity will go a long way in bringing our work to completion.

Ultimately, we should probably view all forms of resistance as residing within ourselves, because if our intention is strong and our purpose unified, no external factors can stop us from proceeding creatively. We may need to adapt, to use unanticipated forms the way the Professor made electrical generators out of coconuts shells on *Gilligan's Island*, but we will find a way if we have the will.

Furthermore, if we treat the external resistances we meet as if they were part of ourselves, we will find that many of them melt under the influence of our acceptance toward them. This process may take time and may involve compromises we would rather not have to make. But the give and take can itself be regarded as simply part of the creative unfoldment of a vision. No truly ambitious vision ever meets our initial expectations, even under the best of circumstances.

In fact, resistance is very much a part of the creative process, and of spiritual evolution in general. Many saints and esoteric practitioners have expressed gratitude for the resistances they encountered along the way in their spiritual work, including physical deprivation, beatings and other abuse from the world. Without resistance, we have nothing against which to measure our spirit, and no guide for the form that spirit should take.

It is no accident that resistance is inherent in the world of material manifestation. The First Noble Truth of the Buddha, that all life is suffering, was never a complaint; rather it is a definition of the challenge we embrace when we take on creative life. We are meant to work with that very suffering, as with the resistance inherent in material existence, in

order to bring to fruition the ultimate creative process, which is the awakening of human consciousness.

Vaishnava Hindu texts agree inasmuch as they assert that the physical world, including its limitations, exists for the express purpose of playing out a joyful game of hide and seek between the Divine (in the form of Krishna) and its lovers. The challenges and conflicts we face in life are, from the highest perspective, simply part of this game. That we have forgotten this fact is part of the game itself.

The place of resistance in creative life is well summarized by the author Harry Remde, who describes the spiritual experience of a craftsman at work. I submit that it could be taken no less as a description of the divine Creator as of the human craft worker:

> Much more of the craftsman's strength goes into the use of his tools than ever is needed by the material. Indeed, it is by means of this excess strength that he gains control of the tool. The material resists; the tool overcomes. There is no need here for extra strength. Yet the extra strength is there in the tool—not potentially nor in abeyance, but there. Whether he works with a chisel on wood, a shuttle through threads, or his fingers on clay, the craftsman in part holds back at the same time that he pushes the tool forward. Thus he adds his own resistance to the resistance of the material and then provides the extra strength needed to overcome it. He resists in the same direction as the material. In general, if the material resists more, he resists more; if the material resists less, he resists less. With so great a proportion of the resistance coming from him, the resistance of the material is relatively small. The material yields in an atmosphere that is always close to zero—the finest control becomes possible.
>
> These opposites—the resistance that he purposefully creates and the strength with which he overcomes it—enable the craftsman to be as if in the material itself. He knows its instant behavior and adjusts to it. His movements may be sudden or slow, or

they may be defeated, but there is no surprise. The notice he receives from the material is continuous with its movement. He listens as the wood awakens, as the clay stirs.

The progression of the work as the steps are completed is for him a joy. An energy in him grows from these completions and beginnings. The energy is renewed in the interval between successive steps.[15]

This experience in the master craftsman completes a circle that began with the creation of life itself, and is not much different from what is earned by the most ardent mediator or yogi. The pleasure of the Divine is not to sit on an idle throne, but to manifest itself in tangible reality, in spite of, and even necessarily by means of, resistance. When we hold resistance rightly, when we persevere in the face of it, we share the experience that God wants to enjoy through us.

Given the implications of this process, it is not surprising if we stand fearful before the blank canvas. Our intuition of what is at stake may paralyze us even before we dip the brush in the paint. But, as Van Gogh declared, our daring can save us. When we meet our fears with open eyes, and defy them along with our other internal resistances, we boldly place ourselves in God's shoes. And while those shoes may be a bit big for us, the fit is good enough that we can really kick some ass.

Hunger

The most important tool the artist fashions through constant practice is faith in his ability to produce miracles when they are needed. Pictures must be miraculous: the instant one is complete, the intimacy between the creation and the creator is ended. He is an outsider. The picture must be for him, as for anyone experiencing it later, a revelation, an unexpected resolution of an eternally familiar need.[1]

—Mark Rothko

*W*e are always hungry, although we don't always know it. Some hungers are more obvious than others, and they usually get most of the attention. Sometimes we even ignore subtler hungers for the sake of those that seem more demanding. But we have deeper needs that must be met, even if addressing them brings us face to face with things we don't want to see.

We make a mistake if we think that feeding our more obvious hungers will be enough to satisfy us. The analogy with food is useful. If we don't know what we really want, we tend to grab whatever is close at hand; hence the success of the junk food industry in America. It takes some effort and attention to have a sophisticated sense of what we are hungry for. Nonetheless, if we have the intention to feed ourselves in a balanced way, the body itself will give us clues about our specific needs. Developing this sensitivity is mostly a matter of removing obstacles to our native, intuitive response to our world. Those obstacles include psychologically

conditioned responses, erroneous assumptions and convenient forms of received wisdom.

As infants and children, we rightfully expect to be fed by our parents. This naturally dependent relationship makes a big impression on us, and tends to color our whole approach to life. In an ideal situation, we move beyond dependence into independence and then the recognition of our interdependence, and a deeper sense of connection with life. We become a provider of value in our world, moving up the food chain, as it were. Typically, however, there are incomplete bits of that original, primal relationship to sustenance that consume our attention in big and small ways. Something is missing somewhere, and we can't quite fully attend to anything else until we find it. Eating disorders are only the most obvious form such incomplete stories take. Other drives can also be enlisted to carry out unexamined imperatives. Compulsions revolving around sex, emotional dependencies, money, control and prestige all have the quality of a hunger trying to be filled.

But as any good therapist can tell us, we can't get enough of what we really don't need. Desires or apparent needs that are standing in for an unrecognized hunger always lead us in the wrong direction. The satisfaction of obtaining what we really want has been transposed or projected onto the current object of our desire, and we find ourselves wrapped up in a drama that implies a real fulfillment at the achievement of a symbolic goal. Indeed, there even seems to be a moment of satisfaction when we fool ourselves into thinking that the craving has been successfully transferred onto the goal at hand when we make that purchase, score that deal, eat that cookie, put that notch in our bedpost. Nonetheless, the satisfaction always fades, usually sooner than we would like to admit.

Real satisfaction in this situation can only come from a willingness to stay hungry. That is, we have to see past the initial impulse to fill a need we think we have. In fact, most impulses that seem to need satisfaction are a mask for something deeper that we really want. Instead of jumping to carry out the impulse, we can pause for a second and try to evaluate the situation objectively. With some practice, we will learn to recognize certain

patterns in our apparent desires—patterns that repeat themselves whether the subject at hand has to do with money (including all forms of power), food (including all forms of survival needs) or sex (including all emotional relationships). For example, a cruel comment we were about to make might actually reflect a desire for our Mommy's undivided attention that goes way, way back. Scoring points in the pecking order right now will never really satisfy that unmet need, and might even make the world a darker place for everyone. Keeping our mouth shut starts to look like a viable option, and in fact it is the more truly clever thing to do.

Once we recognize such patterns, they begin to lose some of their power over us. The more we understand ourselves, the less compulsively we act. In fact, this awareness is the basis for real compassion, because it is only through recognizing our own suffering that we can have any real sympathy for others. Efforts to be "helpful," to "serve" or to "lead" others that lack this foundational awareness are usually just reflections of an unexamined hunger for something else, and while they may in fact do some good in the world (for which we must be grateful), they also tend to be complicated and create unexpected backlash for the players in such symbolic dramas.

What complicates things is denial, the unwillingness to see things as they truly are. Our reluctance to face the truth stems from the painful experience of unfulfilled desires and needs. To revisit the real hunger is to revisit the pain, and on some level we know that nothing in the past can be changed. Rather than embrace the impotence and pain of past suffering, we naturally prefer to conveniently forget it, even to deny its existence. Much of human behavior in the modern world reflects this type of fundamental denial. While there are limits to what therapeutic processes can do for us, there is also real benefit, even power, to be had from looking squarely at our own underworld.

For the creative practitioner, a degree of self-awareness is indispensable. In the arts, a lot of what passes for creative personality is just superfluous drama; it reflects an unmet hunger for something unrecognized. To the extent that dramatic, domineering, flighty, impulsive character traits are identified with creativity itself, people may be reluctant to question

them, and for the dishonest practitioner, this is exactly the point. What better way to mask a fearful hunger than the presumed nobility of creative grandiosity? Anything that questions the fallout of a charismatic artist's crazy-making behavior can be redefined as an insensitive attack on creativity itself. Similarly, a tendency to avoid deep self-examination can be justified as a "creative need" to move quickly onto something else before internal contradictions have time to bubble up to the surface.

By claiming the moral high ground in this way, one establishes a seemingly unassailable roost for an insecure personality, but the end result benefits no one. The artist will not really feel safe for long, and will need to repeat the aggressive pattern again soon to bolster the ephemeral sense of security it engenders. The world outside the artist's skin has been disrupted and cluttered by psychological drama, confused by a false impression of the artist's function and possibly burdened with objects or performances that represent what must be called bad art. These negative impacts could be avoided, and no less art produced, if the artist were willing to question neurotic impulses that are sometimes labeled as "creative."

The same can be said for anyone, as even the solitary monk in a Himalayan cave is involved in a performance that is subject to the same rules of self-honesty. In any field, when we project unacknowledged desires or needs onto our experience, we start to make mistakes—sometimes small, and sometimes catastrophic. We need to be willing to question our own impulses, to ask ourselves what we are really hungry for. And while we may want to avoid the fact, a lot of what we want is really just ego satisfaction. In much of what we do, we have the choice to feed either the ego or something bigger in us we could call the soul.

There is nothing inherently wrong with satisfying the ego itself. Problems arise when this drive is unrecognized, disguised as other things, or projected onto goals that are outside ego's job description. The authentic and necessary function of the ego is to ensure the survival of the organism. In animals, a form of this intelligence is operative relatively constantly, and in the human organism the tendency is to follow the same pattern by default.

In the larger world of consciousness occupied by humans, however, there are lots of situations in which ego is irrelevant. Literal physical survival is not at issue in most of our intimate relationships after early childhood, or in activities like creative practice. Unfortunately, the ego mechanism has no self-regulatory capacity. It has pretty much only one gear in which to operate: full speed ahead. Without intentional effort on our own part, the ego mechanism will implicate itself in everything we do. As a result, otherwise straightforward activities are complicated by paranoid interpretations designed by the ego to justify its own intervention in all aspects of life.

Ego operates in the material realm of physical survival. As a result, it has particular dominance in the world of *things,* with which it tends to identify itself. Our impulses to acquire things, manipulate and control them, ultimately consume them, reflect the priorities of the ego for the most part. In general, we can say that the acquisition of things feeds the ego's momentum, although, as discussed above, it may do nothing to address unrecognized desires that form the basis of specific impulses. When we let these impulses run wild, as our consumer culture encourages us to do, we are reinforcing the imperatives of the ego, as well as bolstering the denial mechanisms that project unexamined needs onto external objects.

The other alternative is to feed the soul. If the impulse of the ego is to identify with and dominate the world of things, the soul is most present in the nonmaterial world. To the extent that we are focused on our experiences, relationships and the inner meanings of elements in our world, we feed the soul—the domain of "Thou" as Martin Buber described it.[2] The soul is the source of our passions, while the ego is the source of desires. When we relate with others deeply, we connect as souls; when we think of or treat people like objects, it becomes a clash of egos. The ego may control knowledge, but the soul is the source of wisdom. The capacity for art and spirituality are therefore born of the soul.

Creative practice operates in an interesting middle ground, in which the wisdom and passion of the soul are brought into physical manifestation,

whether through specific objects or activities of the body. Creative life cultivates food for the soul. This food might incidentally feed the ego in one way or another, but it never lets things end there. The ego is not quite big enough to wrap itself around the fruits of real creative practice. Eventually it gives up, either out of satiation or exhaustion, and the deeper transmission of food to the soul takes place. This is the unstated rationale behind the greatest art and the most powerful spiritual rituals. Such rituals and such art give an identical type of satisfaction, and seem somehow to summarize or complete human experience. They reflect the meaning of being human by addressing our dual nature, and remind us of our unity with a greater reality that operates on this same principle.

The hungers of the soul attract us intuitively to this kind of food. To be called to create such food is an extraordinary blessing, because we get doubly fed in the process. But this kind of feeding is not what we are taught to value in a consumer society.

In the world of ego, we learn that satisfying our desires will bring happiness. In fact, we learn to define happiness, rather unquestioningly, on a linear scale according to the fulfillment of desires. Less money is bad, more money is good. Whoever dies with the most toys wins. In this worldview, hitting the lottery, for example, is one of the best things that can happen, because it implies that we will then have the ability to satisfy our every whim.

But hold on! The facts are not so simple. The many repercussions of such an event, including the impositions of friends and relatives who want a piece of our pie, tend to qualify our happiness in the midst of it. In fact the winners of lotteries are not necessarily so happy, nor are they necessarily smart about how they spend their winnings, which leads to another kind of suffering. Happiness that is based on the fulfillment of desires is also subject to contradiction by the forces that inevitably accompany and interfere with that fulfillment.

In the domain of the soul, the approach is not linear. While there are lesser and greater satisfactions, they are harder to pin down on a neat scale. The right measure of fulfillment is not necessarily "as much as possible,"

and the definitions of terms tend to be more organic. Unlike desire, passion is most enjoyable *before* it is fulfilled, and we lose something, rather than gain, when it is finished. Fulfilling the passions of the soul is in fact more about what we produce or give away than what we consume or collect. The soul's hungers are also sometimes in direct opposition to linear, acquisitive, domineering motivations of the ego. For all these reasons, those who pursue their soul's passions are often perceived as foolish or insane by outside observers whose intuition of the soul remains obstructed. We *seem* to be operating under a different set of rules because in fact we are.

Indeed, the sensitivities of the soul are sometimes best isolated even from the "helpful" interpretations of our fellows. There are certainly valid traditions of creative practice that should be passed between generations, and we can learn much from the experience of others, but such input can never be a substitute for the discoveries we must make on our own. At best, they can validate what we have already experienced or set the stage for our best use of what life throws at us.

The real benefits of mentorship are in establishing a context in which to set our experience of the soul's passions—and in sparing us some of the mistakes that come with "reinventing the wheel." Just so, it behooves anyone in a mentor position to leave much untampered within a protégé. The understanding shared between companions on the path is mostly a recognition of how little one can impose on another's experience, and about having the good sense to shut up when most other people would continue offering advice on how things ought to be.

In short, the creative practitioner's experience of hunger is often quite different from that of the average person, because it comes from a different level of the being. Conventional wisdom operates in the realm of desire. It is like a video game about finding as much happiness as possible by satisfying the greatest number of impulses, while avoiding all the catastrophes. The hunger of the soul operates differently, and may itself look like a major catastrophe from a conventional perspective. The soul is fueled by passion, but strangely, generates even more passion in the

process. And in direct contrast to egoic desires, the soul's passions are best satisfied through what we give of ourselves, rather than what we hoard. Keeping track of the distinctions between desire and hunger eliminates a lot of suffering and confusion in the creative life.

We need to remember that many of our desires actually represent a deeper passion that we might not be acknowledging. Hunger has many levels, and the deeper we look, the more likely we are to find satisfaction. The question is always, *what are we really hungry for?* Ultimately, this is a moral question, because our answers have moral implications. If we unflinchingly pursue the unlimited acquisition of material possessions, sensual pleasures and power as if they were going to satisfy our every need, we injure the world as much as ourselves. The economic and political imbalances of the modern world bear out this scenario clearly, as do the statistics about obesity, heart disease and other maladies in the "developed" countries. A balanced approach to this question does not necessarily require austere renunciation of everything the material world has to offer. It does require a certain self-discipline, which has been defined rather well by a contemporary Sufi as remembering what you really want. The question is whether we acknowledge the imperatives of the soul and not just the ego in our actions. This is what is really meant by the need to stay hungry in any career.

Labels

My aim is to escape from the medium with which I work. To leave no residue of technical mannerism to stand between my expression and the observer. To seek freedom through significant form and design rather than through the diversion of so-called free and accidental brushwork. In short, to dissolve into clear air all impediments that might interrupt the flow of pure enjoyment. Not to exhibit craft but rather to submerge it; and make it rightfully the hand-maiden of beauty, power and emotional content.

—Andrew Wyeth

\mathcal{W}hen artists are working, the impulses we follow are not always neatly defined. Boundaries between art and craft, highbrow and low, purity and compromise are all fluid. For the most part, the boundaries don't even exist during the work. These are things people try to figure out afterwards, in order to talk about what has been accomplished. The need to have something to talk about did not originate with artists, however. In some cases, talking about art is a way of dealing with and integrating the nonverbal impressions it makes upon us; in others, it is a way of muting or deflecting the impact of those same impressions.

The need to apply clear labels to art, and to make such labels stick, is rightly outside the practitioner's concern. To the extent that an artist feels disempowered by a label or lack thereof, he is putting himself *outside the practice* of art. Comparison leads to pain, which is best avoided by focusing on the work at hand. The power that the creative practitioner has is to do the work, and even to empower the audience through the work,

bringing creative stimulation into other people's lives. In some respects, certainty is anathema to creative life.

For example, the difference between "fine art" and "crafts" can be a contentious subject among practitioners in the visual and decorative arts. Although periodically recast as a new and pressing concern, this is a debate that has been ongoing for at least a couple of centuries. Whatever side of the debate one chooses to come down on, the discussion raises some interesting issues for the creative life. As one who works in glass, I can point out some aspects of the way this plays out in my field.

In a lecture given in 2003, the author and glass expert Henry Harlem suggested that the loaded term "artist" might be relinquished by people working with glass as a sculptural medium.[1] Instead, perhaps we should call ourselves simply "object makers" and let someone else decide if we are artists or not. The designation "artist" would probably best be applied by an impartial observer, or by posterity, rather than by the practitioner himself.

This seems like rather a good idea in principle, but not likely to fly in the marketplace because it would confuse our customers too much! Running a glass studio, for example, is an expensive proposition, and you certainly won't find many of us pushing for any diminishment in status that might reduce the market value of the objects we need to sell to pay the rent. Makers of unique glass objects have been working hard to earn the status of "artist" for the last forty years or so, and are not likely to give up the advances made by charismatic individuals or the studio glass movement as a whole. Given that so many customers want to be reassured that the work is worthy of their investment, we are happy to include that reassurance as part of a package deal.

Reassurance has long been part and parcel of art marketing. Dave Hickey observes that the exchange of money is not really about the artist's work at all:

> You are not paying for art. You are paying for assurance, for social confirmation of your investment, and the consequent mitigation of risk. You are paying to be sure, and assurance (or insurance, if

you will) is very expensive, because risk is everything, for every-body, in the domain of art.[2]

Quite often, people like to have risky decisions made for them. The subjective nature of art makes risk itself a malleable commodity. Into such circumstances money, and the concomitant assertion of power, can readi-ly be expected to flow.

It would be interesting to see what might happen if we could really divorce these issues of power from our assessment of quality in the field of art (or craft, or whatever you want to call it). Such an experiment would mean empowering individuals to make their own determinations of qual-ity, rather than relying on institutional consensus. This is what people are reaching for when they assert that art is in the eye of the artist. It is per-haps what the artist Paul Marioni meant when he said,

> I have always felt that you are an artist if your intention is to make art, just like you are a plumber if you install a sink. That is not to say you are a good or even a competent artist or plumber. I dis-agree with the notion that someone else should call you an artist or plumber for verification. They can say you are a lousy artist or naïve but no one else is qualified to tell you what your intention is. I have always said I am an artist. Others can judge my ability.[3]

Such an approach gives everyone the right to mind his own business while taking some of the steam out of the loaded term "artist." It is rigor-ous, yet leaves room for the marketplace. But not everyone will embrace the rigor of this approach. What filters down to the general populace is something vague about doing whatever you want. In a 1991 letter to fel-low poet William Packard, Charles Bukowski lamented the public's appre-ciation for art, which he saw paradoxically as both sloppy and elitist:

> I believe what we have to fear is the feeling of the general public toward poetry and/or art. They have no idea what it is but they

have the thought that anybody can do it if they feel like doing it. They feel that way too—they can do it, after Jill and Bobby finish college and the mortgage is paid. In fact, many of them already label themselves as Artists. "Oh, Bobby paints...Jill writes..." And they even might have little stacks of listless and off-hand work about. They may even have attended classes. They are the piddlers in the field and most of the field are piddlers. These won't lay down any blood to get their work done, they won't gamble with madness, starvation in their need to get the work done. They don't feel it that way. They want fame and name but they won't give up their comforts and their securities. They just claim to be Artists and somehow feel that it will all come together for them. Meanwhile, they might live on hand-outs from relatives instead of having the guts to score for an ugly 8 hour job and try to break the walls from there. The public has this big soft toad concept of Art, they see it as being done by nice scrubbed intelligent pretty folk with French, German or especially English accents. They have no idea that it can be done by a bus driver, a field hand or a fry cook. They have no idea where it comes from. It comes from pain, damnation and impossibility. The blow to the soul of the gut. It comes from getting burned and seared and slugged. It comes from being too alive in the middle of death. It comes from...new and awful places and the same old places...it comes...[4]

Bukowski expresses a democratic ideal of art, in which the practice is available to anyone, but not just anyone will have the intestinal fortitude to do it. Yet, due partly to the intellectual laziness of the public and partly to the ongoing ministrations of the marketing experts, art remains a generally vague symbol for something else. As a result, most people consider art from some version of the wishful thinking position: "I wish I could do it" or "I wish I could afford it." In this situation, both practitioners and appreciators are kept a little bit off balance, never quite resting

in the real experience of art itself. Some commentators and shrewd businesspeople might like things this way, as it places more of the authority about art in their hands.

Most of this process takes place through coincidence rather than conspiracy, although there are plenty of situations in which market values, public opinion and policy can be influenced. From one perspective art and government are strange bedfellows; nonetheless, exchanges of patronage and propaganda of various kinds have always been common. The highest power in any land is often carefully monitored for its leanings regarding the forms and styles of art: what is supported, what is ignored or banned. Those in power bolster their prestige by securing the exclusive services of their domain's best artisans. Artists compete for commissions, grants and prizes that validate their position in the market. Groups or individuals with particular investments may even lobby politically for the benefit of their position. In fact, the encroachment of "crafts" upon the Western fine art world, as mentioned earlier, is not remotely a new development, and it has had ironic twists along the way.

For example, in eighteenth century France, the *Académie Royale de Peinture et Sculpture* was founded in an effort to upgrade the status of what we now think of as the fine arts. This can be viewed in the context of a general movement, during the Renaissance, to recognize the individual artist and to distinguish the "fine arts" from mere artisanry. Previously, painters and sculptors were considered to be in the same class with woodworkers, metalsmiths, potters and other craftsmen. Painting and sculpture were trades like any other, completely without the nimbus of exclusivity they carry in our current society. The efforts of the *Académie* seem to have paid off. In *The Dawn of Bohemianism*, George Levitine describes the *Declaration du Roy Concernment les Arts de Peinture et Sculpture* of 1777:

> This proclamation was meant to erase the last vestiges of the ancient kinship between artists and artisans. It asserted officially that painting and sculpture belong to the liberal arts, that they are noble, and that they should be "perfectly assimilated to letters,

sciences, and other liberal arts." It also stated that painting and sculpture should be totally independent of artisans' organizations, and that they should not be "confused with the mechanical arts."[5]

What could be more reassuring for patrons (ie: investors) than an official proclamation from the ruling power as to the legitimate boundaries between "art" and "craft?" What a boon for the art market! But even an official decree could not put an end to the eternal flux of definitions that have always been fuzzy at best.

The industrial revolution was, quite literally, picking up steam at this time, prompting early stirrings that would lead to the Arts and Crafts movement in England and America. Increasing mechanization and impersonalized factory production of the goods of daily life fostered reactions that favored a return to the values of individual hand craftsmanship. British writers like A.W.N. Pugin (1812-1852), John Ruskin (1819-1900) and William Morris (1834-1896) began raising awareness of the need for well-conceived design in human environments (including workplaces) and imparting a moral, if not spiritual, implication to the work of the individual tradesman's hands.[6] Levitine continues,

> ...after having been confused with artisans for such a long time, the 'true' artists—despite their official 'liberation' in 1777—faced, at the beginning of the nineteenth century, a new form of the same unpleasant problem with artisans actively striving to be recognized as artists.[7]

And so the story goes. Painters, sculptors, curators, collectors and critics who decry the impious influx of "crafts" into the fine art scene in the last forty years can probably relate to this dilemma.

It seems that what matters is the passion and integrity of the creator's own investment in the work, whether it bears the convenient label of "craft" or of "art." At an ecumenical gathering a few years ago, it was agreed among renunciate monks of Buddhist and Christian orders that

they had more in common with *each other* than they did with the lay peo-
ple of their own religion. That is, an average Buddhist townsman would
have less to talk about with a Buddhist monk than would a Christian
monk. The same is probably true among "artists" and "craftspeople": at the
end of the day, we have more in common with each other than we do with
audience members who insist upon dividing things along neat lines.

The value of a label is mostly to people outside the field, that is com-
mentators, marketers and investors. God bless them for creating a situa-
tion that enables (some) practitioners to do their work, but the labels have
only limited relevance to the practitioners themselves while engaged in the
practice. As Ben Shahn put it, "I believe that if it were left to artists to
choose their own labels, most would choose none."[8]

A pure adherence to this position may only be possible when money
(that is, power) is left out of the equation. As long as we have a culture that
does not universally value and celebrate creative work with a willingness to
support such work as a matter of course, money will be an issue. We
should not expect a utopian solution to this situation any time soon.
Instead, each practitioner needs to navigate a course that enables her to
pursue her practice as effectively as she can. For most, this probably means
keeping some kind of day job. Others will have the opportunity to pursue
creative work full-time (or what looks like full-time), generating support
for their work from the practice itself. Either position involves compro-
mise, confounding the rarified intellectual purity of debates about labels.

All the anxiety about whether an object is art or craft—or whether a
person can be called an artist—is something of an artificial overlay, per-
haps an outdated modernist preoccupation in our pluralistic era. The
experience shared by the practitioner and his audience is a personal mys-
tery. The object is an artifact of the experience, which is itself the real
point. For some practitioners, it is the experience of working with a par-
ticular material or the mastery of a form that matters, and for others it is
the intellectual or emotional motivation behind the object that has more
emphasis. Furthermore, there may not even be a fixed demarcation
between these types of experiences and intentions. The audience is along

for the ride. The best economic model to describe the arts may be not that of a marketplace or even a service industry, but that of an amusement park.

The artist at work is not concerned about labels. This quality would have to be part of the label "artist," if we must have one. The artist experiences a mysterious creative power through absorption in his work. Observers experience some part of this power, with pleasure, wonder or even alarm. If we are willing to conspire with the artist, we are refreshed and informed by his efforts, and our understanding of the work grows.

Power and Politics

*The whole problem of educating man to a sane apprecia-
tion of his own importance relative to that of other indi-
viduals is thoroughly muddled by these ethics of fame and
fate, by a morality which perpetuates an educational sys-
tem that is still based upon the classics with their romantic
view of the history of power and their romantic tribal
morality...the importance of the self, of its emotional life
and its "self-expression," is romantically exaggerated; and
with it, the tension between the "personality" and the
group, the collective.[1]*

—Karl Popper

*W*hether one seeks power outright or renounces it as a worldly
distraction, issues of power are always present in creative life.
Many people are motivated to pursue spiritual practices, whether yoga,
shamanism or prayer, for the sake of gaining power. For artists, the power
of impact on an audience and the power to work without compromise are
the Holy Grail of any worldly career.

The power to control one's own body in extraordinary ways (perhaps
to make it immortal, or just to lose weight!) is a compelling attraction to
many would-be yogis and yoginis, as is the accumulation of *siddhis*, or
supernatural abilities. Shamanism, in all parts of the globe, is a technolo-
gy to transform elements of this world through willfully directed spiritual
power. Usually this power is used benignly, for healing purposes, but any-
one who is familiar with the Native American traditions for example, can
attest to the battles for territory and dominance that can rage in the back-
grounds of powwows and other gatherings. And prayer, as it is commonly

practiced, is all about power—the power to get God's attention and direct it to the particular problems that concern the one praying.

The psychology of power is an inescapable aspect of any teacher/student relationship. Students, whether of art or religious practice, often seek the favor of their mentors by mimicking their style, consciously or not. And teachers in both fields who are worth their salt must confront the almost irresistible urge to replicate themselves in their students. Students implicitly borrow the power of their teachers both to advance during their training, and to gain credentials when they go out on their own. Teachers accrue power and ostensible legitimacy by virtue of the number and prowess of their students. These and other elements of power (we haven't even mentioned sexual issues) make for a complex scenario.

Power is also inevitably present where it is not so obvious. In any tradition of great duration or material grandeur, power by association is always somewhere in the consciousness of adherents, whether they acknowledge it or not. As soon as a spiritual teaching develops into a movement or church, power and authority become inescapable issues both within and outside the organization. Who shall be qualified to interpret the teachings? Who shall hold the keys to the treasury? What worldly rulers should be placated, supported or avoided (even undermined) in order to ensure the survival of the organization itself? Things start to become complicated.

Practitioners who are most serious about creative life itself can often be recognized by their disinterest in power plays and the "intrigues of the court." One has quite enough to hold one's attention in sticking to the practice and serving the real needs of one's fellows. Similarly, I would argue, the best artists don't have much time for the ins and outs of political fortune within the art scene. Who has time for jockeying and cat fights when there is creative work to do?

That's in a perfect world, of course, because the inescapable intrusion of money and power into the equations governing the practice of both art and spirituality force everyone to confront power issues on a daily basis. Decisions must be made that have political implications, whether one par-

ticipates in the politics or not, and the tangible consequences of those decisions can have real impact on one's ability to pursue the practice. Nonetheless, one has a choice of whether to focus on the practice itself or the drama that surrounds it. Those who love creative life will not allow their practice to be compromised beyond the actual needs of circumstance.

For those who love power, on the other hand, the games of dominance and jockeying for position take on more priority. The tally of who is where in the pecking order, and what they are able to gain for themselves, their allies or their pet projects, takes on increasing importance the more attention it is given. We often see in organizations, whether spiritual/religious or dedicated to the arts, how obsession with political infighting can grow to dominate daily operations. Procedures that should run smoothly become tangled with hidden agendas and run into obstacles when individuals assert their positions, or attempt to thwart each other's goals because of what they seem to imply.

In spiritual organizations, the result is "churchification," in which the maintenance of the hierarchy itself becomes the subtext of all activities, and the original aim of serving the spiritual needs of members is subsumed by the paranoid drive to manipulate them. In arts organizations—and we might as well mention, in associations founded to foster scientific, athletic, charitable, academic or other pursuits—the result is the same. Instead of supporting the practice that inspired the organization in the first place, the organization can become obsessed with its own survival nearly to the exclusion of real progress in its field.

Members of any group, whether spiritual, artistic or "other," need to be aware of this tendency and stop it in its tracks when they can. Returning one's focus to the actual practice, as performed by individuals and communities, is the key. If that focus can be held by all or most members of a group, then an overall mood of cooperation can be maintained, even when there are disagreements over policy. Remembering the original inspiration, and re-enlivening its shared experience (including the recognition that even our "rivals" are inspired by what inspires us) is essential to the health of any group.

There is little that individual practitioners can do about the way power plays within and without associations, except to remember and demonstrate the original inspiration. In most situations, when life is not at risk, to stridently campaign for one faction or another, or even for reform, is to risk entanglement that detracts from the benefits of the practice (both for oneself and for others). Just as in any ecosystem, there might be short-term benefits, but the unacknowledged long-term costs pile up until a day of reckoning, when the benefits may be overwhelmed. Aside from straightforwardly ethical behavior, the best a practitioner can do is to practice. Practice itself acts like a seed around which clarity and harmony gather, like the chemical elements that form a crystal.

To the degree that one is able to practice even in the face of worldly issues of power, one can exert a beneficial influence that is both subtler and stronger than outward activism, a fact that does not rule out acting on conscience. This is true whether one is practicing art, meditation, politics or medicine. So, while we are often compelled to act in ways that are "political" in one domain or another, we will benefit from remembering that power is secondary. In creative life, good work is its own reward.

From a spiritual perspective, ultimately all power is an illusion. While we may in fact have the power, even the obligation, to vote in an election, support social justice or defend the safety of our friends and family, we cheat ourselves if we place ultimate faith in our material impact on the world. To be "in the world and not of it" as Christ recommended, is to do what is right, but to remain detached from that action. Similarly, it is understood in Hinduism that attachment to the fruits of our action binds us in a never-ending cycle of reaction. This is why, in the *Bhagavad Gita*, Krishna urges the warrior Arjuna to embrace his duty and his destiny while holding his attention on the Divine. "Remember Me and fight," is his summary advice.[2]

Idealistic? Certainly. Will we always be able to avoid compromise in the real world? Hardly. But the difficulty of pursuing the ideal is no reason to abandon it. If our attitude is that the ideal exists and is worth striving toward, our choices and our action push things in that direction. If we

choose the easier, more cynical and dogmatic attitude—*I'll have to com-
promise anyway, so why bother?*—then we support a more general move-
ment in that direction. Moral and aesthetic decay is the result of such an
attitude. The *perfect* can be the enemy of the *possible*.

Compromise, when inescapable, is not necessarily a sign of failure.
Consensus may in fact be a more advanced governing system than major-
ity rule, although it is slower. Moving forward, even to a small degree, in
the support and creation of beauty, compassion and inspiration is always
worthwhile. We do have the ability to make small improvements through
our struggle, and so we persist. To paraphrase Gandhi, whatever we are able
to do will probably be insignificant, but it is very important that we do it.

Creative life has always been a difficult choice on at least one level.
There are many practical, rational reasons that no sane person would
choose such a life! Castaneda is correct to point out that on some level we
must be tricked into it. Given the nature of this life, which is somewhat
impractical, we can empower ourselves or we can erode our own founda-
tion. Certainly there are practical needs to be attended to and we have
responsibilities we cannot abandon. But also, remember that the imprac-
ticality of this life, the impulse to pursue what is impossible to the ordi-
nary eye, to accomplish what is amazing and inspiring, is what makes it
worthwhile, both to ourselves and others.

The impracticality of this life is its strength, not its weakness.
Therefore we can embrace a bit of madness in our pursuit of excellence.
Part of that madness is to do the right thing even when it makes us look
naïve or—heaven forbid!—slightly reduces the value of our stock.

Real Power

The power to do the right thing is always within our grasp. Often we
are seduced away from that responsibility by the possibility of some (seem-
ingly) greater power. Money is the most common seduction, but there are
down to earth situations, having nothing to do with money, in which we
can empower the excellence that inspires our path.

Elegance is an important intersection between inspiration and practicality, a balance point from which simple actions can have powerful effects. In social interaction, simply refraining from gossip, for example, can be a powerful act that benefits ourselves and others, but in the midst of conversation there may seem to be more "juice" in joining the fray. The coziness of shared opinions and knowing glances exerts a powerful pull. How we respond can either exercise our spiritual power (in fact making it stronger by degrees) or deplete it (as we cave in to external temptations).

This is not a moralistic judgment, but a simple metaphysical (even physiological) truth. We can recognize when we have made a mistake by a decrease in our energy level after the fact. The more we can appreciate the real nature of power, the more likely we are to use it in ways that benefit ourselves and others. And it is well to remember that power can just as often come from what we choose *not* to do as from intentional action. By choosing not to participate in dramas that sap our energy (whether in our group or in our own head) we store and extend power of a more refined type.

Such refined energy is of great value in our practice. If we want a practical reference point we need only think of Gandhi's *satyagraha* movement in colonial India, which derived its power from intentional nonparticipation in the expectations of the occupying British. It was the impeccable moral commitment to what is right, the willingness to accept the consequences of one's actions and the absence of violence that gave the movement its appeal and overwhelming force.

A realistic effort to avoid the traps of political fascination begins, like most things, with self-observation. We can recognize our own participation in political games by the degree to which we feel personal insult when power bends in a direction we would not prefer. As we've previously noted, Castaneda says that all of our suffering and spiritual difficulties devolve from the core decision of *self-importance*. The entanglement of political jockeying bears out his point well. If we are honest with ourselves, entanglement begins when we take things personally, or when we indulge an attitude that says "it's all about me." This is equally true in career decisions

and personal relationships. The way to prevent entanglement, or to disentangle ourselves then, is to recognize how we have become enmeshed by making a personal investment.

We have all had the experience of watching a piece of artwork evolve way beyond our initial concept. This process is a good metaphor for overcoming the obstructive fascination with power politics. The most practical way to surrender personal investment is to cultivate an objective view of what is good for the greater whole. We might have our reasons for wanting things done a certain way, but that method may have side effects on other aspects of an organization, for instance, that end up costing more in time, money or other resources. It is not really that different from working on a piece of art: every choice we make has an impact on the whole, and if we are too attached to one blue brushstroke we did at the beginning, the success of the whole work may be compromised. It is not personal.

We have to be willing to reevaluate everything we do at any time, and if the real direction of the piece takes us to a place where the blue brushstroke no longer works, it should go. Professionalism as an artist dictates that we just paint over that stroke and go on, even though we were so pleased with ourselves when we made it. Otherwise, the whole canvas may end up as a waste. This is not to say that one must always overpaint the blue brushstroke, or that one should never overpaint it. Either approach can be a valid way of working; the problem arises when we obstruct the natural flow of a piece, whether it means making a change or calling it finished. Picasso gave the following description of his experience:

> To me every painting is a study. Many times I say to myself: one day I will finish it; I will bring it to an end. When I try to finish it, another painting emerges and then I think: I will try once more. At the end, a new painting was created. When I add the finishing touch to it, I create a totally new painting.[3]

In the same way, our personal investment in one way of doing things can be a dead weight that compromises the success of any venture we are

involved in. If we can muster the maturity to surrender that blue brush-stroke, or conversely, to know when to quit before we go too far and ruin a piece, then we already know how to pursue surrender as a greater context for our life. Engaging that pursuit is just the next step.

Surrendering our personal investment frees creative life from the complexities of political fascination. This surrender is itself a power we must exercise through repeated use, and it becomes stronger and more supportive of our practice as we persist in its application. Or it could be that real surrender is a gift that comes to us from above somehow, which we attract or earn by applying ourselves as best we can.

Regardless of where surrender comes from, we have a choice of whether to support it or undermine it in our own case. Every decision or act that undermines a context of surrender boils down to putting ourselves first, to focusing on the apparent importance of our "self."

The image of the artist as egomaniac is a twisted version of a true practitioner. To one who is inspired, it is true that practical matters, including the feelings and preferences of others, often take on a diminished importance. But this is not the same as egomania. Rather it is a (momentary) loss of self-reference that leads the artist to suddenly change plans worked out in advance with colleagues or assistants, or to break appointments that might disrupt the flow of work. It is not that the self becomes more important than other people; something bigger (the work) supercedes everything else, including people, including oneself.

Having noted this, we have to admit that a fair portion of what passes for the passion of inspiration is in fact egomania. It would seem that artists do not generally receive training in the difference, which is unfortunate. In *The Artist's Way*, Julia Cameron discusses the idea of artists as crazy-makers. A subtle motivation to make other people look bad in order to bolster oneself, or to use power whimsically for the sake of ego gratification does plague many creative people—and especially those who have to deal with them on a daily basis.[4] But the dramatic psychological payoff associated with egomania, including "crazy making," is a poor substitute for the juice we get from diffusing ego instead.

The support and cultivation of surrender is directly useful in our pursuit of an artistic experience that transcends the self for ourselves and our audience. Therefore it is contradictory, if not foolish, to scheme for dominance in the "management" of our career while pursuing surrender in our creative work. Somehow we have to reconcile the artistic impulse with the rest of our conduct. And yes, somehow we must keep our head above water financially while cultivating the largest perspective we can.

Vision

*It is understood that Japanese gods do not appreciate true
things; they do not accept things that are not fabricated by
means of a device (shuko). One must add something to that
which already exists in order to present it to gods or to show
it in public. The art of flower arrangement (ikebana) orig-
inated in the tradition of furyu and was meant to astonish
gods with its ingenuity. It is the adding of something dif-
ferent—an act of eccentricity.[1]*

—Masao Yamaguchi

*D*oes anyone remember Harry Chapin? He had a couple of big
hit songs in the seventies—"Cat's in the Cradle" and "Taxi"—
but was largely unrecognized by the popular music establishment of his
time. Before and after his national prominence, he had a faithful regional
following on the East Coast, and was known to give as many as 200 per-
formances a year, including a taxing schedule of benefit gigs. He has been
called the last of the great troubadours, a musician who wrote and sang
about daily life with a passionate, down-to-earth, idiosyncratic style that
reminded people of their own humanity. He was also a tireless activist. He
kept relatively little of his wealth for himself, using it instead to found
social organizations, including World Hunger Year. He died in a car
accident in 1981, at the age of thirty-eight, on his way to a benefit
performance.[2]

Harry Chapin wrote lots of songs about odd people, struggling peo-
ple, down-and-out people holding on to a passion for life. In this context,

one of his songs always irritated me as a young man. "Dreams Go By" is about the way that fantasies come and go in an ordinary person's life. At first, the boy and girl want to grow up to be one thing, later their image of the good life is something else, later still, something completely different; but at each stage, life itself gets pleasantly in the way. College, marriage, career, kids, grandchildren. At the end, in old age, the singer looks back—rather contentedly despite the passed over aspirations—and says, rather wistfully, that dreams are for the young.

I was always annoyed at Harry for writing this song, which seemed to support the unexamined life. Indeed, one of the life dreams that gets brushed off in the second verse is to be an artist! But the stability of any society probably depends on most people adhering to this pattern. Dreams are interesting but impractical, and any efforts toward a better life or way of doing things are best kept relatively modest. Improve your wealth, comfort or prestige; don't question the nature of these goals themselves. Incremental change is fine, as are reasonable suggestions, reasonably proposed. Life-changing inspirations that do not revolve around guaranteed domestic order or improved productivity on the job should be left to "other people"—people whom we appreciate somehow for their "genius," but whose lives have little to do with ours.

The business of civilization is stability, and while some evolution now and then is refreshing, the status quo generally takes precedence over inspiration. Too much excitement of the dreamy sort, beyond a certain age, is even suspect. Everywhere the message is to relax, not be so intense about changing the world; enjoy the good things of life as you get older and remember that dreams, being inherently impractical, are for the young.

Radical creative passion, or the impulse to effect some change in one's environment, is too costly, in time, energy and social standing for most of us to pursue. Who will take care of the kids, pay the bills? When do we get to have our vacation in the Bahamas? These tangible questions carry the weight of daily reality more convincingly than a dream, even one that may have haunted the dreamer since childhood. And so the fantasy takes a back seat, time and again.

But for some, the dreams do not come and go so easily. The character—either of the dream or the dreamer—has a compulsive quality. Normal priorities are reversed, corresponding to a perceptual framework that most people would find odd or disconcerting. For compulsive dreamers, it may be instead the comforting relationship or the promising career that gets the axe when push comes to shove. The dream, or perhaps it is a calling, is what stays. It is the priority that overrides the other pleasures of life, lending a hollowness to any course that denies the vision.

Dreamers

Most people do not dream particularly well. Their expressed aspirations fit into received categories of dramatic ego gratification: victorious athlete, astronaut, wealthy princess, rock star, acclaimed artist, famous scientist, military hero, power broker. Perhaps it is that children innocently squeeze their dreams to fit into these neat little boxes they have heard about in their limited experience or seen on TV. When their cognitive faculties mature enough to see the pettiness of the little box, they assume, as they are taught to, that it is the dream that is petty, somehow beneath their level of development, their more mature perspective. Socialization might even be understood as the process of leading children through a series of these boxes or cocoons that define their hoped-for self, just as Hansel and Gretel followed a trail of cookie crumbs to the door of a hungry witch.

For a time, it seems good enough to upgrade the dream into a better box, one that seems more realistic or mature. But eventually even this ploy falls short in the face of student loan payments, biological clocks or other adult issues. The dream, having always been an ethereal thing, is written off, grudgingly at first, as an artifact of childhood. It is something that would have been nice if it were possible, but after all it was only a dream.

Yet there may be a different experience for young people who learn (or who are allowed) to dream well. Such children are more matter-of-fact about their dreaming, taking it in stride as something normal, not a faraway bauble burdened with the emotional charge of salvation. Their

dreams never quite conform to the boxes in which other children seem so enthusiastically comfortable.

For some strange reason—call it a blessing or call it a curse—these children perceive, however faintly, that it is the box, not the dream, that fails to fit. Lacking the experience or information to find the right description in which to clothe their dream, they may try to settle on a conceptual image they have heard about, hoping perhaps to "grow" into it. The observation that they may be the only one in their environment chafing in their compartment is subtly disquieting. The telling difference between such children and their social matrix takes on greater meaning for them as they grow older.

At first the persistent dreamers may try to ignore or deny the inadequacy of the conceptual box. Striving to convince themselves that they are satisfied, they follow, perhaps rather well, the outward patterns of acceptable behavior. Nonetheless, there is always a subtle gap that never really escapes their awareness. We could call this the gap between inner and outer experience: the disconnect between what appears to be the case, and what one intuitively perceives. Strangely, the lack of validation for their intuition does not diminish its imposition on awareness. And if they have truly learned to dream well, they will be compelled to listen to that muted but insistent inner voice.

A specific awareness of the inadequacy of the conventional dream, which seems to lack intuition altogether, dawns on effective dreamers over time, and reaches a crescendo in adolescence, at about the same time as their desire to fit into a social context also reaches its peak. The conflict between the desire to fit in, on one hand, and the revulsion at doing so on the other, spells the end for many would-be visionaries. Some percentage of teenage suicides is from this group, but in most cases, it is the inclination toward intuition that dies, as society recommends.

More rarely, one may go on living with the conflict intact, like a burning coal in one's throat. Such a contained irritation can only be distracting, to a greater or lesser degree. And, to a greater or lesser degree, the distracted individual will fail to meet the obligations of a normal person in

society. In mild or well-managed cases, these individuals are regarded as quirky but interesting; their lack of enthusiasm for convention and their slightly twisted or novel point of view may even make them rather popular in "cutting edge" segments of society, where they may be regarded as a genius (especially if their talents also make money for their handlers).

But we don't envy them, really. We find it amusing, even reassuring, that for all their supposed genius, such people often fail to meet the most basic standards of decorum or professionalism that we embody on a daily basis, and which we recognize as essential to the real progress of society. We want very much to hear how their life doesn't work so well, how they have failed to grow up somehow, or made unprofessional blunders in their career. The savvy but sometimes malicious part of us that enjoys films by Christopher Guest (*Waiting for Guffman, Best in Show, A Mighty Wind*) wants to make everyone into wannabes of some sort, including people of real vision. It is somehow right that they should come to grief eventually. This reassurance is of course both the source and the goal of the status quo.

Marshall McLuhan makes a telling distinction between the innocent approach of the "amateur" and what he calls the "environmental" context of the professional. Citing the example of Michael Faraday, whose discoveries about electromagnetism revolutionized the physics of his day, he uses the term "environmental" to refer to that which pervades and sustains the conventional order:

> It is generally acknowledged that Faraday's ignorance of mathematics contributed to his inspiration, that it compelled him to develop a simple, nonmathematical concept when he looked for an explanation of his electrical and magnetic phenomena. Faraday had two qualities that more than made up for his lack of education: fantastic intuition and independence and originality of mind.
>
> Professionalism is environmental. Amateurism is anti-environmental. Professionalism merges the individual into patterns of

total environment. Amateurism seeks the development of the total awareness of the individual and the critical awareness of the groundrules of society. The amateur can afford to lose. The professional tends to classify and to specialize, to accept uncritically the groundrules of the environment. The groundrules serve as a pervasive environment of which he is contentedly…unaware. The 'expert' is the man who stays put.[3]

Artists, then—and mystics—are committed amateurs. Their practical life is at best a major hobby, which is what led Picasso to say that artists must learn to work with the seriousness of a child at play. A child's seriousness is undistracted spontaneity. Things are never really quite settled, and this changeability undermines reliable "professionalism" as adults understand the term. The presence of amateurs in a serious professional environment is at least a little problematic; they are distracted and distracting. Often, the experts disapprove.

Society tolerates and even uses the contributions of such people as long as the benefits are tangible, but really only applauds them after they are safely dead. While Harry Chapin's efforts at enlisting popular musicians in the fight against hunger met with persistent frustration during his life, for example, he was awarded a Congressional Gold Medal six years after his death.

Fortunately, visionaries are not in it for the respect, just as they are not in it for the money. Their investment cannot be traded in the stock market, and low quarterly earnings do not concern them; their profit is measured in a different coin and on a longer time line. Sometimes it is even hard to believe that an intelligent speaker puts much practical stock in her visionary assertions, as when the artist Meret Oppenheim declared in Zurich, in 1983,

When nature has stopped being treated as the enemy of man, when the battle of the sexes has become an unknown, when the so-called feminine traits that men share in full measure—feelings,

moods, intuition—have been fully exploited, when the significance of woman's contribution to the preservation and development of human society has been recognised, when comfort is no longer mistaken for culture, when beauty has become a need again—then, at last, poetry and art will automatically come into their own again, even if the veil of longing always lies upon them like an eternal promise.[4]

Was this lady dreaming, or *what*?! In more than twenty years there has been little sign of progress on this particular front. But the vision Oppenheim offers is not a practical prediction like one might seek in Nostradamus or *The Weekly World News*; rather, it is a statement of a tangible possibility. She describes not a future event, but an opportunity present within any of us here and now. Her poetic description is just one particular, verbal iteration of a map of potential to which all humans have access at any time, if we muster the courage and intention. This potential is no more or less real than it ever has been. What makes it real or timely is how we express it, and this is the same with any work of art.

It is possibility that visionaries serve, and while the particular possibilities they point to may never manifest in the foreseeable future, they might

The poet, the artist, the sleuth—whoever sharpens our perception tends to be antisocial; rarely "well-adjusted," he cannot go along with currents and trends. A strange bond often exists among antisocial types in their power to see environments as they really are. This need to interface, to confront environments with a certain antisocial power, is manifest in the famous story, "The Emperor's New Clothes."[5]

—Marshall McLuhan and Quentin Fiore

well ignite a resonant spark in their audience here and now, which itself makes the vision a reality. Visions are not a description of the future (despite their wording) so much as they are a definition of present potential. They are not necessarily meant to be practical.

Madness and Joy

Sometimes, the impracticality, unprofitability or impossibility of a vision may even be its appeal. As in the traditional Persian tale "Layla and Majnun," the longing for and pursuit of what one loves is its own reward. Unlike a professional goal, eventual fulfillment of that longing can in fact be anathema—not only because one has idealized the attainment in mind, but because it is the longing itself that is so sweet.

On this subject of unfulfilled or unfulfillable desire, artists and mystics speak in similar poetic terms. In the Western legend of the quest for the Holy Grail, dreamy Parsifal's glimpse of the Grail Castle inspires and defines his search long before he has any realistic hope of approaching the goal. The chivalric tradition of the knight's quest revolves around the superhuman challenges that must be surmounted to achieve a goal that may not be any good to the knight himself. Even as a shadow of itself, chivalry carries an air of magical dignity that stirs the imagination. The charm of don Quixote, for example, comes from his anachronistic commitment to an impossible, noble ideal for its own sake.

The mystical Beloved of the Sufis, to give another example, is a fleetingly glimpsed inspiration, forever remembered and irresistibly sought for. The metaphorical Tavern of Ruin is a place where lovers gather to share their yearning for that Beloved, to exchange the tales of their sightings, and most of all to become intoxicated by the longing itself, waiting and hoping somehow that the Beloved will walk through the door. Such hopeless lovers, captivated by the mystic vision of the Beloved, are in effect ruined to worldly life. While they may play out the role of an ordinary, even successful citizen, their inner life has been ravished, leaving them with an insurmountable obsession.

Poets of the mystical Islamic tradition, of whom Rumi is the best known in the West, have held open the door to this Tavern for centuries, and it is not difficult to find similar way-showers among other traditions around the world. Like a kind of mystical *Fight Club*, they are a conspiracy of obsession, ultimately subversive and "amateurish," whose members are marked (by their scruffiness and scars) as not quite fitting into the "professional" world. Nothing outside of their obsession holds any satisfaction, which is of course a kind of madness as far as conventional society is concerned. Unfortunately, therapy may not be effective.

While artists serve an indispensable role to society in the long term, this is often lost on the practical observer. Lasting value is born of a long-suffering yearning for excellence. Paradoxically, the impractical nature of many artists is born of a highly pragmatic, altruistic commitment to a goal forever out of reach. Quirky personality traits may reflect frustration with, or an ironically humorous acceptance of, the impossibility of achieving this end. The Russian painter Kasimir Malevich lamented in 1927,

> The public is still, indeed, as much convinced as ever that the artist creates superfluous, impractical things. It never considers that these superfluous things endure and retain their vitality for thousands of years, whereas necessary, practical things survive only briefly.[6]

Sculptor David Smith spoke more pragmatically, but with a similar spirit when he said, "The promise, the hint of new vista, the unresolved, the misty dream, the artist should love even more than the resolved, for here is the fluid force, the promise and the search."[7] And the author, C.S. Lewis, gave an apt description of the paradoxical motivation engendered by a vision in his book *Surprised by Joy*. Speaking of his own formative experiences, and defining the quality of his inspiration, he said,

...it is that of an unsatisfied desire which is itself more desirable than any other satisfaction. I call it Joy, which is here a technical term, and must be sharply distinguished from both Happiness and from Pleasure. Joy (in my sense) has indeed one characteristic, and one only, in common with them: the fact that anyone who has experienced it will want it again. Apart from that, and considered only in its quality, it might almost equally well be called a particular kind of unhappiness or grief. But then it is a kind we want. I doubt whether anyone who has tasted it would ever, if both were in his power, exchange it for all the pleasures in the world.[8]

Lewis is not alone in this experience, although others have used different language to try to pin down the essence of their calling. The nineteenth-century Romantic painter, Eugene Delacroix, for example, described the futile grappling with his muse in suitably Romantic terms:

There is an old leaven, a black depth that demands satisfaction. If I am not writhing like a snake in the hands of Pythoness I am nothing.[9]

The motivation by joy, as Lewis defines it, confirms society's assignment of amateur status to the visionary. In extreme cases, the visionary goes beyond amateurism and enters the domain of bad taste. If the distracted individual is more absorbed in his vision than normal life allows, society finds it downright annoying. Such an individual's attention is inverted so that the "distraction" takes on the greater reality, while the "reality" of daily life is regarded as distracting. Then ordinary life is perceived as irritating, out of place, and the visionary may naturally shy away from the irritation. But success in escaping the irritation comes at a great price. The regular life of a human being is abandoned, and a kind

of madness ensues. For some, this madness itself is a rewarding experience, the fulfillment of the inescapable dream.

There is of course a tradition of madness among saints all over the world, as well as among artists. June McDaniel examined traditions of religious ecstasy in India. She observed that,

> Mad ecstatics tend to act in certain patterns. Sometimes the person is a trickster who does foolish or outrageous things, smiling mischievously, or he may be a hermit who stays alone in meditation, threatening visitors and potential disciples with magical vengeance or showers of rocks. He may be a lover in separation, crying, burning, and hallucinating, or a lover in union, dancing and singing in the beloved's presence. Indeed, across the various bhakti [devotional] traditions, ecstatics tended to act more like each other than like members of differing belief systems.[10]

Yogi Ramsuratkumar of Tiruvannamalai was a recent example of this long-standing tradition in Indian Hinduism. Dwelling in a state of "God intoxication," he frequently referred to himself as a "mad beggar," even after his devotees (who numbered in the thousands) began to build a comfortable ashram for him, and his material needs were carefully attended to. In the case of Yogi Ramsuratkumar and other mystics, both "madness" and "beggary" can be understood as outer world correlates for an inner state of absorption and inspired desolation, an inversion of priorities in which the sanity of the ordinary man is repugnant, and the impulse to tend to one's personal survival has become irrelevant. The ordinary self has been completely overwhelmed in a flood of rapture.[11]

Rage

Short of madness, there is the more common and unenviable position of living with the irritation while holding fast to a compelling vision. One embraces life in an almost normal way, containing the irritating distraction

it represents within a biography that is defined by the vision's parameters. Such a life, if successful, is best compared to the humble drama of the bottom-dwelling oyster, whose nature it is to craft a pearl as a healing defense against an irritation it cannot escape. The situation is like this for few people, and for these rare individuals there is little validation to be found in the company of normal society, which wants pearls but cares little what the oyster has to endure to produce one.

The internal conditions endured by the painter Paul Cézanne are not entirely uncommon among artists generally:

> Sensitive Cézanne could not suffer anyone standing behind him to watch him at his work. The noise of the workshop or the barking of a dog was disturbing to him. Often he became furious and used the palette knife to tear apart even his finished pictures. He was very critical of his own work. Between 1880 and 1906, Cézanne painted some 1,300 pictures, many failures in his own eyes. Cézanne was meticulous about details in the execution of a work. For example, for the portrait of the art critic Gustave Geffroy, he needed 80 sittings, and for Ambroise Vollard, 115, and at the end, he abandoned the projects![12]

Not all artists are so touchy, picky and eccentric. Indeed, some people would prefer to dismiss such examples as promoting an unfair and counterproductive stereotype. But when the shoe fits, the artist's volatility just might be more than a quirky personality trait. In a description that seems to harken back to Delacroix, Henry Miller describes the confusing mix of inspiration and frustration, creation and destruction, horror and bliss that artists confront when they are doing their job as Miller thinks they should:

> Side by side with the human race there runs another race of beings, the inhuman ones. The race of artists that, goaded by unknown impulses, take the lifeless mass of humanity, and by the fever and ferment with which they imbue it turn this soggy dough

into bread, and the bread into wine and the wine into song. Out of the dead compost and the inert slag they breed a song that contaminates. I see this other race of individuals ransacking the universe, turning everything upside-down, their feet always moving in blood and tears, their hands always empty, always clutching and grasping for the beyond. For the God out of reach. Slaying everything within reach in order to quiet the monster that gnaws at their vitals. I see that when they tear their hair with the effort to comprehend, to seize this forever unattainable, I see that when they bellow like the crazed beasts and rip and gore I see that **this is right.** That there is no other path to pursue. A man who belongs to this race must stand up on the high place, with gibberish in his mouth and rip out his entrails. It is right and just because he must... And anything that falls short of this frightening spectacle, anything less shuddering, less terrifying, less mad, less intoxicated, less contaminating is not ART. The rest is counterfeit. The rest is human. The rest belongs to life and lifelessness.[13]

To the extent that an artist fits this rigorous job description, he or she must live with a contradiction: the very difference which has always made it impossible to "fit in" with the company of normal people is in fact the value that the artist can contribute to his or her social matrix. The value is real, and born of no small sacrifice on the artist's part. Nonetheless, that value does nothing to bring the artist herself into the comforting fold of her fellows. Paradoxically, the artist (like the tribal shaman) can only justify living among people by remaining isolated on some level, in a radically different world. Like the shaman, the artist's visionary capacity is valued by society but comes at a price. And that price is not paid by the society that benefits; rather it is the artist or shaman who pays.

While the image of the bipolar, hypersensitive, hyperactive artist is a cliché that fails to describe all practitioners, there is truth to the spirit of Miller's poetic summary. The best creative work requires a pitch of resonance that is hard to maintain, and a degree of irrational obsession is part

of the artist's calling. Interruptions and frustrations can easily occur in combinations that overwhelm the artist's coping ability, and if he lacks skills, perspective or a workable support structure, the whole world may seem to be falling in upon him. Suicide has always been an occupational hazard for visionaries, just as public reactivity and political condemnation can lead to their destruction by others.

Jules Pascin (1885-1930), for instance, committed suicide in Paris on the day his exhibition opened; A.J. Gros (1771-1835) drowned himself in the Seine because his *Hercule et Diomede* was not accepted with great enthusiasm by the Salon. Robert Lefevre (1755-1830) committed suicide following a nervous breakdown; he had lost his official title—First Painter of the King—in the Revolution of 1830. Leopold Robert (1794-1835) took his own life in Venice, and Richard Gerstl (1883-1908), an Austrian painter (*The Sisters*, 1907), committed suicide in his studio after he burned his works. Picasso's *Still Life with Death's Head* (1908) may have been painted in memory of a German artist, his friend Wiegels, who had hanged himself in his studio in Bateau Lavoir. On June 15, 1938, Ernst Ludwig Kirchner killed himself because of Nazi persecution. Michel Hadad (1943-1977) took his own life in Paris, as did Mark Rothko in New York in 1970.[14]

— Moshe Carmilly-Weinberger

Inspiration is therefore frequently experienced not as a blessing, but as a curse. This is no less true when one finds the inspiration compelling and inescapable. Under these conditions, even altruism can be excruciating. Vincent Van Gogh described his experience this way:

...my only anxiety is, how can I be of use in the world? Can't I serve some purpose and be of any good?

And then one feels an emptiness where there might be friendship and strong and serious affections, and one feels a terrible discouragement gnawing at one's very moral energy, and fate seems to put a barrier to the instincts of affection, and a choking flood of disgust envelopes one. And one exclaims, "How long, my God!"[15]

Many artists—even those less famously disturbed than Van Gogh—find it hard enough to cope with life that they call it quits, resolving their conflicts either by abandoning art or cutting short their own life. Indeed, most visionaries are familiar with the experience of committing "social suicide" from childhood onward. When any road they travel comes to a perceivable fork, the path "less traveled by" will likely be what calls to them. Otherwise they would have no occasion to notice the fork in the first place. How wonderful it would be to enjoy the companionship and easy laughter of the well-beaten path, to simply not notice the fork in the road! But that way is not available, really.

While it is a bit too convenient to attribute Van Gogh's unhappy end to psychological complications alone—his obsession and discomfort were part and parcel of what made his contribution possible—one cannot help but wonder how things might have gone with the benefit of a support system more comprehensive than his brother Theo, a few prostitutes, and the irascible Gauguin. Could someone have stopped him from compulsively sucking on his lead-, cadmium- and mercury-bearing paintbrushes? Could meditation have broken the momentum of his downward emotional spiral? Had some damping force been present to mitigate his mood, might we have gotten more than eight years of enigmatic paintings from this dedicated, lonely and well-intentioned man? But such speculations say more about our desire to make sense of things than they do about the nature of Van Gogh's spirit and his calling. It is quite possible he would have had it no other way.

Even with full awareness that another choice would lead fairly predictably to comfort, practitioners go the way that matches their calling. To see the fork in the road, however, is to lose the bliss of ignorance. Artists' experience of their own condition range from a twinge of melancholy to complete devastation. Edvard Munch's famous painting, *The Scream*, depicts the artist's enervating vision one night of "the great, unending scream through nature." In fact, it would appear that his entire life was a testament to this shattering vision:

> Edvard Munch (1863-1944), the Norwegian painter, was in many ways like Vincent Van Gogh. He knew no peace of mind and had a great fear of death and a persecution phobia. Sickness occupied him his entire life. The main themes of his paintings were the hardship of life, bitter fate, sexual fears, and the dissonances in society. He communicated little with people and built a wall between himself and others. He also suffered from fear of destruction. "For as long as I can remember I have suffered from a deep feeling of anxiety which I have tried to express in my art. Without anxiety and illness I should have been like a ship without a rudder," he wrote.[16]

As far as the practice itself is concerned (whether the field is art, science, politics or some other) the choices that a visionary seems to make are often not choices at all, but the result of a predilection over which he has little control—except through denial, which leads to an unacceptable level of anguish. In fact, the insensitive presumption by some spectators, for example, that an artist makes whimsical choices as a matter of convenience under conditions of low stress is, for many practitioners, irritatingly off the mark.

To express a vision subjects it to the noise and static intrinsic to the means of transmission—whether in art, politics or science. Beyond expressing a vision, one must give it a home—in an object, a movement or a meme. Sometimes, the clarity of expression seems to diminish the

more tangible the expression becomes, and the more it is taken in by others, the more it is misunderstood. Nothing works perfectly, but that little detail is not usually included when the vision comes through, which means that visions are inherently unrealistic even as they are compelling. Frustration is therefore built into most visions, and the bigger the vision, the more likely it is to be compromised out of necessity by the time it reaches the ground.

The visionary is locked in a confrontation with compromise. Many artists experience life as a daily battle in which victory is always provisional and often unrewarded. The patient, savvy practitioner can generally find a way to service emotional and material needs while keeping true to her calling, but compromise and dumb luck always fit somewhere into the equation, and you know that's gotta hurt.

Some artists show a tendency to become dismayed, even enraged, at gestures that they construe as dismissive or intrusive to their creative work. To the extent that an artist does his job well, he may feel that he embraces a sort of maddening insult for the reasons here described. The more sensitive the artist, the more keenly this insult is felt. It should not be surprising if, at times, an artist cannot help but resent further insult at the hands of less sensitive souls who do not share the same vision: Does a tenured critic misunderstand the intention of a work? He is despicable and traitorous! Does a comfortable gallery owner decry the artist's lack of reliability (perhaps while neglecting to pay said artist for work sold on consignment)? She is a soulless parasite! Does a collector express a wish that the painting were more compatible with the living room couch, or interrupt the artist at the studio in hopes of procuring a deep discount? He is…Well, let's not go there.

It *is* possible to get too excited over all this. A vision is compelling enough on its own; it does not need us to get worked into a lather, as if a frantic attitude was our way of helping things along. Further, the romantic image of the tormented artist may fit nicely into a psychological drama one is disposed to enact in any case, with or without any vision at all. It is possible to animate the symptoms of a visionary inspiration independently

of the compulsion a vision engenders. A person may do this to get attention, to feel powerful, or to bolster a personality that is weak or disturbed. Whether disturbed or not, a bit of perspective, even of humor about oneself, is therefore useful to the visionary character.

The insensitive appreciator of the arts does not mean anything personally when he fails to notice the artist's dilemma, and the artist would do well not to take it personally in turn. While the visionary's experience feels personal to herself, the inspiration and its concomitant difficulties are part of a larger, impersonal process of which she is the servant. The visionary's calling and joy is to serve that evolutionary process—call it God or progress or creative energy. The capacity to follow a vision, to serve it truly, comes from the vision itself. It is a mistake to think that we are somehow the source of the vision, that we are the one responsible for its very existence. If we take our role in the vision too personally, too seriously, we begin to make even more mistakes.

The Truth Hurts

In the West, we often think of visions in superlative terms, and perhaps this essay has not helped readers in the matter. We consider "visions" to be higher than ordinary seeing, purer than ordinary reasoning, more holy, moral or ethical than the average bear, undistracted and uncontaminated. But there is a danger to such thinking. The "purity" of a vision, which may be part of its attraction, carries stagnation in seed form. Sometimes, the more one pursues an absolute, the more one becomes boxed in by the definitions implicit in the search. As Prometheus was bound, and as Moses was kept from the Promised Land, visionaries are sometimes unable to find any sweetness in pursuing their vision, especially in success.

In fact, receptivity is part of the responsibility a bearer holds for his or her vision. That receptivity needs to be ongoing. A domineering relationship to the vision, or to life itself in the name of the vision, actually obstructs its manifestation. A vision, properly received, is a living thing,

part of life; a vision is not an escape from relatedness, even if it makes social life difficult. Furthermore, it is a direction, a purpose—not necessarily a tangible goal.

If a vision is held as an icon that is meant to be pure, universal or unchanging, it becomes frozen. Like ice, it sparkles and plays with the light cast upon it, but it lacks a life of its own. For "purity" one may substitute "completeness," "power" or any left-brained, abstract, rationalistic, platonic, phallic or Apollonian idealization. Idealization of our object, whether that object is tangible or conceptual, robs it of earthy reality. Idealization rigidifies because it disconnects—or seems to disconnect—the visionary from the pleasures, discomforts and struggles of embodied existence. Held too narrowly, a vision can separate its bearer from life itself. It becomes a breeding ground for dogma and aggression. As Kuspit observes,

> Indeed, a strange lack of compassion seems to go with knowledge of the truth, especially when those in the know "apply" the truth to life like a corrective punishment, as if life had to be brought to order or taught a lesson for its own good, like a retarded, unruly child. This "adult" coldness makes life seem absurd and problematic to the extent of not being worth living, as Nietzsche said.
>
> Only "art...that redeeming and healing enchantress" can restore the self's loss of faith in life, reminding it that life is inherently more enchanting than art, and can even be more enjoyable. Only art can resurrect love of life and joie de vivre after they have been destroyed by the truth, that unwitting—and sometimes too witting—killjoy.[17]

While visions are often compelling for the visionary, that does not make them compulsory for everyone else. And although we might like, in an ideal world, to see everyone living according to our vision, that is not likely to occur. Our cultural presumption that a vision must be victorious to be valid ("might makes right") is not immune to question. The frequent tendency of visionaries to become more isolated than they need to

is not unavoidable. In fact, we would do well to consider perspectives offered by cultures in which vision is integrated more effectively than our own. In Native American culture for example, the Lakota people often use the expression "all my relations" (*mitakuye oyasin*) as a greeting or exclamation in sacred spaces such as places of prayer and sweat lodges. It refers not only to one's human family, but all of life, affirming the speaker's place in a connected universe. Such a use of language reflects a cultural predilection that embraces life for what it is instead of trying to impose a concept on top of it.

The Native American writer Gerald Vizenor spoke about the cultural context in which a visionary role can be held for a better end result:

> ...tribal cultures are comic or mostly comic. Yet they have been interpreted as tragic by social scientists...not tragic because they're 'vanishing' or something like that, but tragic in their worldview— and they're not tragic in their worldview...In a tragic worldview people are rising above everything. And you can characterize Western patriarchal monotheistic manifest-destiny civilization as tragic. It doesn't mean they're bad, but they're tragic because of acts of isolation, their heroic acts of conquering something, always overcoming adversity, doing better than whatever, proving something, being rewarded for it, facing the risks to do this and usually doing it alone and almost always at odds with nature. Part of that, of course, is the idea of the human being's divine creation as superior.
>
> The comic spirit is not an opposite but it might as well be. You can't act in a comic way in isolation. You have to be included. There has to be a collective of some kind. You're never striving at anything that is greater than life itself. There's an acceptance of chance. Sometimes things just happen and when they happen, even though they may be dangerous or even life-threatening, there is some humor. Maybe not at the instant of the high risk, but there's some humor in it. And it's a positive, compassionate act of survival, it's getting along.[18]

Somehow, despite our best efforts, we have come full circle to the attitude proposed by Harry Chapin that began this consideration. We can't deny that there is something compelling, uncompromising, magical and transcendent about a dream. To be captivated by such a calling is a rare and extraordinary opportunity that should not be taken lightly. At the same time, life goes on in the mortal realm. Lots of dreams come and go. We can expect to have quite a few of them catch our eye or bend our ear in a lifetime. Many or most will be momentary inspirations, suitable only to one stage of life or another.

To be fair to Harry, we should remember that in general, his songs were quite often about impractical and visionary characters, overlooked or spurned by society, whose contributions make life better, longer or more real for those around them. "The Rock," "Corey's Coming," "What Made America Famous?," "Bummer," "She is Always 17"—and maybe even "Shooting Star"—spring to mind, although they may, sadly, not be familiar to many people today. In fact, in light of Chapin's total *oeuvre*, the song with which we began, "Dreams Go By", is probably best understood as a token nod to the noble task of managing a normal life of relationship instead of trying to be some kind of crazy hero.

By the time we are done with life, there will probably be only one or two dreams that prove to be callings, defining our purpose on this insignificant little rock in space. Furthermore, we may not even know what they are until we have the benefit of hindsight. This means that even a committed visionary is groping blindly in chaos, like Brad and Janet at the end of the *Rocky Horror Picture Show*. As we cannot tell who or what will really be most important by the time we die, it behooves us to treat everyone and everything in our life with the care and respect worthy of a gift from God.

Endnotes

Chapter 1 – Lascaux

1 Brion, Marcel in: *Animals and Art* (London: George G. Harrap, 1959), 12, as quoted in: Collier, Graham, *Art and the Creative Consciousness*, (Englewood Cliffs, New Jersey: Prentice Hall, 1972), 170-171.

2 McLuhan, Marshall and Quentin Fiore, *The Medium is the Massage: An Inventory of Effects*, (San Francisco: Hardwired, 1996), 57.

Chapter 2 – The Loneliness of the Artist

1 http://www.antenna.nl/~anaisnin/lettertoleonard61945.htm

Chapter 3 – Relevance and Polarization

1 Motherwell, Robert, from: "The Modern Painter's World," *Dyn*, VI (1944), as quoted in: Rose, Barbara, *Readings in American Art Since 1900*, (New York: Frederick A. Praeger, 1968), 131-132.

Chapter 4 – Self-Indulgence

1 Castaneda, Carlos, *The Power of Silence*, (New York, Simon and Schuster, 1987), 169.

2 Grand Master XIV, Urasenke School of Tea, from: Soshitsu Sen, *Tea Life, Tea Mind*, (New York: Weatherill, 1979).

3 Corliss, Richard, "Andrew Wyeth's Stunning Secret," *Time Magazine*, August 18, 1986.

Chapter 5 – Dogmatic Mind

1 Carmilly-Weinberger, Moshe, *Fear of Art*, (New York: RR Bowker Company, 1986), xiii.

2 Fletcher, Rachel, "Proportion in the Living World," *Parabola*, Vol. XIII, Number 1, February, 1988, 36-51.

3 *Tiger's Eye*, No. 6, December 1948, quoted in: Rose, Barbara, *Readings in American Art Since 1900*, (New York: Frederick A. Praeger, 1968), 158.

4 Interestingly, this development, unique in the world, has been attributed to the development of glass lenses in Europe at this time. *See*: MacFarlane and Martin, *Glass: A World History*, (Chicago: University of Chicago Press), 53-54.

5 McLuhan, Marshall and Quentin Fiore, *The Medium is the Massage: An Inventory of Effects*, (San Francisco: Hardwired, 1996), 53-57.

6 Plato, *The Republic*, Jowett, Benjamin, trans., (New York: Barnes & Noble, 1999), 85.

7 Carmilly-Weinberger, 11.

8 Ibid., 31-32.

9 Carmilly-Weinberger, 152

10 As quoted in: Barrett, Terry, *Criticizing Art*, Second Ed. (Mountain View, Calif.: Mayfield Publishing Company, 2000), 4.

11 Taylor, Joshua C., "Futurism: Dynamism as the Expression of the Modern World," in: Chipp, Herschel B., *Theories of Modern Art*, (Los Angeles: University of California Press, 1968), 281.

12 From: "What Abstract Art Means to Me," *Museum of Modern Art Bulletin*, XVIII No. 3, Spring 1951, as quoted in: Rose, Barbara, *Readings in American Art Since 1900*, (New York: Frederick A. Praeger, 1968), 153-54.

13 For an interesting analysis of early twenty-first century American politics in the context of futurism and its ideals, see: "Quitting the Paint Factory" by Mark Slouka in *Harper's Magazine*, November 2004.

14 Beamont, Kathryn, "Food For Thought," *Princeton Alumni Weekly*, June 4, 2003, 14-15.

15 From: "The Foundation of Futurism," as quoted in: Collier, Graham, *Art and the Creative Consciousness*, (Englewood Cliffs, New Jersey: Prentice Hall, 1972), 141.

16 Hillman, James, *A Blue Fire*, (edited by Thomas Moore), (New York: Harper & Row, 1989), 143-65.

17 Miller, Alice, *For Your Own Good*, (New York: Farrar, Straus, and Giroux, 1984), 143.

18 Kuspit, Donald, *The Cult of the Avant-Garde Artist*, (Cambridge: University of Cambridge Press, 1993), 54.

19 Carmilly-Weinberger, xiii.

20 From: "A Layman's Views of an Art Exhibition," the *Outlook*, March 9, 1913. As quoted in: Rose, Barbara, *Readings in American Art Since 1900*, (New York: Frederick A. Praeger, 1968), 80.

21 Chipp, Herschel B., *Theories of Modern Art*, (Los Angeles: University of California Press, 1968), 474.

22 Ibid., 474.

23 Trungpa, Chögyam, *Dharma Art*, (Boston: Shambhala, 1996), 67.

24 For a summary of this idea as it relates to the work of Darwin, Oliver Wendell Holmes Jr., and others, see: Menand, Louis, *The Metaphysical Club* (New York: Farrar, Straus and Giroux, 2001).

25 Carmilly-Weinberger, 17-18.

26 Schwarz, Arturo, in: Kuenzli, Rudolph E. and Francis M. Nauman, Ed., *Marcel Duchamp Artist of the Century*, (Cambridge, MA: MIT Press, 1989), 19.

Chapter 6 – Subconscious Sabotage

1 Smith, David, in: Fry, Edward F. and Miranda McLintick, *David Smith: Painter, Sculptor, Draftsman*, (New York: George Braziller, Inc., 1982), 24.

2 Particularly useful for considering this subject in depth are the works of Alice Miller, especially *The Drama of the Gifted Child*, (New York: BasicBooks, 1990).

3 Castaneda, Carlos *The Eagle's Gift*, (New York: Simon and Schuster, 1981), 280.

4 Moore, Thomas, (Ed.), in: Hillman, James, *A Blue Fire*, (New York: Harper & Row, 1989), 143-65.

5 Cameron, Julia, *The Artist's Way*, (New York: G.P. Putnam's Sons, 1992).

6 *See:* Desjardins, Arnaud, *The Jump Into Life* by (Prescott, Arizona: Hohm Press, 1994).

Chapter 7 – On Being and Becoming

1 Klee, Paul, from: *Paul Klee: On Modern Art*, (Paul Findlay, trans.), (London: Faber and Faber, 1948), in: Herbert, Robert L., ed., *Modern Artists on Art*, (Englewood Cliffs, New Jersey: Prentice-Hall, Inc., 1964), 89.

2 Kandinsky, Wassily, "On the Problem of Form," *Der Blaue Reiter* (Munich: R. Poper, 1912), 74-100, as quoted in Chipp, Herschel B., *Theories of Modern Art*, (Los Angeles: University of California Press, 1968), 158.

Chapter 8 – Community

1 Lawrence, D. H., "Morality and the Novel," in: *Selected Literary Criticism*, ed. Anthony Beal (New York: Viking Press, 1956), 109, as quoted in: Collier, Graham, *Art and the Creative Consciousness*, (Englewood Cliffs, New Jersey: Prentice Hall, 1972), 171.

2 Letter to Robert Hooke, 5 February 1676, http://www.24carat.co.uk/standin-gontheshouldersofgiants.html

3 Javacheff, Christo, in: Diamonstein, Barbaralee, *Inside New York's Art World*, (New York: Rizzoli, 1979), 85.

4 Matsumoto, Michihiro, *The Unspoken Way*, (New York: Kodansha International/USA Ltd., 1988), 49.

5 *See:* Lozowick, Lee, *The Alchemy of Transformation*, (Prescott, Arizona: Hohm Press, 1996).

Chapter 9 – Objective Art

1 Lucie-Smith, Edward, *Movements in Art Since 1945*, (London: Thames & Hudson, 2001), 10.

2 Mondrian, Piet, "From the Natural to the Abstract: From the Indeterminate to the Determinate" *De Stijl*, ed. Hans L.C. Jaffe (New York: Abrams, 1971), 53, as quoted in: Kuspit, Donald, *The Cult of the Avant-Garde Artist*, (Cambridge: University of Cambridge Press, 1993), 47-48.

3 Le Corbusier, Charles-Edouard, and Amadée Ozenfant, "Purism," (1920) in: Herbert, Robert L., ed., *Modern Artists on Art*, (Englewood Cliffs, New Jersey: Prentice-Hall, Inc., 1964), 62.

4 Ibid., 73.

5 Einstein, Albert, as quoted in: Gowan, John Curtis, *Trance, Art, and Creativity*, (Northridge, CA: John Curtis Gowan, 1975), 245.

6 Mondrian, Piet, "Plastic Art & Pure Plastic Art," in: Herbert, Robert L., ed., *Modern Artists on Art*, (Englewood Cliffs, New Jersey: Prentice-Hall, Inc., 1964), 126.

7 Ibid., 127.

8 Kandinsky, Wassily, "Reminiscences," in Herbert, Robert L., ed., *Modern Artists on Art*, (Englewood Cliffs, New Jersey: Prentice-Hall, Inc., 1964), 32.

9 Kuspit, Donald, *The Cult of the Avant-Garde Artist*, (Cambridge: University of Cambridge Press, 1993), 14.

10 Greenberg, Clement, *Art and Culture* (Boston: Beacon, 1961), 133-138, as cited in: Chipp, Herschel B., *Theories of Modern Art*, (Los Angeles: University of California Press, 1968), 577-79.

11 For an extensive consideration of this and related topics in the context of African art, see: *EXHIBITION-ism: Museums and African Art*, (New York: Museum for African Art, 1994).

12 Tucker, Michael, *Dreaming With Open Eyes: The Shamanic Spirit in Twentieth Century Art and Culture*, (San Francisco: Harper/Aquarian, 1992), 5-6.

13 Yenawine, Philip, *How to Look at Modern Art*, (New York: Abrams, 1991), 124, as quoted in: Barrett, Terry, *Criticizing Art*, Second Ed. (Mountain View, Calif.: Mayfield Publishing Company, 2000), 38.

14 Kuspit, 15.

15 Regarding the predicament in which we find ourselves in this regard, Castaneda described our condition as a natural consequence of the way our sense of self evolved, based on self-pity. According to Castaneda, modern man, "… finds himself so hopelessly removed from the source of everything that all he can do is express his despair in violent and cynical acts of self-destruction." Castaneda, Carlos, *The Power of Silence,* (New York, Simon and Schuster, 1987), 169.

16 Commoner, Barry, "Unraveling the DNA Myth: The Spurious Foundation of Genetic Engineering," *Harper's Magazine*, February 2002. See also the website : <http://www.criticalgenetics.org> for updates on the points made in this article.

17 Pollan, Michael, *The Botany of Desire*, (New York: Random House, 2001), 183-238.

18 Hillman, James, "The Practice of Beauty" in: Beckley, Bill, ed., *Uncontrollable Beauty: Toward a New Aesthetics,* (New York: Alworth Press,) 261.

19 From: "Why I Stopped Hating Shakespeare," *Sunday Observer* (London) April 19, 1964, Sec. 2, page 1, as quoted in: Collier, Graham, *Art and the Creative Consciousness*, (Englewood Cliffs, New Jersey: Prentice Hall, 1972), 113.

20 Einstein, Albert, *New York Times*, March 29, 1972, as quoted in: Gowan, John
 Curtis, *Trance, Art, and Creativity*, (Northridge, Calif: John Curtis Gowan,
 1975), 260.

21 Anderson, William, "The Central Man of All The World," *Parabola*, Volume
 XIII Number 1, November 1988, 8-9.

22 Kuspit, 63.

23 *The Collected Writings of C. G. Jung*, G. Adler, A.M. Fordham and H. Read ed.
 (Princeton: Bollingen Foundation, 1966), 101, as quoted in Collier, Graham,
 Art and the Creative Consciousness, (Englewood Cliffs, New Jersey: Prentice
 Hall, 1972), 58.

24 Ouspensky, P.D., *In Search of the Miraculous: Fragments of an Unknown
 Teaching*, (New York: Harcourt, Inc., 1949), 26-27.

25 Ibid., 296.

26 Ibid., 296.

27 *The Last Testament*, Volume 3, #24. as quoted at: www.otoons.com/giolloart-
 dezign/ GiolloMarco/insights2.htm

28 Trungpa, Chögyam, *Dharma Art*, (Boston: Shambhala, 1996), 107.

29 *The Last Testament*, Volume 3, #24 as quoted at: www.otoons.com/giolloart-
 dezign/ GiolloMarco/insights2.htm.

30 Trungpa, 115.

31 Zalesky, Jeffrey P., "Echoes of Infinity: An Interview with Seyyed Hossein
 Nasr," *Parabola*, Volume XIII, No. 1, February 1988, 35.

32 Trungpa, 108.

Chapter 10 – Journey Between the Worlds

1 Tucker, Michael, *Dreaming With Open Eyes: The Shamanic Spirit in Twentieth
 Century Art and Culture*, (San Francisco: Aquarian, 1992), 2.

2 Kuspit, Donald, *The Cult of the Avant-Garde Artist*, (Cambridge: University of
 Cambridge Press, 1993), 90-91.

3 Shahn, Ben, *The Shape of Content*, (Cambridge: Harvard University Press,
 1957), 73.

4 A fascinating and thorough analysis of the performing arts as a vehicle for
 shamanistic practice is *The Death and Resurrection Show*, by Rogan P. Taylor
 (London: Muller, Blond & White Limited, 1985). For a more general consid-
 eration of Shamanism, try Michael Harner's *The Way of the Shaman* (New
 York: Bantam, 1982); *Shamanism: Archaic Techniques of Ecstasy*, by Mircea
 Eliade (New York: Pantheon, 1964); *Shamanic Voices: A Survey of Visionary*

Narratives, edited by Joan Halifax (New York: Dutton, 1979); and Joseph Campbell's, *The Hero With a Thousand Faces,* (Princeton, New Jersey: Princeton University Press, 1972).

5 Tucker, xxi.

6 Rawson, Philip, *Primitive Erotic Art,* (New York: G.P. Putnam's Sons, 1973), 9.

7 Gowan, John Curtis, *Trance, Art, and Creativity,* (Northridge, Calif.: John Curtis Gowan, 1975), 230.

8 Boyd, Doug, *Rolling Thunder,* (New York: Dell Publishing Co. Inc., 1974), 92.

9 For a detailed description of the *hanblecheyapi* ritual see: Brown, Joseph Epes, Ed., *The Sacred Pipe: Black Elk's Account of the Seven Rites of the Oglala Sioux,* (Norman, OK: University of Oklahoma Press, 1953), 45-66; also, Tedlock, D & B, *Teachings from the American Earth,* (1975). Similar ritual forms have traditionally been used by other tribes native to the plains of North America.

10 Lame Deer (John Fire) and Richard Erdoes, *Lame Deer, Seeker of Visions,* (Washington Square Press, 1972), 42.

11 Lucie-Smith, Edward, *Movements in Art Since 1945,* (London: Thames & Hudson, 2001), 10.

12 As quoted in: Ray, Gene, Ed., *Joseph Beuys: Mapping the Legacy,* (New York: Distributed Art Publishers, 2001), 150.

Chapter 11 – Resistance

1 Castaneda, Carlos, *A Separate Reality: Further Conversations with Don Juan,* (New York: Pocket Books, 1972), 215. Other sources using the spiritual warrior motif include *Warrior's Way* by Robert S. de Ropp (Nevada City, Calif.: Gateways/IDHHB, Inc., 1992) and *Shambhala: the Sacred Path of the Warrior,* by Chögyam Trungpa (New York: Bantam, 1986).

2 Castaneda, Carlos, *The Teaching of Don Juan: A Yaqui Way of Knowledge,* (New York: Pocket Books, 1974), 83.

3 Ibid., 83-84.

4 Ibid., 85.

5 Ibid., 86.

6 Ibid., 87.

7 Ibid., 87.

8 Lozowick, Lee, *Laughter of the Stones,* (Prescott, Arisona: Hohm Press, 1975), 81-82.

9 There was a great deal of press attention on Werner Erhard as a result of scandalous allegations made against him in the early 1990s. Much less attention

was paid when the allegations were thoroughly retracted. For a complete account, see: Jane Self's *60 Minutes and the Assassination of Werner Erhard* (Houston: Breakthru Publishing, 1992).

10 From a seminar handout provided by Werner Erhard and Associates.

11 Huxley, Aldous, *The Perennial Philosophy*, (New York: Harper Bros., 1945), 117, as quoted in: Gowan, John Curtis, *Trance, Art and Creativity* (Northridge, Calif.: John Curtis Gowan, 1975), 131.

12 Lozowick, Lee, *Laughter of the Stones*, (Prescott, Arizona: Hohm Press, 1975), 79-80.

13 *The Artist's Way* by Julia Cameron (New York: G.P. Putnam's Sons, 1992) features excellent techniques for breaking through this, and other kinds of creative blockage.

14 Yamamoto, Tsunetomo, *Hagakure: The Book of the Samurai*, (Wilson, William Scott, trans.), (Tokyo: Kodansha International, 1979).

15 Remde, Harry, "Close to Zero," in: *A Way of Working: The Spiritual Dimension of Craft*, D.M. Dooling, Ed, (New York: Parabola Books, 1986), 52-53.

Chapter 12 – Hunger

1 From *Possibilities*, No. 1 (Winter, 1947-48) as quoted in: Rose, Barbara, *Readings in American Art Since 1900*, (New York: Frederick A. Praeger, 1968), 144.

2 Buber, Martin, *I and Thou*, (New York: Charles Scribner's Sons, 1970).

Chapter 13 – Labels

1 International Flameworkers Conference, Salem Community College, Carney's Point, New Jersey, March 8, 2003.

2 Hickey, Dave, "Dealing," in: *Air Guitar: Essays on Art and Democracy*, (Los Angeles, Art Issues Press, 1997), 110, as quoted in: Barrett, Terry, *Criticizing Art*, Second Ed. (Mountain View, Calif.: Mayfield Publishing Company, 2000), 12.

3 Personal correspondence, October 12, 2003.

4 Cooney, Seamus, Ed., *Charles Bukowski, Reach for the Sun: Selected Letters 1978-1994, Vol. 3*. (Santa Rosa, Calif.: Black Sparrow Press, 1999), 199.

5 Levitine, George, *The Dawn of Bohemianism*, (University Park, Pennsylvania: The Pennsylvania State University Press, 1978), 13-14.

6 Kaplan, Wendy, *The Art That is Life: The Arts & Crafts Movement in America, 1875-1920*, (Boston: Little, Brown and Company, 1987), 52-54.

7 Levitine, 15.

8 Shahn, Ben, *The Shape of Content*, (Cambridge: Harvard University Press, 1957), 48.

Chapter 14 – Power and Politics

1 Popper, Karl R., *The Open Society and Its Enemies* (Princeton, New Jersey: Princeton University Press, 1950), 458-460, as quoted in: Kuspit, Donald, *The Cult of the Avant-Garde Artist*, (Cambridge: University of Cambridge Press, 1993), 114.

2 *Bhagavad Gita*, 7:8, http://www.thegitaspace.com/verse4.htm.

3 Carmilly-Weinberger, Moshe, *Fear of Art*, (New York: RR Bowker Company, 1986), 191.

4 *See:* Cameron, Julia, *The Artist's Way*, (New York: G.P. Putnam's Sons, 1992), 44-49.

Chapter 15 – Vision

1 Yamaguchi, Masao, "The Poetics of Exhibition in Japanese Culture," in: *Exhibiting Cultures: The Poetics and Politics of Museum Display*, Ivan Karp and Steven D. Lavine (eds.), (Washington, D.C. and London: Smithsonian Institution Press, 1991).

2 For a complete account of Harry Chapin's remarkable life, see: *Taxi: The Harry Chapin Story* by Peter M. Coan (New York: Carol Publishing Group, 1990).

3 McLuhan, Marshall and Quentin Fiore, *The Medium is the Massage: An Inventory of Effects*, (San Francisco: Hardwired, 1996), 92-93.

4 As quoted in: Tucker, Michael, *Dreaming With Open Eyes: The Shamanic Spirit in Twentieth Century Art and Culture*, (San Francisco: Aquarian, 1992), 11-12.

5 McLuhan, 88.

6. Malevich, Kasimir, "Suprematism," in: Herbert, Robert L., ed., *Modern Artists on Art*, (Englewood Cliffs, New Jersey: Prentice-Hall, Inc., 1964).

7 As quoted in: Tucker, Michael, *Dreaming With Open Eyes: The Shamanic Spirit in Twentieth Century Art and Culture*, (San Francisco: Aquarian, 1992), 41.

8 Lewis, C. S., *Surprised by Joy*, (New York: Harcourt, Brace, Jovanovich, Publishers), 17-18.

9 Carmilly-Weinberger, Moshe, *Fear of Art*, (New York: RR Bowker Company, 1986), 190-191.

10 McDaniel, June, *The Madness of the Saints: Ecstatic Religion in Bengal*, (Chicago: University of Chicago Press, 1989), 8.

11 Young, M., *Yogi Ramsuratkumar: Under the Punnai Tree* (Prescott, Arizona: Hohm Press, 2003).

12 Carmilly-Weinberger, 195-196.

13 Miller, Henry, *Tropic of Cancer,* (New York: Signet Classic, 1995).

14 Carmilly-Weinberger, 199.

15 Van Gogh, Vincent, *The Complete Letters of Vincent Van Gogh*, Vol.1, (Greenwich, Conn.: The New York Graphic Society, 1958), letter 133, July 1880, as quoted in: Chipp, Herschel B., *Theories of Modern Art*, (Los Angeles: University of California Press, 1968), 27.

16 Carmilly-Weinberger, 201.

17 Kuspit, Donald, *The Cult of the Avant-Garde Artist*, (Cambridge: University of Cambridge Press, 1993), 90-91.

18 Vizenor, Gerald, quoted in: Ryan, Allan J., *The Trickster Shift: Humour and Irony in Contemporary Native Art*, (Seattle: University of Washington Press, 1999), 4.

Index

A

Absolute, 27
Absolutism, 27
abstract art, 90, 92
abuse, 144
*Académie Royale de Peinture et
Sculpture*, 159
acceptance, 39, 48, 52, 57-58, 59, 139-
140, 144, 191
accountability, 132-134
addiction, 54, 56-59
aesthetic, x, xi, 27, 39, 97
aggression, 34-35, 46, 66-67, 190
Anderson, William, 100
archetypes, 113, 118, 136
Arentino, Pietro, 47
Aristotle, 26
Armory Show, 44
arrogance, 13, 90-91

artist(s), spirituality and, viii-ix; image
and, 1; as problem solver, 3-4;
loneliness of, 5-8; guards the
spiritual, 10; attitude toward
audience, 12-16; power and the,
29, 35 (*see also*: power); church
and, 32, 47-48; dogmatic mind
and, 36, 48; inspiration and, 36,
38, 100, 134; humor and the,
48-49; productivity and, 56-58;
creating, 61-62, 66-69; uncer-
tainty and, 81-82; objectivity
and, 102-106; suffering and the,
112-114; as shaman, 114-118; as
warrior, 128, 143-144; discipline
and, 133; faith and the, 147;
descriptions of, 157-158, 161;
egomania and, 170; suicide and
184-185
Auschwitz, 121

R

S

Recommended Reading

There are many inspiring and practical books on the practice and philosophy of art. Here are a few of this author's favorites:

Bennett, J.G, *Creative Thinking*, (Sherborne, England: Coombe Springs Press, 1975).

Cameron, Julia, with Mark Bryan, *The Artist's Way: A Spiritual Path to Higher Creativity*, (New York: G. P. Putnam's Sons, 1995).

Csikszentmihalyi, Mihaly, *Creativity: Flow and the Psychology of Discovery and Invention* (New York: HarperCollins Publishers, Inc, 1996).

Dooling, D.M., Ed., *A Way of Working: The Spiritual Dimension of Craft*, (New York: Parabola Books, 1986).

Franck, Frederick, *The Zen of Seeing: Seeing/Drawing as Meditation*, (New York: Vintage Books, 1973).

Holly, Bruce, *Doughnuts and Destiny: Essays on the Psychology of Creativity*, (Upper Fairmount, MD: Art Calendar Publishing, Inc., 1995).

London, Peter, *No More Secondhand Art: Awakening the Artist Within*, (Boston: Shambhala, 1989).

Trungpa, Chögyam, *Dharma Art*, (Boston: Shambhala, 1996).

About the Author

Bandhu Scott Dunham's artistic career began with his exploration of lampwork glassblowing in 1975, while still in high school. After two years of self-instruction, he trained informally with the Chemistry Department Glassblower while studying Chemical Engineering and Visual Arts at Princeton University, before completing his apprenticeship under American and European masters at Urban Glass (then located in Manhattan), The Pilchuck Glass School (Stanwood, Washington) and the Penland School of Crafts (in North Carolina). His work is in the permanent collections of a number of museums, including the Corning Museum of Glass (U.S.), The Niijima Glass Center (Japan), and Glasmuseum Lauscha (Germany). Bandhu is currently an independent artist living in Arizona; he has taught at studios and glass schools across America and internationally.

Bandhu's interests in spirituality and human potential also developed at an early age. After his introduction to metaphysics and new age philosophies in his teens, he lived for five years on an ashram in the Southwest United States, studying guru-yoga in a school that had originated near Mount Arunachula in Southern India. He has edited the spiritual journal, Divine Slave Gita, and the radical nonconformist punk zine, *Attitude Problem*.

Bandhu is the author of the definitive glassblowing text *Contemporary Lampworking*, now in its third edition, and F*ormed of Fire: Selections in Contemporary Lampworked Glass*.

More information on Bandhu and his current work is at
www.salusaglassworks.com